Art Therapy and AD/HD

of related interest

The ADHD Handbook
A Guide for Parents and Professionals
Alison Munden and Jon Arcelus
ISBN 1 85302 756 1

Parenting the ADD Child
Can't Do? Won't Do?
David Pentecost
ISBN 1 85302 811 8

Art Therapy with Children on the Autistic Spectrum
Beyond Words
Kathy Evans and Janek Dubowski
ISBN 1 85302 825 8

Medical Art Therapy with Adults
Edited by Cathy Malchiodi
ISBN 1 85302 679 4 pb
ISBN 1 85302 678 6 hb

Medical Art Therapy with Children
Edited by Cathy Malchiodi
ISBN 1 85302 677 8 pb
ISBN 1 85302 676 X hb

Contemporary Art Therapy with Adolescents
Shirley Riley
ISBN 1 85302 637 9 pb
ISBN 1 85302 636 0 hb

Art Therapy and Computer Technology
A Virtual Studio of Possibilities
Cathy A. Malchiodi
ISBN 1 85302 922 X

Art-Based Research
Shaun McNiff
ISBN 1 85302 621 2 pb
ISBN 1 85302 620 4 hb

Art Therapy and AD/HD
Diagnostic and Therapeutic Approaches

Diane Stein Safran

Jessica Kingsley Publishers
London and Philadelphia

First published in the United Kingdom in 2002
by Jessica Kingsley Publishers Ltd
116 Pentonville Road
London N1 9JB, England
and
325 Chestnut Street
Philadelphia, PA 19106, USA

www.jkp.com

Copyright © Diane Stein Safran 2002

Library of Congress Cataloging in Publication Data
A CIP catalog record for this book is available from the Library of Congress

British Library Cataloguing in Publication Data
A CIP catalogue record for this book is available from the British Library

ISBN 1 84310 709 0

Printed and Bound in Great Britain by
Athenaeum Press, Gateshead, Tyne and Wear

About the Author

For as long as she can remember, art has been important to Diane Stein Safran. Her life has been enriched by active participation in the creative process, as well as observing and appreciating the artistic achievements of others. This book, *Art Therapy and AD/HD: Diagnostic and Therapeutic Approaches*, is a culmination of both her lifelong interest in art and her career working with the AD/HD population.

The process of making art is highly therapeutic, whether it is a preliminary sketch, drawing, painting, craft or integrated art project. This book stems from over 20 years of experience as an art therapist working with children, adolescents, adults and families, many of whom have attention deficit/hyperactivity disorder. Art therapy is part of a multimodal approach that is incorporated in Diane Safran's private practice and in a multidiscipline practice known as the Attention Deficit Disorders Institute in Westport, Connecticut. Mrs Safran is a co-founder of the ADDI.

Mrs Safran is a registered, board certified art therapist and a licensed clinical marriage and family therapist. Her studies have also included group psychotherapy. Additionally, she is a court appointed expert witness using art therapy to determine whether or not a child has been sexually or physically abused. She has also lectured throughout the USA on the use of art therapy with the AD/HD population.

Mrs Safran is married and has four grown children. Both her husband and two of her daughters have AD/HD.

Contents

This book is dedicated to the memory of Eva Stein. Without your legacy of perseverance and intellectual curiosity this book would not have been completed. Thank you Mom for your encouragement, belief in this project and continual love.

Acknowledgements

There were many people who helped me in completing this manuscript. Myra Levick, Jerry Oser, John Ratey and Virginia Minar all read the first manuscript and offered constructive suggestions to the revision of the book. My husband, Frank, was my constant reader and critic. Leslie Carr provided editorial help. Thank you to all my patients who were willing to share their stories and drawings with me, making this book possible. My daughters – Elysa, Becca and Dayna – provided continual encouragement. However, without my son Jonathan's help this book would not have been completed. Thank you.

Foreword

This book is a remarkable accomplishment. Diane Safran has taken a complex diagnosis, its myriad of manifestations and multitude of treatment possibilities and created a work that is both understandable and user-friendly.

Confronted with some forms of AD/HD in her own family, Diane Safran felt compelled to explore this illness further. She modestly acknowledges that she cannot compare herself to such researchers as Piaget and others who have studied their own children. Nevertheless, observing and sharing the struggles of her children and husband with this illness provided her with a road map and impetus toward this work.

In the very first chapter Diane Safran provides the reader with a clear definition of this complicated and involved disorder. She also clearly expounds on why art therapy is such an excellent treatment approach. A teacher first, she recognized early on that art provided significant information about the artist who produced it; information that could be given back to the artist and appropriate others in the environment. She also realized that she needed more education to guide this process and went back to school to become an art therapist. Her knowledge, skill and experience as an art therapist is evident throughout this book.

There are seven chapters, each addressing a specific area of diagnosis and treatment with a specific population. Diane Safran has a broad knowledge of medical, physical and emotional development. No individual is treated until he or she has undergone a comprehensive evaluation including family history and developmental information. She and her multidisciplinary team are open to all data obtained from this, intake

interviews and early assessments. There is no pat treatment approach but there is a framework – once the diagnosis is confirmed, treatment evolves. Although this framework provides a structure, flexibility and respect for individual needs determines the process. Treatment strategies emerge from the knowledge of all aspects of AD/HD with a focus on specific symptoms, behaviors and manifestations.

Diane Safran's knowledge and experience (personal as well as professional) has taught her that it is not sufficient to work with the AD/HD child alone. She has learned the importance of educating the child or adolescent and their families about this disorder before treatment can begin. Chapters 2 and 3 succinctly lay out this initial phase of educational groups for children, adolescents and parents. Once completed, group therapy is initiated for children and adolescents. The number of meetings and group members are based on the developmental needs of the children and adolescents and the manifestations of the disorder. Diane Safran is also cognizant of normal developmental issues and structures the groups with this in mind. In Chapters 4 and 5 she takes the reader through these sessions and on to group sessions for those individuals who continue in therapy. Along with these concise descriptions of the group process, Diane Safran provides illustrations of drawings produced as an integral part of the group process. They are a testimony to her conclusion that art therapy is a meaningful treatment approach.

More recent literature has indicated that it is not only children who are afflicted with this disorder, but many adults, struggling with symptoms related to this illness and now diagnosed with AD/HD. In taking family histories, Diane Safran recognized the need to develop diagnostic and treatment strategies for individual adults and families beyond the parent groups for children with AD/HD. Continuing with the interdisciplinary team approach, which provides ongoing communication between therapists, Diane Safran describes her work with these populations in Chapters 6 and 7.

No stone has been unturned to better understand this disorder and develop treatment methods for AD/HD populations. Diane Safran has produced a remarkable work demonstrating the intrinsic value of working with an interdisciplinary team and art therapy as a therapeutic process. At the end of the book she lists her references and provides a summary and a

list of resources that will be most useful to anyone who has any connection to someone with AD/HD. Most important, her discussions, goals for the different populations and illustrations show us the progress and achievements of those individuals and groups she has worked with. This book is not just for the art therapist working with this population, but also for all clinicians confronted with persons diagnosed with AD/HD.

Myra F. Levick, PhD, HLM, ATR

Foreword

Although my co-authored books, *Using Drawings in Assessment and Therapy* (with Patricia Gould, A.T.R. Brunner/Mazel, 1987) and *Clinical Uses of Drawings* (with Sarah Montgomery, MSW. Aronson, 1996) provided a broad framework for reasons to introduce drawings into the therapeutic encounter, neither provided in-depth details of how to implement drawing directives into specific populations. Now we have Diane Safran's book to fill that gap.

This very readable book, written from a personal as well as professional context, is replete with exquisite illustrations and common-sense interventions that fascinate the reader. Diane Safran, a registered board-certified art therapist and licensed marital and family therapist, is able to clarify the nuances of working with AD/HD children and adults. At the same time, she demonstrates how using drawings and other art media can enhance the expression of frustrations and bewilderment that arise with this disorder. The various examples used throughout the book provide clear-cut strategies that can only enhance the clinician's toolbox in working with AD/HD clients.

Today's clinicians are confronted with increasing amounts of information, and are in need of clear guides that promote creative interventions and enhance the therapeutic relationship. Obstacles can occur when working with children, adolescents or adults, and clinicians need additional techniques at their disposal to deal with resistance or other subtle defenses that impede progress. Regardless of diagnosis or theoretical framework, the therapist must have a broad range of techniques in order to maintain an ongoing relationship. This book describes how

directives from an art therapist can become an integral part in treatment with problematic AD/HD clients.

Drawings and other uses of art media permit those individuals in therapy to express their feelings and thoughts in a different manner that is perhaps less threatening than talking through one's problems. With the addition of art activities within the therapeutic encounter, both children and adults can "speak" with another voice – providing another avenue for the sharing of conflicts. This extra measure of self-expression conveys alternative means of "talking" about painful issues that may otherwise remain hidden.

This informative book describes how an art therapist with over twenty years of experience and who is co-director of an AD/HD clinic shares her personal and professional passion through a unique and very creative perspective. Her use of art therapy provides strong visual learning skills that lend structure to sessions and provide a groundwork for reflection and insight. The utilization of art products also supplies a visual record of feelings and ideas that can be used for therapeutic progress and review during termination. This record is highly valuable for those individuals with AD/HD who would otherwise have difficulty using what they learn without constant reminders.

Through discussions of AD/HD – including the history of the disorder, frequent comorbid conditions, interview methods, assessment techniques and the applications of art therapy directives in individual, groups and family sessions – the reader can learn many valuable interventions that strengthen their skills as clinicians. Helpful strategies are clearly described and art therapy guidelines will enhance the understanding of the visual language of the client. This book should prove to be an extremely valuable resource within the clinical literature. It is truly a unique and welcome addition to the field of psychotherapy. Creative therapists from all persuasions have much to learn from its contents.

Gerald D. Oster, PhD. Clinical Associate Professor, University of Maryland Medical School, Baltimore, MD

Introduction

Why art therapy with AD/HD?

When I recall my early experiences working with adolescents in a drug treatment center, I now question whether these patients may have had AD/HD. In the 1970s, the medical and mental health community did not believe that AD/HD was as prevalent as they do today; consequently, many patients went undiagnosed (or were diagnosed incorrectly). All of the elements of AD/HD were present in this population: *hyperactivity, distractibility* and *impulsivity*. Perhaps their drug and alcohol problems were side effects of AD/HD, related to their poor judgment and impulsivity.

Throughout the history of mental health, there have been researchers who have discovered so much from the observation of their own children and identifying their own frustrations (e.g., Piaget, Melanie Klein and Sigmund Freud). I certainly do not presume to be on a par with these investigators; however, the knowledge I have gained from my children is of profound importance to my work with children and families. Something else had been going on within my family for many years. Talk about the shoemaker's daughter! I became more aware of the impact of AD/HD on families – especially my own – as I observed two of our daughters struggle to succeed academically in school and socially among their peers. Both are very bright but, for different reasons, had difficulties with test taking. Remember, 20 years ago no one talked about extended or untimed tests, nor was there much knowledge about managing medication for disorders like AD/HD in the school setting.

My second daughter, Becca, was diagnosed as being hyperactive at age two and a half by a noted child psychiatrist at the University of Michigan. Ritalin was prescribed at a high dosage level. In the early 1970s, as a schoolteacher, I saw children on Ritalin become lethargic, even fall asleep in class, so I was reluctant to follow that treatment recommendation. As a result, Becca struggled without medication until high school. She exhibited all of the typical symptoms of AD/HD: she was extremely impulsive, distractible and distracting, constantly interrupting, always acting like the class clown and could not focus or sit still. Pediatricians, psychologists and child psychiatrists whom we consulted told us that she had no lasting problem, and that whatever problem did exist stemmed from my inability to adequately parent her as her mother.

Like many other concerned parents of hyperactive or underachieving children, we bounced from one highly recommended medical professional to another. As her mother, I did not know how to classify or define her disorder at that time, but I did know for certain that her behavior was not the result of inadequate parenting or inconsistent attention or love. I knew with a mother's instinct that there was some type of disorder, something not yet fully understood, and I never gave up the search for help, or of hope for a less frenetic life for her.

At the same time, school professionals were complaining that our third child, Dayna, was a "daydreamer" whom we now recognize as a person who has predominately inattentive AD/HD, a form without hyperactivity. In many ways, the quiet child is more difficult to diagnose and understand because of their lack of overt symptoms.

This book evolved as my career did. The help I sought for so long for both of my daughters was found in a profession that combined a lifelong love of the creative process with a growing interest in people, families and psychology. Finding the help I sought for my daughters led me to realize the effectiveness of art therapy for diagnosis and treatment of AD/HD with personal, client and family observations and experiences of dramatically changed lives. Art therapy provided an answer to many professionals and families and the need to disseminate this information became this book.

Art Therapy and AD/HD: Diagnostic and Therapeutic Approaches is organized to make it easy to focus on age-related diagnosis and treatment

of children, adolescents and adults. For example, the importance of careful group selection for children ages 5 through 7 is discussed in Chapter 2.

Art Therapy and AD/HD: Diagnostic and Therapeutic Approaches describes how art therapy is an integral part in the treatment of AD/HD patients. This work incorporates what I have learned over twenty-plus years of diagnosing and treating AD/HD patients, living in an AD/HD household and using the tools that have worked best in my practice. New ways that patients have learned to concentrate on what they enjoy most and do best, to focus, to forgive and appreciate themselves and to cope with their impulsivity, will be discussed at length in this book. Many pictures drawn by patients are included with the belief that these are more memorable than words and more accurately identify the true feelings of patients of all ages. These illustrations serve to document the hypothesis: *Art therapy is a highly valued modality for diagnosis and treatment of AD/HD.*

This did not just happen overnight. The work presented here represents years of experience in learning about the needs of this population, culminating in the formation of the Attention Deficit Disorders Institute in 1992, an institute devoted to the multimodal approach to the diagnosis and treatment of AD/HD, similar to the concept advocated by Peter Jensen (1999) in "Fact versus fancy concerning the multimodal treatment study for attention-deficit-hyperactivity disorder."

I
Conceptualizing and Assessing Attention Deficits

Introduction

The diagnosis of attention deficit disorder, with or without hyperactivity, is a recent one. It was first included in the *DSM II* (APA 1967). It is now seen as a neurologically based disorder that impacts both learning and behavior (Zametkin 1991). Since it is a hidden disability, it often impacts school performance and beyond (DuPaul and Stoner 1994). It is frequently mislabeled as laziness or stubbornness, misdiagnosed and misunderstood.

The history of AD/HD goes back as far as references by a German physician, Heinrich Hoffman, in a poem he wrote in the mid-1800s about a hyperactive child, "Fidgety Phil." Even Shakespeare made references to the malady of attention in one of his characters in *King Henry VIII* (Barkley 1997). There is a great body of literature that suggests the existence of Attention Deficit Disorder as early as the 1800s. However, the syndromes affecting these children went by other names (e.g., "minimal brain damage" or "minimal brain dysfunction") until recently. In the 1950s and 1960s, the label "hyperkinetic impulse disorder" was used to describe these children. In 1960, Burkes and Chess gave the diagnostic term "hyperactive child syndrome." In 1968, *DSM II* described this as Hyperkinetic reaction of childhood (APA 1968). In *DSM III* (APA 1980), the disorder was called Attention-Deficit Disorder, and in *DSM III-R* (1987) the disorder was named Attention-Deficit/Hyperactivity

Disorder. A great deal of research on the disorder followed, which led to separate lists of items for AD/HD when *DSM IV* was published (APA 1994). One list was for inattention and one for impulsive hyperactive behavior. This was the first time that DSM was providing a distinction in subtypes of AD/HD (Barkley 1997, pp.4–9).

In 1902, Dr George Still described a group of 20 children in his clinical practice as having a deficit in "volitional inhibition" (Barkley 1997, p.4). Initially, the focus was on hyperactivity and treatments were geared toward behavioral symptoms (e.g., a child's constant fidgeting, impulsive outbursts and aggressiveness with peers). Over time, however, the cognitive roots of these behaviors came to be emphasized, so that the current definition in the *DSM* (1994) of Attention Deficit/Hyperactivity Disorder (AD/HD) now takes into account the cognitive processing problems that are behind these behavior problems.

Like so many of the disorders defined by the DSM, Attention Deficit/Hyperactivity Disorder (or "AD/HD" which is the designation used throughout this book) is frequently comorbid with other disorders such as learning disabilities, anxiety, depression and conduct disorder (Ackerman, Dylman and Oglesty 1983). Teachers of students with learning disabilities from four states representing different geographical regions of the USA were surveyed about students diagnosed with attention deficit/hyperactivity disorder on their caseloads; results indicated that 22.7 per cent of the learning disabled students were also diagnosed with AD/HD (Snider, Frankenberger and Aspenson 2000).

AD/HD has many individual manifestations, but several clear components, which will be discussed in this chapter. As useful and important as the DSM guidelines are, a case example is perhaps a more vivid and useful place to begin to gain a full impression of this disorder. Tom, a 14-year-old male patient, upon hearing his therapist's positive comment that he seemed to be doing a good job of focusing on her lips as she spoke, exclaimed:

> I'm watching your mouth because you have told me that it will help
> me to pay attention, but your furnace just kicked in, someone drove
> up and I can't figure out what kind of car it is, there is a tree being
> chain-sawed somewhere near here, someone's cutting the grass, I
> heard your doorbell ring, which means your next patient is here, that

light bulb is flickering and, by the way, are you having chicken soup for dinner because I can smell it.

This boy had to work hard to accomplish even the minimal concentration most of us take for granted. Today we see his inattentiveness and restlessness as a symptom of an overactive sensory apparatus, not merely as a behavioral problem loosely labeled as "hyperactivity." We will return to his case below.

Why art therapy?

Contained in this example is not only a picture of a typical moment in the life of an AD/HD patient, but also a clue as to why art therapy is such a fruitful treatment modality. Just as art is often an intensified expression of experience, the experience of the person with AD/HD is generally that there is a lot going on. Art is a good medium for capturing this intense experience. Also to its advantage is that it is (a) an activity that (b) uses what are often stronger visual learning skills to (c) lend structure and (d) give people who tend not to be contemplative a way to express their feelings in therapy. The product of art therapy, the art itself, provides the patient with a visual record of those feelings or ideas that have come up. Since the person with AD/HD often has difficulty using what they learn (because their mind has moved on to many other things), the artwork becomes a way for them to record and re-encounter those feelings or thoughts again and again, thus making learning from them easier.

Art therapy is but one valuable resource for the team working with an AD/HD patient. It provides a visual benchmark of the patient at initial diagnosis, and becomes a way of documenting a patient's progress throughout ongoing treatment, regardless of the modalities employed. It is most useful when combined with psychiatric observation, psychological testing, individual and/or group therapy and educational support – in other words, as part of a multimodal treatment program (Jensen 1999).

Because attention disorders are often associated with other learning and behavioral problems, it is essential to sort out which problems have their basis in AD/HD and which do not. Thinking of AD/HD as a deficit of attention is a misnomer. This is not a disorder of not being able to

attend, but rather an inability to select what is to be attended to (Barkley 1998).

The DSM IV criteria

DSM IV identifies three AD/HD core components – inattentiveness, impulsivity and hyperactivity – and three subtypes of the disorder: predominantly inattentive, predominantly hyperactive and combined type.

Inattention

Inattention or distractibility is common with most of the AD/HD population (Barkley 1998). The ability to focus and maintain concentration, whether on an appropriate stimulus or a task, is considered a basic requirement for academic, behavioral and social success. AD/HD patients are often weak in this area, which may cause inefficiency and underachievement. If the inability to focus attention is severe, it may threaten the child's success at school and social situations altogether. Furthermore, this lack of success may ultimately undermine the child's self-esteem (Fagan 1996).

As the case of Tom given above indicates, for many AD/HD patients, hyperactive sensory perceptions are a source of their inability to focus their attention. AD/HD people experience a bombardment of distractions (Hallowell and Ratey 1994). For example, Tom was unable to focus on any single person, event or activity. He felt tremendously frustrated by his inability to read with comprehension and stay on task in school and had to work so hard to listen, to attend school, study, read and achieve. In therapy, efforts focused on finding ways to reduce the energy required to maintain attention so that it could be applied to listening, learning, and productively using the learned information. In Tom's case, this was learned by:

- becoming educated regarding AD/HD and more clearly understanding his vulnerabilities

- being part of an educational-social skills art therapy adolescent group where he was able to practice socially appropriate skills such as listening, not interrupting and being relevant

- the use of silent cues, in school, home and in group (a tap on his shoulder) to refocus

- medication.

Inattention can take other forms, such as daydreaming. One boy's picture drawn in response to the question "Why is school difficult for you?" depicts his brain flying out the window (Figure 1.1).

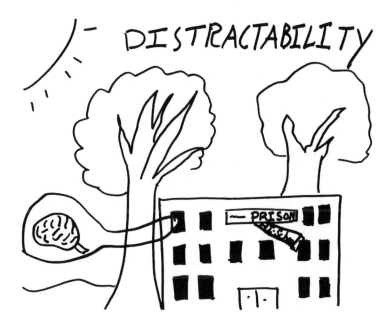

Figure 1.1 Distractibility

This high school student drew himself in his high school classroom while his brain flew out the window, releasing him from his 'prison.'

These children are often quiet, non-disruptive students whose *internal* distraction of a vivid imagination does not allow them to attend fully to their teachers. For example, one student, Sheldon, complained that his classroom seat was near a window. During the entire spring, he had been watching a beaver building a dam across a playing field. In his head, this distraction led him on many adventures, such as thinking about Davy Crockett and his hat. Needless to say, Sheldon missed a great deal of classroom discussion that spring.

Impulsivity

Impulsivity, essentially acting or talking without thinking, is a basic feature of AD/HD. Even adults with the disorder tend to think they can accomplish unrealistic tasks (Barkley 1997).

> Judy, an undergraduate, made a sudden decision to spend the summer taking a statistics course at a large university. She did not think through whether she would be able to handle the intensive workload: a 15-week course, condensed into just seven. In the first week she realized it would be an impossible task, but she postponed talking to her advisor. By the time she met with him, the deadline for withdrawal had passed; so had the deadline for declaring the "pass/fail" option. Even worse, it was too late to get her $3,000 tuition back.

Once the impulse and subsequent thought or action begins, the person has no idea how to stop and is often unaware of the consequences until it is too late. They set their expectations too high, jump right in and are surprised when they are not able to accomplish them. This sets in motion a "failure chain." Rather than learning from this mistake, they repeat it over and over again.

Another example is 13-year-old Mike, who rode a three-wheeler into a ditch. He explained to his therapist that his intention was to jump over the ditch, and was quite surprised to find himself in and not over the ditch. In doing so, he broke his arm in three places, which prevented him from traveling with his hockey team on an international tour.

While Judy's impulsivity is an example of not thinking an idea through, Meg, a middle school student with AD/HD and learning disabilities, often spoke out impulsively, and irrelevantly. One day at her small private school for students with learning disabilities, she and her classmates gathered to hear a guest speaker. When the time came for questions, Meg blurted out, "What's your birthday?" That startled the speaker, interrupted the discussion and made Meg look ridiculous to her peers. Discussing it in therapy later, she became embarrassed when she realized the effect of her impulsivity. Much of her therapy time was spent helping Meg understand how important it is to stop and think before blurting out questions. Cognitive-behavioral therapy tools, such as role

playing, writing her questions down, asking herself if her questions would be relevant to the discussion, counting to ten before she blurted out a question or a response, have helped Meg reduce her impulsivity further. Initially, asking her therapist if the question was relevant was helpful because it allowed her to confirm her own understanding and led to Meg being able successfully to internalize the process through repetition.

Impulsivity can lead to other problems, such as lying, because such behavior is by its nature blind to the idea of actions having consequences. An elementary school girl was so desperate for friends that when a classmate asked her to steal something from a boy, she did – never thinking about the consequences. Youngsters who yearn for friendship are quite susceptible to doing things to please their "friends." Therapy in this case (she was caught) focused on working on both her impulsivity and her vulnerability to others' suggestions.

Hyperactivity

There are many ways to be hyperactive. They may take the form of externally visible symptoms, such as motor activity, restlessness, nail biting, hair twirling, etc. Internal phenomena include sleeplessness, talkativeness, overactive imagination, or generally being constantly bombarded with a flood of ideas with little ability to channel or prioritize them.

> Sarah, a 6-year-old student, could never sit quietly at her desk. She was always dropping things, disturbing her neighbors, and was generally restless. Her therapist and her teacher decided together to give her two desks so that rather than wandering aimlessly around the classroom, she would always have a place to go.

> Bob's desk, both inside and on top was in complete disarray, things spilling over in every direction. He could neither organize his thoughts nor his papers and books. Teaching him to use color-coded organizers and milk crates, plus placing his desk away from neighbors, was a start in helping him.

> Kurt's hyperactivity, in an art therapy social skills group of 5 to 6-year-old boys, took the form of aggressive behavior. In the group, his therapist used a stop sign to alert Kurt about his aggressiveness. At one point, he was able to stop himself from an expected aggressive

move toward another boy, and when asked how he did it, Kurt proudly said, "I guess I learned to stop and think!"

Many hyperactive children report difficulty falling asleep (Ball *et al.* 1997). They say that their minds are too filled with thoughts. Teaching these children how to fall asleep with relaxation techniques like yoga has been helpful. *Sweet Dreams for Little Ones* (Pappas 1982) is a useful book for parents to read to their young children as it teaches them how to relax.

Assessment and diagnosis

In order to make a differential diagnosis, the criteria of *DSM IV* and many other instruments are helpful. In diagnosing children it is important to follow a thorough protocol because AD/HD can look like or be comorbid with many other disorders, such as anxiety, bipolar disorder or depression. What follows is a short list of some of the family history materials and rating scales helpful in making a differential diagnosis. There are many rating scales available today. I have found the following to be the most helpful, probably because I am more familiar with them. Each of these assessment steps and instruments is helpful in undertaking the differential diagnosis, but all are not used in every case.

Family intake

An extensive child and family history including a genogram (McGoldrick and Gerson 1985), medical history form and a parent–child interaction form provide important background information when trying to determine if a child or an adult fits the AD/HD diagnostic criteria. One needs to understand the family and child's history to get background on any genetic predisposition to disorders, as well as current family stressors, such as divorce. The family history is the beginning of understanding if there are any other emotional or adjustment problems as well as medical problems, which may be contributing to these behavioral symptoms.

Behavior rating scales

These can be sent to school and home. The following are among the rating scales often used in diagnosing AD/HD patients:

- Child Behavior Checklist (Achenbach 1991)

- Teacher's Report Form (Achenbach and Edelbrock 1991)

- Child Attention Profile (Barkley 1990)

- School Situations Questionnaire – Revised (Barkley and DuPaul 1990)

- Home Situations Questionnaire – Revised (Barkley and DuPaul 1990)

- Academic Performance Rating Scale (Barkley and DuPaul 1990)

- Conners's Rating Scale for Teachers, 39 (Conners 1997)

- Conners's Parent Rating Scale, 93 (Conners 1997)

- Teacher Information Form for Conners's Rating Scales (Conners 1990)

- ANSER System (Levine 1986)

- Self-Administered Student Profile (Levine 1986)

- Attention Deficit Disorders Evaluation Scale, Home Version (McCarney 1989a)

- Attention Deficit Disorders Evaluation Scale, School Version (McCarney 1989b)

- Yale Children's Inventory (Shaywitz *et al.* 1986)

- ACTERS-ADD-H Comprehensive Teacher's Rating Scale (Ullmann, Sleator and Sprague 1988).

Assessing the school environment

When appropriate, school observations/school team meetings are a helpful part of an assessment and diagnostic protocol. This gives the art therapist the opportunity to observe the child and their school setting and to ascertain what other factors may be contributing to the symptoms (e.g., ineffective teaching, other disruptive children, and over-stimulating and unstructured environment).

Other areas and professionals useful in assessment and diagnosis

1. Child interview (discussed further below).

2. Medical examination. May include referrals to pediatrician, pediatric neurologist, ophthalmologist, allergist, or child psychiatrist. This is to rule out the possibility that the symptoms may be related to medical conditions, such as lead poisoning, head trauma and developmental delays.

3. Psycho-educational evaluation by a psychologist or neuropsychologist when learning disabilities are suspected as well as when there are concerns about thought disorders related to severe psychiatric illness.

4. An audiologist may be consulted to rule out central auditory processing difficulties.

5. A speech and language pathologist may be consulted to evaluate language processing and articulation difficulties.

6. A physical therapist may be consulted for gross motor control problems, and an occupational therapist may be called upon to rule out issues regarding sensory defensiveness and fine motor control problems.

7. An art therapy evaluation may be done which may include a Family Art Therapy Evaluation (Kwiatkowska 1978).

Assessing adults

The protocol used for diagnosing adults is similar to that for children. When an adult is seeking out the diagnosis of AD/HD, an extensive clinical interview – such as Dr Kevin Murphy's "Evaluation Interview for Adult AD/HD" (1992) – is given which may take two or three sessions. Parents and/or spouses should be encouraged to participate both in the interview as well as helping fill out personal history forms. The adult is asked to bring in school records and any testing that may have occurred during their school years. One can also use a self-assessment question-naire, such as that prepared by Hallowell and Ratey (1994) and "The Utah

Rating Instrument" by Wender (1995). The object is to verify that symptoms of motor restlessness, difficulties with attention, distractibility, and impulsiveness are part of the patient's childhood history. It is extremely important to think about differential diagnosis because of the overlap of many serious psychiatric disorders as well as a history of learning disabilities or medical problems such as sleep apnea or substance abuse.

As in the diagnosis of children, the diagnosis of adults may include the input of other professionals in addition to the initial interviews. A psychologist may be consulted for testing or to review records for the existence of a learning disability. An adult psychiatrist may be consulted to clarify the issues of comorbidity such as with anxiety disorders, bipolar disorder, other mood disorders, and the impact on the patient. The psychiatrist is also critical for help in making medication decisions and prescribing medication if it seems necessary (Weiss, Heehtman and Weiss 1999).

Issues in AD/HD assessment

Mental health professionals have written a great deal about the process of assessment of children. For children who are referred because of suspected AD/HD issues, the evaluation is no different in that we are assessing all systems that are involved in a child's life, including family, school, peers, and of course the child him/herself. However, because not all AD/HD patients have overt, highly visible symptoms, an evaluation of a potentially AD/HD child requires a high degree of vigilance and intensity. In addition, there is the possibility, mentioned earlier, that symptoms which look like AD/HD may in fact belong to other syndromes, such as anxiety, depression, family issues, medical problems, or environmental problems. It is incumbent on the evaluator to have a protocol that includes all eventualities and allows for referral to other sources when there are suspicions of other disorders that require collaboration with other disciplines.

The process of assessment and diagnosis begins with an intake interview. In the case of the AD/HD patient, the therapy will start with parents supplying information regarding the child's birth and developmental, medical and academic history. It is also helpful to have parents complete a questionnaire on parent–child interactions.

Taking the family history

The family history section can take into account aunts, uncles, grandparents, siblings and cousins. The evaluator is looking for the reasons why this child may be exhibiting the symptoms that recommended them to an evaluation in the first place. The evaluator will want to take note of relatives who have a history of alcoholism, drug abuse, bipolar disorder or other psychiatric disorders. Family data may suggest the possible contribution of genetic components as causal factors on either side of the family. It is also helpful to try to discover how the family functions as a unit – to determine if it is chaotic, single parent, or one in which a divorce or separation is taking place or has occurred. If possible, direct observation of the family is most helpful.

In addition to parents' possible pathologies, one needs to know if the child suffers from other psychiatric, physical or learning disorders. Any of these may or may not have already been diagnosed. The important thing in intake interviews and early assessment is to be open to whatever may present itself and to avoid reaching conclusions too rapidly and thus possibly missing something that doesn't fit the diagnosis one is leaning toward. It also helps to keep in mind that many AD/HD children suffer from poor self-esteem, have low self-worth and few real friends, making it difficult at times to separate psychological symptoms from psychological effects.

Initial sessions

Though the specific details and sequence of initial sessions will of course vary with the circumstances, the first step is to gain as broad and accurate a view of the child's global functioning, as possible. (For the purpose of this chapter, I will assume that the patient is a child.) One wants to see the child as a whole being as much as possible and his or her environment as completely as possible – in school, at home, with peers or siblings. Towards this end, it is most helpful if one is able to meet with the parents and speak with teachers and administrators at the child's school as well as see the child separately two or three times (for a total of several hours). In addition, one should review the child's test results, report cards with teacher's comments and samples of the child's schoolwork. It may also be

useful to observe young children at their school prior to meeting with them.

Specific assessments using drawing

Since art is to be a part of the therapy, it may also be used as a means of assessment. A "Kinetic Family Drawing" (Burns and Kaufman 1972), a "Draw a Person in the Rain Drawing" (Hammer 1967), a "Free Drawing" (Ulman 1965), "The House–Tree–Person Technique" (Buck 1978), "The Bender-Gestaldt Test" (Bender 1938) and Silver's "Drawing Test of Cognition and Emotion" (Silver 1996) can all give information on a variety of different aspects of the child's learning style, including their organization and use of space and the child's ability to plan and sequence the steps of these tasks.

For the Kinetic Family Drawing (KFD), ask the patient to draw a picture of themselves and everyone in their family doing something. Use 18 x 24 inch white paper and offer a box of 12 colored water markers. There is no time constraint. When the patient has completed the task, ask them to label each family member, title their drawing and put their name and date on the paper.

For the Draw a Person in the Rain (DAPR), offer 8.5 x 11 inch white paper with two number 2 lead pencils; the pencils should have erasers on them. The paper should be handed to the patient vertically. The instructions for this drawing are simply, "Draw a picture of a person in the rain." There is no time constraint.

For the Free Drawing, offer the patient 18 x 24 inch gray paper and a box of 12 cray-pas (oil pastels). Ask the patient to draw whatever comes to mind. There is no time constraint.

The House–Tree–Person (HTP) technique is a series of four to eight drawings. The patient is offered one 8.5 x 11 inch sheet of white paper at a time. For children, begin with one box of eight crayons. Offer the patient the paper horizontally for the first drawing and ask them to draw a picture of a house. Explain to them that they will be doing many drawings and it is not necessary to make them elaborate. The following three drawings are done vertically. Offer the patient the paper one at a time with the following directions: "Draw a picture of a tree." "Draw a picture of a

person." "Draw a person of the opposite sex." Following the recommended query, this exercise is repeated in pencil. There is also no constraint for these drawings.

For Dr Silver's test, offer her booklet and follow the instructions contained within. These drawings are done in pencil.

Doing art in the initial sessions during the assessment process may also create a situation where anxiety issues could be heightened or other factors that may interfere with performance may be on display. Sometimes the way a child handles art materials suggests that an occupational therapy evaluation is needed. For example, they may have a poor pencil grip. The drawings during this assessment phase, like all the products of art therapy, become part of the patient's evaluation documents and can be reviewed by staff as background material for diagnosis (Cane 1951). Sometimes intake and initial assessments suggest there may be other, family-related issues. If that is the case, one may have the entire family come in for a family art therapy evaluation (Kwiatkowska 1978). In this session, each member of the family is asked to draw a series of pictures, which include everyone working together on one drawing (see Chapter 7).

Psychological assessment

If assessment has suggested that other disorders may be present, then other instruments geared toward them are called for. A depression scale such as the Reynolds (1986) Adolescent Depression Scale (RADS) may be useful. The Anxiety Rating Scale (Hamilton 1969) may be used to determine if anxiety is interfering with performance and contributing to inattentive behaviors. Depression may also be revealed in projective drawings, which are part of a psychological evaluation that includes personality testing. These are used when emotional factors in a child's functioning are suspected. A full psycho-educational or neuro-psychological assessment is used to ascertain if learning disabilities or inefficiencies exist.

Medical assessment

If one suspects any type of seizure disorder or other brain anomaly present, an examination by a pediatric neurologist may be needed.

Sometimes following a thorough physical examination, a pediatrician will refer the patient for an AD/HD evaluation. A child psychiatrist may also be useful in determining if any other psychiatric reasons are contributing to the child's problems.

There may be sensory integration problems. An Occupational Therapy Evaluation may be recommended (Ayres 1979). If teachers and parents are reporting an auditory processing problem and it is supported by clinical observation, a speech and language evaluation and sometimes an auditory screening test (such as the SCAN) may be needed. In some cases, children actually need their eyes examined and are found to require glasses. Often the assessment process reveals problems which parents and school personnel may have overlooked. For example, the way children handle materials (e.g., hold them too close to their eyes) may be a sign of vision problems as much as, or even instead of, a processing problem.

Using assessment to uncover hidden factors

As stated earlier, AD/HD demands as complete an assessment as is feasible. While some may feel they can pick an AD/HD child out in a classroom, in truth, the disorder is significantly more complicated than that. It is not just a behavioral problem, but also one that involves minute cognitive variations. A thorough assessment program is the first step in discovering problems so they can be treated most effectively.

An experienced clinician, observing the symptoms of AD/HD in a child, may believe that a diagnosis is likely, but there is a good deal more to it than that. The reason a child in question is so oppositional, for example, may be because he is sitting in a noisy room with very bright lights, which make him irritable. This is something that may not be discovered in the first stages of assessment, but it reflects the spirit of being open to a variety of explanations that should guide this process. Is the child irritable because the environment is not comfortable for him, or because he has problems with self-control? The mental health professional needs to discover the answer to that question.

One may sit in on school meetings and hear teachers say, "This child is stubborn," or parents complaining, "This child is lazy." It is probably more realistic to take the view during assessment and beyond that children are

not innately stubborn or lazy and in fact want to please adults and be successful for themselves and their relations with peers. They may be out of the loop, which is a defining feature of AD/HD (Barkley 1997), and thus on their way to becoming oppositional or conduct disordered (Train 1996). Rather than pathologizing, it is more useful to try to determine the reasons for symptoms. For example, does the child who misperceives information do so because of inattention or because of an auditory processing problem or both? It is important to know the answer in order to help that child. The adult who is hypersensitive and not doing well in her job may be having problems because a terrible environment negatively affects her. She can never work in a white room with fluorescent lights, but performs superbly in a quiet, dimly lit space.

In this vein, assessing the AD/HD patient should take into account what is known about the more specific manifestations of the disorder. Some AD/HD children are very tactile sensitive. Others are described as sensory defensive. Their behavior is inconsistent. They are extremely reactive to their environment, often irritable, impulsive and aggressive. They can become easily overstimulated. If such patients are assessed accurately and the aversive environmental stimuli removed, then a great deal of "treatment" may occur automatically, almost magically. Early intervention alerts teachers and parents to techniques which help diminish overstimulation and enhance consistency in the child's responses to his/her environment.

Summary

The understanding and acceptance of AD/HD as a syndrome to be treated has come a long way; so too have various techniques of assessing and planning treatment for this disorder become much more effective and reliable. Art therapy has been seen as an extremely effective tool in early assessment as well as treatment. This book will describe in detail how and why one may use art therapy as an effective treatment for AD/HD individuals.

This work has been very exciting. As more is understood about this disorder and as the population of AD/HD patients continues to grow, it has become apparent that a multidisciplinary team is crucial to under-

standing and working with the myriad of problems experienced by AD/HD patients (NIMH 1994; Pelham 1999). What is most exciting to me is how effective and important art therapy is as part of a multidisciplinary team approach to treating AD/HD.

This book will describe in great detail exactly how art therapy has been used with AD/HD patients who are children, adolescents, adults, couples and families. Art therapy groups for children, adolescents and adults with AD/HD are discussed in detail, to allow the reader the opportunity to understand how and why a therapist employs these techniques. This discussion begins with education about this disorder and social skills training, one of the most common problems of AD/HD individuals.

2

Setting Up Children/Adolescent Educational Social Skills Art Therapy Groups and Parent Educational Groups

Introduction

Art therapy groups are an effective method for the treatment of AD/HD for the therapist, the AD/HD patients themselves and their family members. Art therapy groups offer the mental health professional a further means to continue the assessment process. In particular, educational social skills art therapy groups for children allow the therapist a more complete picture of the needs and services that are best for each individual (Safran 1989, 1991–1994, 1995, 1996, 1997a, 1997b, 1998, 1999, 2000). Educational social skills art therapy group also offers the patient a new understanding of his or her real-life strengths and weaknesses by providing an arena in which those strengths and weaknesses can be played out (Mills 1992). For children especially, group work offers a chance to be exposed to strategies to help them become better students and friends as they learn how to plan, organize and share ideas, feelings, space and materials, all of which enable them to feel more comfortable in school and on the playground (Henley 1998; Mooney 2000; Olive 1991; Pfeiffer 1994). Finally, a parallel educational group for parents enhances their ability to parent, as well as understand the impact of AD/HD on

their child, their family and themselves (Burte and Burte 1994; Corkum, Rimer and Schachar 1999).

Overall, art therapy group provides the therapist with a comfortable environment in which to teach and offers the patient a safe environment in which to learn the social skills needed to effectively participate in the surrounding world. However, if a therapist's practice is not as focused on AD/HD patients as to make group therapy possible, the techniques of this chapter can still be applied to varying degrees in one-on-one therapy.

There are a lot of "different flavors" to AD/HD (Safran and Safran 1995). As discussed in the previous chapter, the more precise a therapist is in pinpointing the specific processing problems associated with a particular patient, the better the chance of developing strategies to help the patient overcome their specific cognitive deficits (Waschbusch, Kipp and Pelham 1998). Participation in a group allows the therapist the opportunity to assess the unique differences of each individual patient as their "flavor" stands out within the group sessions. Group work is particularly useful with children and much of this chapter will focus on children's groups. However, many of these techniques can also be applied to adolescent and adult groups.

Group art therapy is also a way of observing and assessing children on medication for AD/HD, which enables the medical professionals to fine-tune medication. If children are on medication during group time, the therapist will have an opportunity to see the threshold and possible rebound of the medication, as well as its efficacy. Art therapy enhances this observation because it is an activity encouraging spontaneous behavior, thus testing the effects of the medication. Many physicians count on the observations of parents, teachers and psychotherapists – and even their patients – to aid in managing medication dosages, as the medicating physician does not often see children more than once or twice a year. Anton Miller found that it is rare to find physician practice in accordance with expert recommendations (Miller 1999).

What are the goals of group therapy?

The major goals of both children's groups and parent groups discussed below are educational. Children, adolescents and their parents should

come away from the group experience with a clearer understanding of how the diagnosis of AD/HD is made, the impact on them and their families, and strategies helpful to relieve AD/HD symptoms. Additionally, group therapy is important in alleviating feelings of isolation and establishing better communication between family members. These groups offer the child the opportunity to practice new strategies to become more socially successful as well as enhancing their self-esteem. Finally, group therapy teaches the child self-advocacy, as well as teaching the parents to advocate on their child's behalf.

Many children (and parents) come to the group in denial of the impact of AD/HD on their lives. However, participating in a group with other people who share the same kinds of problems helps make them more willing to accept their AD/HD or that of their children, and this acceptance means a great deal. Children are more willing to use medication because they learn why they need it and how it works. They take responsibility for their disorder and for their performance at home, in school, with parents and with their peers. At the same time, parents can begin to understand the chronic nature of the disorder and what medication can and cannot do through the adult sessions.

From the first day in group therapy, it is helpful if the therapist makes the point that having AD/HD is not an excuse for poor or unacceptable behavior. It is also helpful for the therapist to keep in mind that AD/HD patients are consistently inconsistent. The therapist should lay the groundwork for understanding that the issues with which AD/HD presents a person will not magically disappear. They are there to be worked with as an ongoing part of life. Conveying that AD/HD is a chronic condition and recovery is an ongoing process not only gives children a realistic set of expectations, but can also make the diagnosis seem far less threatening. Treatment becomes learning a life strategy instead of training for a test that one can (again) fail.

In addition to laying out what parents and children can expect from group work, it is also helpful to schedule an evaluation halfway through the educational social skills art therapy group to review a child's progress with parents and to determine if the child has been able to put any of the experiences he or she has been having in group to use at home or at school.

A successful outcome of group therapy is that the AD/HD child recognizes the need for help and becomes open to solutions. However, it is unrealistic to believe that all of this can be accomplished within eight weeks. Consequently, most children with AD/HD are well served by participating in an ongoing group where they can practice the strategies they have learned. Ongoing group work is discussed in later chapters.

Setting up a group for children

The idea behind art therapy groups is to provide an opportunity for children to meet their peers in a safe, controlled environment where they can achieve a successful social and educational experience. It is useful to mirror school experience and place boys and girls into groups of children who are compatible in terms of age and gender, giving them a place where they can observe their peers and where the therapist can observe them with their peers. The optimal size for children's groups is six to eight patients with one therapist, but this can increase to ten if there are two therapists. Limiting group size in this manner is necessary because AD/HD patients perform better in smaller, less distractible and more predictable environments.

The social skills training is a behavioral approach designed to help children learn more acceptable ways of interacting with their peers, teachers and family. Behavioral changes do not always follow cognitive skills (Braswell and Bloomquist 1991). Practice and repetition of newly learned skills over a long time are necessary. It helps to involve family members, school personnel, coaches, religious teachers, therapists and anyone else connected with a particular child to reinforce and enhance the child's learning.

The child entering the group should be aware of his or her AD/HD diagnosis. Hopefully, this has occurred following diagnosis or during the assessment for group participation. Many children come to group reluctantly because new situations are often difficult for these patients. This reluctance is not surprising since most AD/HD children arrive having had a great deal of difficulty and lack of success socially and will look upon group sessions as another place to fail. Many are highly defensive, very energetic, stubborn and creative children.

Be selective to be successful

If one has a practice that is sufficiently focused on AD/HD to make a group feasible, the next issue becomes one of selecting children so as to put together a group that can work to all the children's advantage. Establishing the parameters of the group involves several important early decisions about whom to accept, and how many children to take in any one group. If at all possible it is advantageous to have two therapists in the group at all times. Managing six boys or girls who are devoid of social skills would be an overwhelming responsibility for a single therapist.

To make the group a very successful experience for these young children, it is important to establish clear criteria for inclusion. It helps to get to know the family and child first and, as mentioned above, parents of children invited to participate should be required to make an initial commitment for a minimum of eight weeks. Most children who join these age-related young children's groups find them highly effective and continue in the group for at least the rest of the school year, if not longer. Once a group has started, it is best not to let new children join until the first eight weeks are over so the group is not disrupted.

Screen out extremely hyperactive, very aggressive and oppositional children. The children are screened to be compatible, to have similar social and educational needs. One can visit young prospective group members in their academic environments to observe them participating in their usual classroom "group." Other concerns about a child's participation in an educational social skills art therapy group revolves around including children with extreme speech developmental delays, children with a wide variety of learning disabilities, or children with significant physical disabilities.

Children in the group should have at least an average IQ. This is important because this is an educational experience, so they need the capacity to learn the concepts introduced each session. Group therapy should offer the patients an opportunity to learn the skills they lack and to feel successful from the start with their progress in the group.

Good candidates for children's groups are academic under-achievers, children who are unable to manage themselves on sports teams or other extracurricular activities, socially isolated children and children who are unable to use unstructured time effectively. Many of these children also

have sleep-related problems. Children who are impulsive and distractible are typical candidates. Chances are that these children know that their parents and teachers are frustrated with them and do not know what to do since nothing seems to work. Once it is established within the group that each of the members shares similar problems, the group members will be more open to learning.

It is very helpful to convey a sense that the group work offers a place where children can have a fresh start and a new opportunity for social success with peers. This may help dispel some of the defensiveness, anger and frustration AD/HD children generally carry around with them. Also, it may be helpful for some to see group as a place where they can try out new behaviors for school and with friends, a place to practice newly gained skills.

Experience suggests that it is not necessary to tightly restrict the ages in the initial group. For example, mixing children between the ages of 7 to 11 tends to work as well or better than a group of only 7 to 9-year-olds. Having older children present frequently settles down the younger members, who are intent on impressing their older peers. Additionally, older members enjoy the opportunity to mentor younger ones, while building their own self-esteem. However, middle school and high school adolescents need to be in a separate group as they have different psychosocial needs and are more sophisticated intellectually. Not only would being placed in a group with younger children be embarrassing to them, but also high school students are sufficiently developed that they are able to offer insight and feedback in ways that younger children simply cannot. Also, the use of art therapy offers these adolescents the opportunity not only for a cognitive experience, but also a "transpersonal one with the other therapeutic means of reconciling emotional conflicts, while fostering self-awareness, developing social skills, managing behavior, solving problems, reducing anxiety and ... increasing self-esteem" (American Art Therapy Association 1996, fact sheet). If a therapist is working solely with AD/HD children and has many group candidates, they can break down groups by smaller age ranges such as 4 to 6 or 7, 7 to 10, 11 to 13 and high school (14 to 18).

Wherever possible, it is helpful to have young children's groups meet shortly after school so the therapist can meet with the children before they

have had a chance to get too comfortable at home. A second reason why this is recommended is because it is early enough in the day to give the child medication without interfering with their sleep. Third, children are used to after-school activities and will, hopefully, be less resistant to attending group sessions.

The adolescent AD/HD population

Defensive and at risk

For adolescents, being finally diagnosed as AD/HD can be a huge relief. Many patients are not diagnosed until they reach high school. Unfortunately, by this time they are totally turned off to school and view teachers as their enemies, have lost faith in their parents and tutors and their self-esteem as learners is nonexistent. They are tired of hearing how bright they are and no longer want to believe it. Many have had several automobile accidents – the results of abusing alcohol or drugs, driving too fast, taking risks, and/or not paying attention. These teenagers struggle much more with their parents and other adults than most adolescents.

One student described herself as "dumb and stupid." The classes she took and the grades she received embarrassed her. Finally she was diagnosed, put on the right medication and received counseling. Her parents became informed about AD/HD and she received SAT tutoring and raised her score dramatically. Suddenly she was beaming. After 17 years, a huge weight had been lifted off her shoulders. She applied to and was accepted by several good colleges.

However, when adolescents first begin therapy, they are likely to be angry and discouraged. They will have been angry with their parents because they have been told they are lazy, because their parents have not stood up to teachers for them, or because their parents have bribed them to get good grades. Chances are no one has ever taught these adolescents the skills and strategies they need to handle their attention problems. An appropriate analogy is to compare asking an AD/HD teenager to handle the demands of high school academics without help to handing a child the keys to a car, without teaching him how to drive. When the car gets stuck in the mud, such a teenager says, "I know how to get out" and revs the engine. So he gets stuck even more.

As a result, adolescent groups are more sophisticated than those for younger children. They take into account the high school student's heightened ability to grasp concepts quickly and approach problems with a certain degree of humor. The directions for the drawings are similar to those used with other groups, though a little more didactic. In addition, more time is spent processing the intrapsychic dimension of their drawing. For example, they often become intrigued with the concept that their drawings provide a springboard from their unconscious self.

The parent educational group

Setting up the group for children or adolescents is only half of the plan. Parents (and siblings too) need to receive the same education that the AD/HD child is learning. Parent educational groups in which the parents of the children in the art therapy group meet once a week, usually a day prior to the children's group meeting, provide the therapist with a chance to discover what has been happening with the child during the week and to keep abreast of his or her home life. They also help parents understand their AD/HD child more clearly (Barkley 1998). Since the parent/sibling groups meet in concert with the AD/HD patient group, this allows for discussion between family members on the lessons taught within their respective groups. (See Table 2.1 for a sample parent educational group outline.) This shared experience enhances not only the lessons, but also communication and respect for the impact that AD/HD has on all members of the family.

Learning through the therapist's observations, parents come to understand their child's learning style, social skills (or lack thereof) and individual coaching needs better (Ratey 1994). This makes it easier for parents to help their child achieve and participate more fully in school, outside activities, at home and with their peers. Since parents are also responsible for managing the medication process, parent groups give them a chance to discuss and learn more about what medication can and cannot do for their children.

The educational aspect offered to both children and parents in groups are highly successful, as they are not only learning from the professional therapist but from each other. Finally, groups are effective in that they further the skills and techniques learned in individual sessions as the

patients – as well as their families – understand that they are not alone, which makes them more receptive and enhances their sense of community. Research has found that the combination of social skill training and parent education with proper medication management over a long period of time enhanced the patient/family ability to manage AD/HD with success (Jensen *et al.* 2001).

The therapist should schedule the parent group for 90 minutes one night per week with the children's group the following day for one hour. (Some sessions may be 90 minutes to two hours long, depending on the age of the members, size of the group and content of a particular session.) One therapist is sufficient for the parents' group. However, outside specialists should be invited to participate in these meetings based on subject matter, which is why the parent group sessions are longer (e.g., when reviewing medication, it may be helpful to have a psychiatrist or psychopharmacologist present to discuss pharmacological, dosage and monitoring information). Also, when discussing the impact of AD/HD on a non-AD/HD sibling and entire family, it can be useful to arrange for parents and siblings of previous patients to attend the session, present their experiences and discuss the impact of the disorder on their lives.

Ground rules for parents

It is important to establish some ground rules for parents in order for group therapy to be successful for their AD/HD child. First, because it is disruptive to both the individual and group learning, parents must commit to bringing their children to group every session. The therapist should emphasize that group therapy is not something just to try. Attendance at every session is important as it (a) allows them to have the full experience; (b) teaches them about living up to a commitment; (c) addresses a typical concern that parents voice about their AD/HD children, namely that they start but do not finish tasks or endeavors. Since it is highly likely that the children will complain or become disinterested after a couple of sessions, as AD/HD kids often do, it is important to require that parents commit to bringing their child to every session. Payment in advance, or at least a deposit, can help ensure that parents will honor this commitment.

Working with parents' expectations

Parents often seek therapy for their child because they are confused about what is and is not acceptable behavior. Some parents may not be bothered by certain behavioral traits, such as restlessness, because they may be acceptable in their family experience. In these cases, parents may express irritation or confusion regarding behaviors which their child's school rejects. The therapist may need to help them understand that what may be appropriate at home is not appropriate at school, where there are often 25 children and a single teacher. It may also turn out that parents do not see the same problems that the mental health professionals treating their child see. However, if a therapist believes that a behavior is likely to be unacceptable to a teacher, then the parents need to be made aware of the problem and its significance in terms of long-term functioning and social adjustment.

> For example, Marvin's parents describe him as "a bundle of energy, always on the go." Even as an infant, he required little sleep. They loved his creativity and encouraged his inquisitive mind. Marvin was always questioning everything. However, his restlessness and constant interrupting concerned his kindergarten teacher; she saw Marvin as distracting and intrusive. She expressed these concerns to his parents and recommended that he be evaluated for AD/HD, which totally surprised his parents.

Often parents seek group therapy because they are desperate to help their child and see the sessions as an opportunity for their child to have at least one positive social experience during the week. On the surface, this would appear to be a tremendously useful parental position, but it actually often contains some hidden costs. One of the biggest problems in working with the AD/HD population is that parents frequently want and expect therapy to provide an immediate, permanent cure. As a society, we have been conditioned to expect fast cures for medical problems and other disorders. What these parents are likely to be seeking is a cure for their own discomfort. They want their child to be "fixed" so they do not have to feel sad or defensive about their child anymore. Their discomfort may mean they are unwilling to go through a parent educational group, or join only reluctantly. Very often one parent may come willingly, dragging in

his or her spouse. In these cases, it may be a mistake for the therapist to assume that the active parent is more comfortable with the diagnosis and treatment plan than the other. Instead, the therapist may be witnessing the discomfort directed at the reluctant spouse (i.e., the active parent may believe if he or she can gain the other spouse's involvement, the problem of AD/HD will disappear).

In some cases, the reluctant parent may not believe in either the diagnosis or in medication; instead, they may feel the child just needs to "shape up." It is useful to try to uncover the hidden agenda that each parent brings to the treatment process. One parent might think the group can help both of them learn to cooperate in the co-parenting process. Another may be hoping that therapy will be helpful for the entire family. Often, after learning more about AD/HD, a parent may come to identify with the child – it is sometimes the case that parents are diagnosed as also having AD/HD. It is often useful to invite grandparents and childcare givers to attend group sessions as this helps demystify the disorder and provides a chance to teach them all the same strategies.

Though each therapist will develop their own approach, the parent group tends to be a place where more information is better. Books on parenting and AD/HD, selected videos, visiting experts, handouts and information on family management with AD/HD can all help parents understand AD/HD better. See the reference material in Appendix 1 for a sample list of recommended materials.

A typical eight-week parent educational group

Table 2.1 contains a sample eight-week parent educational group outline.

Table 2.1 Parent Educational Group Outline
Eight consecutive weeks – 90-minute sessions
Session 1: The nature of AD/HD, Part 1 *Session leader:* Clinical director *Topics:* Introduction of group members and handouts *Diagnosis:* What AD/HD is and what it is not; "flavors" of AD/HD *Video:* It's Just Attention Deficit Disorder *Handouts:* "Diagnostic Criteria for AD/HD", "Some Difficulties Children With AD/HD Face", "Outline of Procedures for Diagnosis of AD/HD"
Session 2: The nature of AD/HD, Part 2 *Session leader:* Clinical director *Topics:* Discuss family history, comorbidity and differential diagnosis *Questions*
Session 3: Educational issues for AD/HD students *Session leader:* Educational specialist/educational director *Topics:* Organizational skills problems; AD/HD and co-existing learning disabilities; Discussion of OHI, IDEA and 504; advocating for child in school, community and family; public v private schools; college problems; transition from school to job *Handouts:* Educational handouts adapted for this population regarding the laws, accommodations for AD/HD students, classroom strategies and parent strategies to manage homework
Session 4: Behavior management, Part 1 *Session leader:* Family art therapist *Note:* Children's drawings are used during the next two sessions *Video:* 1-2-3: Magic! *Family meetings* *Handouts:* Book by Thomas Phelan, Ph.D (1990) *1-2-3: Magic!* Glen Ellyn, IL: Child Management Press

Session 5: Behavior management, Part 2

Session leader: Family art therapist

Topics: 1-2-3: Magic!; behavior modification, communication tools; charting; parent burnout; coaching

Questions

Session 6: Siblings/impact of AD/HD on the family

Session leader: Family art therapist

Note: Siblings (over 7 years old) of AD/HD child are invited to attend this meeting

Topics: What it is like being the sibling of an AD/HD child; parents' own childhood experiences

Children have an opportunity to process in a small group with other sibs using art

Parents meet to review *1-2-3: Magic!* and family meeting concerns

Session 7: Medication update

Session leader: Child psychiatrist

Topics: A psychiatrist will discuss myths and realities about medications for AD/HD; parent, child, relatives, school attitudes about medication; medication management; brief outline of how medications work and discussion of recent research

Handouts: Material on medications prepared by pharmaceutical companies, plus handouts prepared by ADDI explaining all the different medications available, dosages, side effects, information re why the choice of one over another

Questions

Session 8: Final session

Session leaders: Staff

Notes: A successful AD/HD college student is invited to this session to help parents realize that their child(ren) can be successful

Topics: Review of behavior modification and charts (are parents in charge yet?); vacation opportunities/summer camps; parent advocacy

Questions, questions, questions

Note: Artwork created by children and adolescents during their educational group may be used at each session to demonstrate the points being made

As can be seen in Table 2.1, the eight weeks cover a variety of topics, including the nature of AD/HD and medication. As mentioned above, the therapist should not hesitate to bring in outside references and professionals to reinforce the group teachings.

The therapist should use the children's artwork from the preceding week to help the parents better understand their child, as the artwork presents a crucial piece of information supplementing that which the parents hear through verbal communication. For example, when one girl was asked to draw how she felt about having AD/HD, her drawing stated, "I wish it [AD/HD] would go away!" This proved to be important information for her parents. Although every other parent in the group could relate to this sentiment, her parents were totally surprised by the fact that their child, who had never expressed this verbally, had thoughts and feelings of which they were not aware.

In the parent group we introduce some very specific tools, such as *1-2-3: Magic!* (Phelan 1990), "Family Meetings" and "Family Charts". The details of these techniques are included in Appendix 2 at the end of this book. When parents use these tools, their child may become less defensive, more responsible and more cooperative.

The importance of parental involvement

There is a very different prognosis for the AD/HD child of parents who do not participate in the parent educational group – typically, there is less success when the parents are not part of the solution. In *Beyond Ritalin*, Anmarie Widener (1998) emphasizes the importance of the parents' role in the therapeutic process. She believes that working with parents is essential if change is to occur. Like children, all too many parents of AD/HD kids want immediate fixes, and they will try something for a day or two. When they do not see a total cure within 48 hours, they will give up and announce, "It doesn't work." Some parents will give this or that idea a try only to move on to another provider or some other promising cure, as long as it promises to be quick and easy. For parents who themselves have AD/HD, it is the nature of the disorder to be impatient and have unrealistic expectations (Weiss *et al.* 2000).

However, parents who are eagerly involved, ask good questions and use the management systems taught in group to become better advocates for their AD/HD child, whether in school, sports or any other activity. Finally, as the parents become more educated and involved, family life frequently becomes more satisfying.

Ongoing work with parents

It is a good idea to do extensive parental interviewing to get to know both parents well. You will want to see how parents relate to their children and listen to their child's concerns. Parents of these children all offer similar complaints about management issues and their son or daughter's behavioral problems at home. Some are relatively unconcerned with their child's lack of close friendships with other children of the same age, believing that their child will catch up developmentally. The parents have to be educated as to the social skills deficits that are part of AD/HD. It's a good idea to offer a parents' group in which one can cover these issues as well as teach parents how to manage their child. This parent educational group will give the therapist a better understanding of the parents and the way they interact with the child. A strong relationship with parents is also important in facilitating any behavior modification strategies a therapist may want to introduce in the home or school setting.

Many of the children are on medication. Therefore, it is essential to have a child psychiatrist involved in the program from the beginning. He can observe the children in his office as well as in the group environment. The art therapists can then work with the child psychiatrist – to discuss changes in behavior and attitude in group, to offer feedback regarding the efficacy of medication and dosage as the children interact in a stimulating group environment and, ultimately, to relate to parents regarding their child's performance within their group.

It is important that parents understand what are appropriate goals. Some parents hope their child will enter group and miraculously, in eight weeks, learn – and practice – appropriate social skills, become very well liked, and no longer be hyperactive, impulsive or aggressive. Those are not appropriate goals. The educational social skills art therapy group's objective is to take tiny, beginning steps toward reaching the child's

long-term goal of becoming a strong self-advocate and actualizing their potential.

In the initial educational social skills art therapy group work, the therapist commits to meet with the parents individually at the midpoint of that period, after four weeks, to review their child's progress, to hear what came home from the group and to learn if the child can generalize any of the strategies taught in the group. In the meantime, parents are asked to observe what their child is like coming to group and leaving it. (One of the reasons we demand an eight-week commitment from parents and children is to prevent parents from giving in to their child's request to be allowed to skip "that dumb group.") That is important information, easily obtainable in the eight-week parent educational group. The purposes of communication are to assess their child's progress, to discuss appropriate goals for each individual child and to enhance the overall group experience for their child.

3
The First Session

Introduction

The earlier chapters detailed the reasons why group therapy is valuable for both the patient, the parents and therapist. Group therapy provides the children and parents with the opportunity and safe place to learn and practice group skills and manage their AD/HD. It also provides the therapist with another avenue to observe and treat the patient. This chapter will outline the first group session, discussing what a therapist may expect from the children and the types of activities that have proven successful in promoting a positive group experience. It is important to keep in mind that the first session is critical in establishing the trust of each of the individual children so that they commit to the group process and allow the therapist to help them.

Preparing for the first session

The therapist should organize the room for the group session in the following manner. Each group member should be seated in chairs with arms as this helps provide structure and boundaries for the AD/HD child. The children should be seated in a semicircle facing the therapist (or therapists). Any room consistently used for art therapy should have a couple of walls covered with white homosote, or a similar substance. The pressboard makes it easy for children to tack up their drawings with pushpins, turns walls into art galleries and also acts as soundproofing, which helps when groups get noisy. Further, having the children work on

walls allows for movement within a defined space (their paper). Scented markers are recommended because the smells intrigue the children and the manner in which they react to the markers adds another element that can be helpful in assessing their distractibility and the time required to refocus them. Markers also provide structure because they are easy to control. Finally, any other distractions should be removed from the room.

Introducing the group

The therapist should begin the first group session by making sure everyone is introduced. The therapist will know the children, but most likely, none of the children know each other. After brief introductions, the therapist should refer to the duration of the session and explain the concept of group therapy and what it offers. Also, it is important that the therapist let the children/adolescents know that everyone in the group has AD/HD. The therapist will ask group members, "Do you know what AD/HD is?" A mini-lecture on this topic will ensue with a discussion following that includes group members. It is essential that these group members have a clear understanding of what AD/HD is and what it is not.

After this, the therapist should begin a discussion on group ground rules. Invite the children to suggest some. Among the rules that may be mentioned are: no hitting, kicking, punching, biting, screaming, slamming doors, silliness (or "being hyper"), jumping on furniture, saying mean things, name calling or drawing on someone else's picture. Also, children should take turns talking, tell the truth, be a good listener and go to the bathroom before group starts. The therapist should also ensure that each of the children understand that what is said and done during group sessions is confidential. You may need to explain the word "confidential" to both the child and their parents. Finally, the therapist should write these rules down as they emerge from the group and place them in a highly visible space (and review weekly with small children).

First drawing: Introduce yourself

After these ground rules have been established, the therapist should ask the children to make a drawing introducing themselves, specifying that they draw their name and illustrate it with the things or activities they find

interesting and important (18 x 24 inch white sulfite 80# paper is good for this). The therapist should explain that, although each has already introduced themselves by name, a more meaningful way of getting to know someone new is to learn something that he or she thinks is an important identifier that makes them special. This exercise allows the children a chance to learn more about each other in a quick, colorful and visual way.

The therapist should ask the children to place their name, the date, the title and number of session on every drawing. Give them approximately 15 to 20 minutes to do this drawing, explaining that this (and all the artwork they will be producing in group) is meant to be a fairly quick project so that there is adequate time to discuss their work, which is an important part of the exercise. When they are finished, each child can sit down leaving their artwork on the wall where it can be easily viewed.

The therapist should observe not only what they draw, but also how they have used space and materials, as well as where they hang their paper. Minor details such as who stands next to whom as they draw, who leads the hanging activity and who is following, who isolates his drawing from the others and who has trouble planning where to place hers all provide information for ongoing diagnostic efforts. This is another example of how the process of the art is as important as the product. While the picture itself will be the means of encouraging each child to describe their own interests (and for other children to ask questions or make comments about the drawings), it also offers the therapist an opportunity to note any seemingly visual or auditory processing problems. The therapist will also be able to observe difficulties the child may have managing time or planning and organizing themselves for the task at hand, as well as examples of impulsive or intrusive behavior. Some children may show evidence of anxiety or perfectionism. Some drawings may be incomplete, while the use of space is poorly planned in others. Some drawings may have cross-outs or the child may have turned the paper over to begin again.

All those key components – impulsivity, poor planning, disorganization and even remembering what it is they are supposed to do – are observed. Many children do not ask questions. Some children do not know that they do not understand the directions; therefore, they do not

realize they need to ask questions. Others are afraid to admit they do not know what is being asked of them. To those who appear to be heading off in a direction different from the drawing assignment they've been given, the therapist may say privately something like, "Tell me what you think it is I asked you to do." Do this quietly, so the child does not feel singled out or criticized and make note of the fact that the child needs to learn either the strategy of asking for clarification or simply understanding that they may not understand or hear all of the directions because of their distractibility.

Typically, one will see that the drawings are filled with many activities, with boys almost always involving sports. Many AD/HD children are actually quite cautious, however, and it is good to keep an eye out for those who have had such poor social experiences that they find it difficult to put themselves forward. The drawings serve as a vehicle for self-expression where verbal communication is not always possible. For example, a child who cannot talk about his favorite activity may find it far easier to first draw a picture of a football. Then, with the drawing in front of him, it becomes easier for that child to talk about himself and his interest in football.

Some children may be too forward. They have no inhibitors and know no middle ground. They spew too much information about themselves in both their drawings and their discussions during the very first meeting. They need to learn that no one needs to know so much about them at the first meeting. Other children will simply copy from one another. One girl once wrote "The Gap." All of a sudden every girl in her group did the same. At this point, it is important for the therapist to observe and record these behaviors so that they can be addressed in later sessions.

After all the pictures are completed, the therapist should have the group sit in a semicircle facing the drawings. Each child should be asked to introduce themselves and their drawing. Allow the children to embellish upon things they did not include and answer questions other children may have about their picture. The exercise of *learning to look and listen*, as well as asking appropriate questions is an important part of the group experience. Additionally, the presentations are important because many of the children are not able to present information in a clear manner. This helps them do so, while also helping the other children listen. During

this exercise, it is the therapist's role to model an appropriate way of asking questions.

After each of the children has presented, the group can then turn around and face the semicircle away from the picture wall. Focusing more on the group now and less on the art, though anyone can turn and refer to a picture if they need to, each member of the group is asked to introduce the other members, using their name and mentioning one thing they learned about the person. The exercise is important because this population often has trouble with their memory and distractibility and this "game" forces them to focus on the activity, as well as ensure that they learn something about each member of the group.

This exercise should provoke many questions from the children. For instance, depending upon the ages of the children involved, medication may come up and they may ask each other what sorts of medication they are on. They may also share other concerns about their diagnosis with peers who have similar experiences. This exchange of information is important for the children as it reinforces that they are not alone and the group concept begins to appeal to them. They do not feel they are "different." They are in a situation where everybody finally has something in common with them and they are normal. In this context, their AD/HD becomes the unique quality that gains them membership in this special group.

The "I CAN" exercise

The special qualities of AD/HD that come up can be used to lead into the "I CAN" exercise. Many of these children have suffered severe damage to their self-esteem in school, on the playground or in other social situations. Most come into the group therapy very cautiously, anticipating a repeat of past experiences. They expect to be identified as a loser kid with no talents – dumb, stupid and incompetent. It is the therapist's task to set things up so that they quickly see the worth of this group, are eager to participate and want to be part of it as a learning experience. That is the purpose of the "I CAN" exercise.

The therapist should write the words "I CAN" vertically on a large sheet of paper mounted on the wall. The therapist then asks the group to

use each letter to generate different words that describe children with AD/HD. When faced with the letter I, some children will volunteer a word like "incompetent" because they are used to other people calling them that. If they do, rather than simply discount the idea, the therapist can talk about the ways of thinking about one's self and what goes into those feelings.

It may be helpful to use the image of a ledger system in which credits and debits are tracked. Many children have a fairly good or at least balanced "ledger" when it comes to them. AD/HD kids often have a ledger loaded with negative input. Mention that one of the goals of the group is to begin to change that by helping group members earn more positive feedback as they act more appropriately. It is also helpful to teach the children to learn to give themselves credit when credit is due. For some children, it is a struggle just to imagine positive things about themselves. The therapist should encourage them to list more positive qualities such as "intelligent," "inquisitive" or "imaginative."

Sometimes the "I CAN" exercise becomes very competitive – who can think of the most words? Sometimes impulsivity and competitiveness generate lists upon lists of words. At other times, silliness and the need to be a class clown get in the way of performance. Since this is everyone's first introduction to one another in a group setting, one can use the chaos that may ensue to gain a quick understanding of how to plan for the rest of the group sessions, whether additional rules need to be established and how to reinforce them. (See Appendix 2 for sample group rules.) The key point is to start the group with a very positive experience, right from the beginning.

Certain words – "imaginative," "creative," "active" – will come up often. Even the youngest children will mention them. But for many children, the struggle is not identifying positive words, but feeling positive about themselves and understanding that they are meeting in a safe place. That is much more difficult. Most AD/HD children have not had enough positive experiences to enable them to trust positive and safe feelings. Therefore, they may be reluctant to accept and trust these positive feelings in their first group meeting. They are waiting for the other shoe to drop. It can be helpful to bring these feelings out, even if just in passing. Recognizing that they may be thinking "This is too good to be

true" is itself a valuable acknowledgment of the effect of so many past experiences and can also bind the group together. The group's "I CAN" list should be hung in the room as a positive reference for every subsequent group meeting as it is connected both to where they have been and where they are going. It may be the first time in a long time they have allowed themselves to think that maybe they can.

At the end of each session it is important to review what took place during the session. The therapist will also encourage the child to share with their parent(s) the events of the session. This will reinforce learning. The therapist will remind the group members to leave appropriately, discouraging predictable inappropriate behavior before it takes place. It is also important and respectful to ask the group members' permission to share their drawings with their parents at the following parent meeting. In this way communication and sharing between the child and their parent(s) is encouraged.

4
Group Therapy for Children
Weeks Two through Eight

Introduction

The previous chapter discussed the first session, which is important in setting the tone and establishing an environment of trust. This chapter covers the remaining sessions of an educational social skills art therapy group for children. During each session, the therapist should discuss the diagnosis of AD/HD (repetition is necessary with this population) and the impact on each group member, emphasizing their differences. The format of each session should be consistent: a review of the last session; a mini-lecture on the current topic; a drawing exercise and group discussion.

Each of the following sessions has a separate theme, which revolves around the art activity presented by the therapist. When facilitating group art projects, it is important to remember that a patient's artwork is like a lens – a telescope or magnifying glass. This enables the therapist more clearly to understand the child, almost without restraint, and tap into areas that the patient would otherwise never talk about. Group therapy builds upon that lens by also allowing the therapist to observe and assess the patient in a social setting. In a group setting, the therapist is privy to a range of behaviors that cannot be seen through individual sessions, such as where the patient chooses to sit, how they interact with their peers and how they behave in a group. It is also important to note that while the artwork may be the fun part of each session, it is often only through the non-threatening art experience that the therapist can understand the

serious thoughts and feelings of these children. This allows the therapist to understand the individual needs of each child, which aids in developing more effective and appropriate social skill sets, in turn leading to a happier, more fulfilling life.

Week Two: "How do you feel about having AD/HD?"

In Week Two, the therapist asks the group to draw their response to the following question: "How do you *feel* about having Attention Deficit/Hyperactivity Disorder?" Many of the children will answer that question with comments such as: "I'm not happy," "It's not fair" or "It makes me angry." Others may say: "I feel frustrated," "I feel different" or "I don't feel normal." This is often the first time that the children have expressed their feelings in a group setting without being guarded, silly or highly defensive. Many of these AD/HD children feel different from their peers. They feel victimized. It is important for the therapist to keep this in mind and emphasize that, through understanding the impact of AD/HD, the children can learn to become proactive, rather than reactive and feeling like a "victim." However, some patients may hear the question "How do you feel about having this disorder?" as one more attempt at victimization.

This is an opportunity for the children to communicate their feelings and it frequently happens first through their drawings. The children may take a few minutes to talk about how they feel before beginning to draw. The therapist should ask them to make a picture that shows how they *really feel* about having AD/HD – a drawing that even the therapist, as an adult who hardly knows them, can understand clearly. Typically, the patients want to help the therapist understand their feelings and will work to comply with this request. There is an element of trust here, which was first developed during the intake interview, evaluation process and possible individual sessions and is further enhanced during group therapy.

Many of these children are externalizers and incapable of insight. They are not necessarily able to express themselves verbally, especially in terms of their emotions. They talk a lot, but they talk *around* their feelings. When it comes to emotions, they are so busy that they are not empathic to

their own feelings or even aware of them. However, when asked to do the drawing *"How do you feel about having AD/HD?"* they can become very powerful and clear communicators, as will be seen from their drawings, which follow.

Bill (who will be presented later) expressed his feelings about AD/HD, depicting them as a big storm. The picture in Figure 4.1 shows how he feels inside.

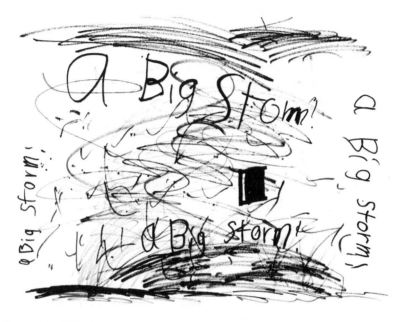

Figure 4.1 A big storm

This experience helps everyone: for example, one young boy drew a picture of himself and labeled it "Broken in the Head." This led to a 7-year-old girl stating, "It's not fair!" (which is the title of her drawing). That freed up an older boy to agree with her. He had drawn a picture titled "Hot Under the Collar" which showed smoke coming out of his ears, shark-like teeth and fiery yellow-red eyes as if he was about to explode. He then discussed that having AD/HD left him feeling angry, irritable and helpless most of the time

When they are finished drawing, the therapist should say to the group, "Let's look at your drawings." Children often want to see what other

group members are drawing or hear what they are thinking about. It helps to solidify a group experience, which initiates the development of trust in the group. It also teaches the children that it is safe to discuss their feelings and helps them make a verbal connection with whatever feelings they are emoting on paper – even the anger revealed in a drawing. Discussing what is apparent in a child's drawing, with that child and the entire group, helps everyone relate to what this person drew and the feelings exposed in the drawing. It also enables others in the group to share their individual feelings, both visibly in their artwork and verbally in the group discussion.

The therapist can use the work of one child to spark more conversation from the entire group. In one particular instance, a girl had scribbled many different colors together in a chaotic conglomeration – she had a difficult time differentiating what she was feeling at any one time. Her picture displayed graphically what it feels like to be bombarded by multiple senses and feelings simultaneously. It also presented an opportunity for the therapist to turn to the other members of the group and ask, "There are lots of feelings here, layer upon layer of feelings. Do other people in the group feel that way at times?"

All of the feelings that each child has about their AD/HD certainly are not revealed in this session. But those that are revealed and discussed provide a foundation on which other emotions and feelings can safely be disclosed at another time. A good practice is to ask the following week what they had learned about themselves or each other the previous week. Feelings are part of the life of each of us, which all too often we have been encouraged to repress. In the case of the AD/HD child, repression of feelings about AD/HD can have unnecessarily harsh consequences. Therefore it is necessary that the therapist ensure that the group environment is a safe place for the children to express their feelings and to explore the reality and substance behind them.

Week Three: "How does AD/HD get in your way?" and "How do you feel about taking medication?"

The educational social skills art therapy group sessions typically last an hour. However, Week Three will be longer (90 minutes to two hours,

depending on the ages of the children in the group) as these topics are closely related and should be covered in the same session. The therapist should include a five-minute break after the end of the discussion of the first drawing.

The eight-week program can be looked at as a set of building blocks, which when completed have both form and function. In the first session, the children receive a mini-lecture on AD/HD, introduce themselves to one another, introduce another child they have just met for the first time to the group, and then work on the "I CAN" exercise. Also, rules are established to provide structure and boundaries.

In the second session, the therapist reviews the major elements of the initial group meeting and helps the children explore their feelings about AD/HD. Hopefully, by the end of this session, the children begin to believe that group is a "safe" environment.

The third session should begin with another review of the information covered in the first two sessions. It is important that the therapist always reviews prior learnings because repetition is essential for these children as it helps them internalize the information. Then the therapist should explain that the goal of this session is to allow the children to see what they have previously only heard about.

Many of the children in the eight-week program have only recently been diagnosed AD/HD, some as recently as a few weeks prior to entering the group. Asking these children how they *feel* about having this disorder, which is so new to them, is often unreal. The children, especially the adolescents, may have been struggling for years with school, social and family failure. They are beginning to learn that there is a reason for this, but this is only the beginning. This session, where they begin to see the effects of AD/HD, can be extremely powerful.

To help accomplish the goal of the session, a video entitled *It's Just Attention Deficit Disorder* (Goldstein and Goldstein 1991) is recommended. Their parents should also see this video in the parent education group. However, before showing the video, the therapist should do several things. First, the therapist should introduce the video and preview what it is about; the therapist should explain the visual and auditory cues within the video that will aid them in understanding the concept of AD/HD. This will help the children understand what they should look and listen

for. Next, the therapist should introduce the questionnaire that comes in the accompanying book. This "Yes" or "No" questionnaire is a list of questions that helps the therapist understand what the children know, do not know or possibly misunderstand about AD/HD prior to watching the video. Finally, the therapist should structure the screening in such a way that will help them be more successful watching the video – keep in mind that many AD/HD children are fidgety and restless. The children should be seated in chairs with arms to provide a definition of their own personal space. This reduces their hitting or bumping into one another. Also, by conducting the questionnaire beforehand, the children are alert to the important ideas and concepts when they do view the video. The therapist should give each child a pencil and 4 x 6 inch index card and ask them to make notes or write down questions that arise during the movie. An important caveat is that while writing notes or questions is helpful for some children – because it helps keep them focused and on task – it can be distracting to others and the therapist should be alert to this. After all this has been finished, the therapist plays the video for the group.

This video is often controversial. Many children and parents like it immensely, while others do not like it at all because it is highly stimulating, with many distractions. The actor playing an adult with AD/HD does not look or act intelligent – but then, children with this disorder use poor judgment and do impulsive things. However, the video is successful with AD/HD children because it is so visually stimulating, which serves to screen out other distractions in the viewing room. At the same time as children complain about it, they frequently extract important information. It brings up for discussion such vital questions as "Will I ever outgrow AD/HD?" and "Will I always have to take medication?" These are very poignant questions.

The video includes several young people who talk about their experiences with their AD/HD disorder. This helps the children in the therapy group understand that other children have dealt with AD/HD successfully and suggests that they can as well. The video also reinforces what the therapist has stated to each child and parent from the very beginning: that you are not alone in this disorder. There are other children, adolescents and adults who have AD/HD and do very well. Many are highly successful, even though they may have had difficulty in the beginning.

As stated above, AD/HD children (and their AD/HD parents) frequently respond well to the video. They often refer back to it throughout the remaining group sessions. Although other children may complain, they usually glean an enormous amount of information from the video as well because it provides AD/HD boys and girls with information in a media that they are used to. This familiarity makes it a powerful educational tool. Non-AD/HD people who watch the video may find it very distracting, but this is also important because it allows them an understanding of what life is like to be so overly stimulated and distracted.

After seeing the video, the therapist should review the questionnaire and ask the children to talk about what this experience was like for them and to think about AD/HD in their own lives. This discussion should lead into a drawing exercise where the therapist asks them to draw *"How does AD/HD get in your way?"* These drawings help them visually to show the things that are negative for them about having AD/HD. (Remember, the group started with a very positive "I CAN" exercise.)

So far, the children have received new insights into the disorder and more information about how other children have responded to it. The therapist should now help them self-identify the parts of AD/HD that get in their way, in order to help the children develop strategies to manage those things. Some typical responses to this drawing include: their temper, hyperactivity, impulsivity, distractibility, inability to get up in the morning; inability to make and keep friends; their social failures, academic failures and failures in the family. Some may say they feel dumb or stupid because they are somehow not able to live up to their parents' expectations.

Figure 4.2 How does ADD get in my way?

In Figure 4.2 Kris has depicted the impact of AD/HD on himself by drawing four pictures. Like many patients with AD/HD, Kris suffers from a bad temper, is easily bored, frequently lies and seeks high-risk exciting activities like fire setting.

Figure 4.3 Reversed sleep habits

For Joe, having AD/HD means having reversed sleep habits (Figure 4.3). This, of course, interferes with his ability to get up in the morning and concentrate in school. Joe's restlessness and internal hyperactivity contribute to this problem, as his mind is not able to slow down and allow him to fall asleep. This is not an uncommon problem for AD/HD patients (Ring *et al.* 1998).

Following discussion of their drawings and because the topic of medication often comes up, the therapist should explain the use of medication and how it is believed to work. There is a variety of different medications and group members will discover that many of them are on medication. (The parents' parallel session, led by a child psychiatrist, involves learning in depth about the different medications used, their benefits and their side effects.) The therapist will then ask them to draw a picture titled, "How do you feel about taking medication?"

Figure 4.4 Pills are a pain

Joe did not like taking medicine; like the young girl described below, Joe felt that taking medicine interfered with his life (Figure 4.4).

Figure 4.5 How do I feel about medicine?

Kris was confused about how he felt about taking medicine (Figure 4.5). His parents and teachers believed it helped him, but he could not tell the difference.

Figure 4.6 Medicine

For Bill, medicine is a "treasure" and being able to use medication is a relief (Figure 4.6). He had not been able to use medication when he was a young boy. When he finally could use medication, he stated it helped him to focus and be more successful in school.

Figure 4.7 Pills...no apitite

One young man, like many patients, complained that the medication interfered with his appetite (Figure 4.7). Some children hate their medication or the fact that they have to take it. For example, one little girl drew a picture of herself alone at recess time after another classmate asked, "Would you like to go out and play with me?" She could not play because she had to go to the school nurse for her AD/HD medication. She deeply resented the time away from her girlfriends and other activities. Most of all she felt that it was not fair that she had the disorder and was "not normal." It is natural that the children dislike their medication, but the therapist must make sure that the children understand how the medication works and its benefits. The therapist should discuss how research shows that taking medication can improve schoolwork including reading, math and even handwriting (Benedett and Tannock 1999). The therapist should also explain that medication is not used to *control* their behavior (or minds) but to improve symptoms of AD/HD that interfere with learning and behavior.

How children, like the young girl mentioned above, *feel* about having AD/HD has much to do with how the disorder gets in their way. There is actually a lot of similarity that crosses over from the drawings made during the second and third sessions. The relationship between the discussion from Week Two and Week Three is substantial, which is not accidental. The group sessions should be structured this way – and use repetition and frequent review – to reinforce what the children have learned and to segue into what lies ahead in the remaining sessions.

In this session the children have seen what AD/HD is like and begun to discuss how it affects them. Often they reveal the deep feelings of negativity they have towards AD/HD and how it impacts on every area of their lives. The therapist will continue this conversation in the next session, when the group focuses on how AD/HD often gets in the child's way at school.

Week Four: "How does AD/HD get in your way in school?"

The order of the sessions is not accidental, but rather follows a clear rationale established to allow the children to build upon each learning experience. In the end, they should develop a cohesive understanding of how AD/HD impacts them and what they can do to minimize the impact in their lives. For this reason, it is important to have the children discuss their medication (as done in Week Three) before this session's topic: "How does AD/HD get in your way in school?" The children should be aware of how their medication works and the benefits of taking it *before* attending school, which is arguably the most important activity at this point in a child's life. Many of the children who come to group resist taking medication, especially those in middle school whose overwhelming drive is to be normal, not to stand out, and not to have to go to the nurse for medicine. Even with six-hour and twelve-hour dosages (when tolerated), patients resist taking medication. The sessions are structured so that the discussion about medication and its significant benefits, followed by AD/HD-related school problems, may break down some of the resistance towards medication.

Students feel pressure to excel in school – often the same, if not more, pressure than an adult feels from their job. School is the child's job and it is important to the child that he/she does well academically and socially in the school environment. Medication often makes a major difference in the academic achievement and social/interpersonal relationships of AD/HD schoolchildren (Barkley 1998). One of the goals of the educational social skills art therapy group is to help them understand that the major benefit of AD/HD medication is its ability to help them sustain attention and focus on the important aspects of learning in the classroom. Medication helps them stay on task without being distracted – even when they believe what they are learning is "boring." Group therapy is often very effective at teaching this message because the children can see that they are not alone in having to take medication, so they begin to feel less "different."

Many of the effects of AD/HD (e.g., hyperactivity, restlessness, chronic fatigue and the inability to focus and pay attention) impact the children at school. Many have learning disabilities (Cantwell and Baker 1991). As a consequence, many AD/HD children frequently feel like failures at school. These children are at high risk to have low self-esteem and low self-worth (Brooks 1994). Some become frequent truants or drop out from school. Others simply avoid doing homework, become class clowns, create scenes designed to interrupt, turn into avoiders or become learning inefficient. For some, the very thought of sitting still, being organized or thinking sequentially is not possible – it is simply not the way an AD/HD child's brain is wired.

Dr Melvin Levine's questionnaire ("Self-Administered Student Profile for Developmental, Behavioral and Health Assessment", Levine 1986) poignantly shows how AD/HD children see themselves in school. This questionnaire should be used as part of the intake interview with the child. A large percentage of these students see themselves as different, believe their memory is not as good as other children and observe that homework requires much more time and energy from them than from many of their classmates. They see themselves as school failures, unequal to their peers and academically inept. Many AD/HD students are extremely sensitive and become highly defensive. Fights often develop with their parents because the children feel that their parents put pressure on them for good grades or constantly ask questions like, "Why are you

doing so badly?" Parental academic pressure is exacerbated by comments from teachers and school administrators suggesting the child "try harder, pay more attention, get work done on time, stop daydreaming, stop wandering around the room and stop leaving the classroom for the restroom." In one drawing a young schoolboy is seen asking his teacher "What did you say?" Her response – "If you had been listening" – is a recurring theme for many students with AD/HD.

Getting the right diagnosis (discussed in Chapter 1) is the beginning of relief for the AD/HD child and the foundation on which parents and therapists can build. The diagnosis helps the parent understand that there are neurobiological reasons why the child is struggling in school, why the child does not want to/or cannot do homework or sit still in class. It is not because the child is a bad person or lazy. Some AD/HD children also have auditory processing problems that make it difficult to differentiate the sounds they hear and understand exactly what they have heard. Many AD/HD students have to work very hard to stay focused and not become distracted and, as a result, feel chronically fatigued. Some have sleep problems, causing them to have difficulty waking up in the morning and getting ready for school on time, let alone staying awake in school. A large number of AD/HD patients also have learning disabilities (Wachtel 1998).

This fourth session is often a watershed session for the children because it helps them understand the reasons why school is a place that makes them feel unhappy. The students are not the only ones who experience an epiphany. Teachers who see drawings by their students are surprised, if not chagrined, by the depth of feelings their AD/HD students have expressed in their artwork about attending school. Children with AD/HD frequently characterize school as "like being in jail," "school is a pain," "school is a place where I am distracted" or "school is a place of failure."

After a discussion of some of the issues included above, the therapist should ask each of the children to draw in response to the question, "How does AD/HD get in your way in school?" When finished, the therapist should ask the children to hang their pictures on the wall. Often, the children see each other's work with comments such as "can't sit still" or "gets yelled at" or "is always told I have such potential and should get good

grades" and have an immediate and empathic recognition: "I'm not the only one who feels this way!" This can lead to a feeling of connection and continued relief at being able to be open about AD/HD and their unhappiness. All these sessions reinforce that for the first time these children feel they are not alone and that someone else has some or even all of the same feelings of isolation and failure. They become much more open to the idea that there are things they can do – together – that will help. They may be able to share good ideas and find solutions to their problems. The following drawings and anecdotal responses to *"How does AD/HD get in your way in school?"* illustrate this point.

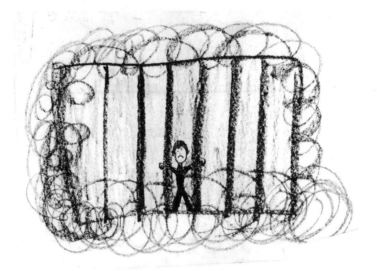

Figure 4.8 In prison

David was a child targeted as a troublemaker to the point where the public school he attended wanted him to leave. He was large for his age, yet drew a picture of a large jail with him as a very small child behind bars, surrounded by bands of barbed wire (Figure 4.8). I took his picture to a school meeting, showed it to his teachers and asked, "Can you put yourself in his position? Imagine going to school day after day, feeling like a prisoner in jail, behind bars, surrounded by barbed wire? Imagine his feelings every day as he comes to school." His drawing helped his teachers re-evaluate their opinion of him.

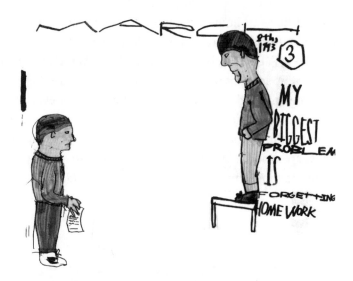

Figure 4.9 My biggest problem is forgetting homework

Joe drew a classroom in which he was the only student. Towering over him was a teacher who looked enraged (Figure 4.9). Teachers often asked Joe, "Why can't you remember to do your homework? What's wrong with you?" Joe simply did not remember what the homework assignment was and seldom turned in his homework on time. He felt terrible. He felt inadequate and a failure, and believed he would never be able to remember to do the important things required of him by his teachers.

The drawings often show unhappiness. Children in the group begin to talk about the reality of having teachers who do not understand them or know how to teach them as children with AD/HD. They also discuss parents who expect them to get grades they believe are impossible. They also recognize that their drawings say, "I'm not doing well in school. I'm getting in trouble." They see their drawings collectively and again realize that they are not alone; many of them seem to have the same problems. Many draw failing report cards and the unrealistic expectation others place upon them to be high achievers. Other drawings depict their inability to read, write papers and complete homework, forgetfulness, inability to attend, daydreaming, tardiness and distractibility. Reading is a common problem for these children as it is difficult for them to concen-

trate and to remember what they read. Doing long-term projects is a nightmare; planning ahead requires organization which is a weakness for most of them. All recognize their inability to be organized and manage time.

The emphasis of this session is to talk about the pressure children feel from their lack of success in school. Some talk openly about how they get around the pressure to succeed in school and many AD/HD students actually say that the only way they are going to get through school is by cheating. Another group of AD/HD children may complete their homework, but leave it on the bus, forget to hand it in or lose it because they are so forgetful. Therefore, they do not receive credit for all of their work and both teachers and parents get upset with them. Parents see them complete the work, the child remembers taking it to school but the teacher never received it to be graded or counted. Many AD/HD children feel like victims. They have trouble getting up in the morning, are late to school, have trouble remembering to bring books and homework to and from school, and have trouble when a teacher looms over them asking why they never complete their assignments or are late to class or forget their materials (see Figure 4.9).

These are typical AD/HD problems experienced by elementary, middle and high school students. They constantly feel incompetent in an environment that they know should be their primary occupation and major life activity. They want to do well and compete successfully with their peers, but usually perform poorly and experience failure. It is no wonder that AD/HD children become so defensive and unhappy.

Rick Lavoie, who directs a school for learning disabled children, often tells the story of a little boy who awakens in a beautiful room in a wonderful home, gets dressed for school in the latest, most stylish clothes and picks up his expensive backpack (Lavoie 1994). His mother loads him up with everything he needs to be successful. She wants him to have all the "warm fuzzies" he can, to be a successful learner and human being. She makes him a great breakfast and a fabulous lunch before he leaves for school – "with a million chips sends him off" [positive reinforcement]. The concept here is that building self-confidence early in the day gets everything off to a great start. When he gets on the bus, the driver knows he is a problem and commands him to sit in the front. Right away he has

lost some of his "chips." Children on the bus begin to tease him and no one wants to sit with him. By the time he gets to school, he has already lost more "chips." Throughout the school day he continues to lose more in the classroom and halls, on the playground and in the cafeteria. Completing his work, taking a test, eating lunch and playing in gym are all disasters. When he steps off the bus at his driveway, he has not only lost his million "chips," but is in deficit. It is easy to see that story repeated over and over again with AD/HD children. Unfortunately, these same children are at high risk later for drug and alcohol experimentation, or for experimentation with other life-threatening, thrill-seeking activities.

The recognition that they are "not alone" allows these children to become more open to the idea that there is a norm, and their norm is AD/HD. Because of that realization, they do not have to feel so angry and frustrated by not being like Dick or Jane; they can be like other children who are also AD/HD. Most importantly, they realize that they are not incompetent, but are being asked to do things that they cannot always do. The children now understand that they do not succeed in school, or do not please their parents and teachers, not because they don't want to, but rather because of a disorder that simply is not their fault.

The similarities between the members of the group is one of the factors that makes educational social skills art therapy groups so effective. As this process proceeds, the group begins to take form as a whole entity rather than as individuals. Social awareness and even compassion appear.

The parallel parent educational group, led by an educational specialist, presents the impact of AD/HD on students. Strategies for becoming a better student are discussed. Students' drawings are used to illustrate to parents the devastating impact of AD/HD on their child.

It is important to note that there are several things that can be done to help an AD/HD child in the classroom:

1. The teacher needs to be aware of each student's specific diagnoses and what modifications, if any, need to be put in place.

2. The AD/HD student should identify himself to the teacher.

3. The student needs to learn self-advocacy strategies, such as asking to sit in the least distracting space or close to the teacher.

4. The therapist should help the teacher recognize typical behavioral characteristics of the AD/HD student including: hyperactivity, distractibility, impulsivity, frequent interrupting, inappropriate comments, rapid mood swings, the inability to maintain focus on a subject or idea for a lengthy period of time and the inability of many children simply to sit still in one place. Teachers should also understand that many of these children are hypersensitive. Their feelings are easily hurt – even though they may not show it.

5. The therapist can help teachers to understand and use some of the tricks that help the AD/HD child to focus and become more of a regular participant in classroom activities. For example, doodling or wiggling their toes in their shoes helps some children minimize distraction from a variety of extraneous thoughts, visual/auditory impulses or the usual classroom confusion, while keeping the child motorically active. Some AD/HD children become better students when they are appointed errand runners for the class. Frequent, requested or permitted movement during the school day will be helpful to AD/HD children (and the entire class). Assigning an AD/HD child to two desks has also worked well for teachers with young children. It provides a physical change in space, an emotional change of pace and an actual change of scenery and classroom neighbors once or twice each day.

6. The environment needs to be predictable, consistent and not overly stimulating. However, an inspiring teacher often helps AD/HD students focus on them.

7. The therapist can help parents and teachers better understand the laws that cover AD/HD children. Most AD/HD children fall under IDEA, OHI or Public Law 504, a civil rights act mandating modifications to qualified children such as more

time to complete schoolwork, untimed tests, a less distracting environment in which to take tests and less clutter on their paper. Children diagnosed with more specific problems, such as a learning disability, are entitled to additional resource help. Public Law 94-142 is the handicapping law, which also can include, when appropriate, the AD/HD population (US Department of Education 1991).

One objective for the AD/HD population is to find ways to modify the school environment, so that AD/HD children can experience academic success without feeling incompetent. Medication is one important part of the solution for many such children, but every AD/HD child also needs to learn strategies and "tricks" to be academically and socially successful. (These will be discussed in depth in Week Six.) Schools must be cooperative and flexible. Teachers need to understand that some of their comments are highly destructive to an AD/HD child – for example: "If you had been listening you would have understood." "How many times do I have to tell you?" "Why can't you ever remember?" Too often, teachers misinterpret AD/HD students as manipulative, stubborn, oppositional, lazy or disinterested. Parents often say, "My kid is lazy!" However, most of these children are not lazy. They usually want to please adults and will work very hard to please – especially young children.

As the students, parents and teachers become more educated about AD/HD through group sessions and teacher meetings and learn strategies to deal with AD/HD, the children become less defensive and, therefore, more open to suggestions. This helps them in school and they no longer have to be the class clown, the interrupter or the child who makes outrageous remarks to get attention from classmates. The therapist and other adults can help them find different ways to do things that are more socially acceptable and find those "isles of competence" that Robert Brooks talks about where they can be the best of whatever it is they want to be (Brooks 1994). This will ultimately help their esteem grow, as they feel more confident, competent and better self-advocates. This session helps the children take the first step towards that goal.

Young children can eventually learn to be effective self-advocates. Initially they need a parental advocate with their school, as well as

advocacy assistance with the school from the child's therapist. The AD/HD child's pictures present images of the child's feelings about teachers, peer relationships, classroom activity and the overall school experience. These drawings reveal many reasons behind the child's behavior at school or on the playground and can be brought into school meetings to enhance understanding and foster a more comprehensive academic program for the student.

Week Five: "How does AD/HD get in your way at home?" and "How does AD/HD get in your way with making and keeping friends?"

AD/HD children frequently have low self-esteem, caused primarily by difficulties in school and at home. The previous week's session discussed strategies for improving school life for these patients. The goal of this session is to help the AD/HD children understand how their AD/HD affects their family, as well as give them some strategies to improve their family relations. This is also a longer session, either 90 minutes or two hours depending on the ages of the children in the group.

The therapist should invite siblings (ages 7 and up) of the AD/HD patients to attend the parallel parent education group session this week. At one point during this meeting, the siblings should be separated from the parents and form their own group. The therapist should ask them to draw how AD/HD impacts the family. The therapist may find that the siblings are often afraid to show their drawings to the rest of the family, as they are fearful of either hurting or enraging their AD/HD sibling. The therapist leading the sibling group needs to be aware of these feelings and ask for permission to share the drawings, if they believe that this will be useful for either the AD/HD patient or the parents to see them. (See Chapter 2 for a discussion on the parent educational group.)

During the entire eight-week educational social skills art therapy group, the patients deal with the issue of impulsivity: how to deal with moments in life when one needs to stop, step back and *think* before acting. One particular girl, who was argumentative to the point that she drove people away from her, made a "Stop" sign for her parents or nanny to hold up whenever she started doing something inappropriate. She had agreed

that if they held up her "Stop" sign, she would stop whatever she was doing, take a step back and consider what she was doing that was inappropriate. This worked on several levels. First, it helped by stopping the inappropriate argument or activity. Second, it represented a mutual agreement she had reached with her family. Third, it helped her determine and understand what was inappropriate about her behavior.

The previous example illustrates the point that it is not just in school where AD/HD children are unsuccessful. Home must be the primary area in which change takes place for them. They have to feel that home is their safe haven. AD/HD children are going to find themselves in many negative situations, whether in sports, music, camp, Sunday School, recess, the school cafeteria, the classroom or on the school bus. They will constantly experience difficult situations, which is why helping them make their home a place where they feel safe is fundamental to their well-being.

AD/HD children often have difficult family relations. Their family frequently does not know how to deal with their impulsiveness, lack of focus or hyperactivity, which strains all family members. Sometimes the AD/HD child is blamed and made to feel responsible for arguments and disruptions. Frustrated parents have made comments to their children such as "I wish you were never born," "If you weren't in our family, our lives would be so much easier" or "The reason your father and I argue so much is because of you." AD/HD children hear statements such as these, which affect their self-esteem and compound their problems. Consequently, AD/HD children frequently become avoidant in family group activities.

AD/HD children often talk about always being blamed. During group meetings, they make statements like:

> On a trip, as soon as we get in the car there is a fight. It's always my fault. We're trying to get ready, and I may not be ready on time. It's my fault. I've ruined the whole family's trip, the whole vacation. We go to a restaurant, and it's hard for me to sit still in a restaurant. All of a sudden people are yelling and I'm embarrassed. I'm embarrassed that my father's yelling at me. I just want to leave. I want to go hide in the bathroom or sit in the car. My parents always tell me to do that, so what's the point of going out anyway? Why would I want to go out?

And when we all get ready to go out, why do I want to go? I'm not sure it'll be such a great time. I can't trust myself.

Another source of difficulty may be interactions with their non-AD/HD siblings, who have the ability to focus, organize activities, maintain relationships and keep schedules. The AD/HD child may compare themselves to their siblings and feel inadequate and have low self-worth, which may lead them to be defensive. When the therapist opens this session by asking the group to draw *"How does AD/HD get in your way at home?"* they often show, through their drawings, intense feelings never before verbalized.

AD/HD can destroy a family's unity. During the sibling breakout session (discussed above as part of the parent educational group), they are asked to draw a picture of the impact of AD/HD on the family. They often express feelings of anger towards their parents, who are unable to manage their AD/HD brother or sister. They may also be angry with their AD/HD sibling, who requires much of the family time.

In Figure 4.10, a non-AD/HD girl describes feelings of being isolated and missing what she imagines normal family life would be like. She sees her family as "conflictual and chaotic." She sees her AD/HD sister as the centre of attention. Other siblings see the family as splintered. This is demonstrated in one boy's drawing of each family member apart from each other and away from his storming AD/HD sister. The empty dining room table illustrates the family's incohesiveness (Figure 4.11).

Often non-AD/HD siblings will discuss the constant irritability and mood swings that their AD/HD brother or sister exhibit. For example, one girl discussed how her sister could be mean and hurtful and then, moments later, sweet and loving. This causes the non-AD/HD sibling to possess feelings of mistrust and wariness towards their AD/HD counterpart.

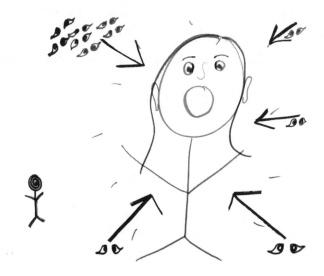

Figure 4.10 All eyes on her

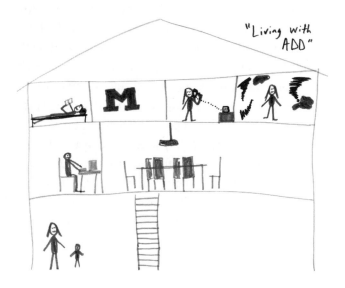

Figure 4.11 Living with ADD

Over the course of the educational social skills art therapy session, while viewing and discussing each of their pictures, the children begin to understand that their AD/HD has a tremendous – and often negative – impact on other family members. This may lead the non-AD/HD family members to feeling as if the AD/HD is ruling the family's life. As one boy said, "Whenever I come home, my sister rushes to her room and slams the door." Another AD/HD child drew a picture with the words "I Hate You" because his older sister always tells him this and refuses to sit on the school bus with him. The constant theme represented by these patients is one of anger being directed towards them, as one boy drew his older brother chasing him away. The AD/HD patients, when not being defensive, recognize their role in creating the family's disruptions. This is a difficult thing for them to learn, but it is easier for them to hear it while in a group session where they do not feel alone. They express feelings of sadness and pain. Also, they are often jealous of their non-AD/HD siblings.

AD/HD also impacts the development of relationships outside the family. To stimulate discussion on this topic, the therapist should ask the children to draw a response to the question: *"How does AD/HD get in your way of being able to make and keep friends?"*

Frequently, their responses express pain, social isolation and great unhappiness. A particularly poignant drawing is Jack's illustration of his bike trip, which shows a line of bikes with no one on them. This drawing represents his belief that no one would want to go with him. Bill drew a picture of himself as an orange face amongst dozens of the same images. He described this drawing as his wish to be like everyone else. In this way, he believed that all the other children would like him and be his friend.

Another young girl drew a scene that she frequently experiences on the school playground – the other students telling her, "You have ADD. Ha Ha! You are stupid! You have to take medash! [medicine] You have ADD! Ha Ha! You are so dumb!" (Figure 4.12).

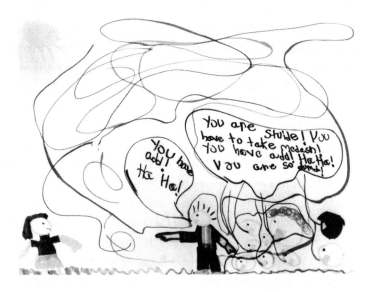

Figure 4.12 You have ADD

In this picture the AD/HD child is being ridiculed by her peers on the playground. They are calling her stupid because she has AD/HD.

Another drawing shows a ping-pong table complete with ball and paddles, but no one with whom to play. Children with AD/HD have a drive to be just like everyone else and not stand out because of their behavior (or any other reason). These children are in sad, embarrassing situations. They want to have friends, children with whom they can play and do everyday things. They know what they want to do and think they know how to do it, but believe that no one will befriend them.

Discussion after this drawing typically revolves around their trouble making friends and the fact that they often do not understand why. Some AD/HD children have no trouble making friends, as they are very outgoing, but may have difficulty keeping them. When they discover that these problems are common in the group, they realize it must be an AD/HD trait and they become more open to finding solutions. Only then can they understand that their problem with making and keeping friends stems from the fact that they are impulsive, distractible and have difficulty picking up social cues – their hyperactivity does not help either.

The therapist should ask them to think about their distractibility; how they look at so many things simultaneously and are flooded by all the

information being received. With so much going on, they are often unable to pick up the salient information. For example, if someone makes a face at them, they may see the face but at the same time also may see a car going by. To them the two images are equal; they have missed the signal in the other child's face that was designed to tell them they were being annoying.

Teamwork can be extremely helpful in this lesson. The therapist can teach the young children an eye contact game. They sit in a circle and one person talks at a time. Everyone watches the person talking. When that person stops talking, the first to raise their hand is allowed to talk next. The children look steadfastly at the face and into the eyes of the one talking, seeking cues that may indicate the end of that person's talk. The therapist should continually reinforce concepts like eye contact as they teach the AD/HD children to become better communicators. Initially, this game encourages competition, but with frequent practice the AD/HD children develop an understanding of conversation flow, without bringing in tangential thoughts. The game is also valuable because it helps the children to avoid being easily distracted and to focus on what they are hearing while observing the facial response of a speaker. Remember that repetition is essential in the learning process of AD/HD children so this game may be played more than once.

Role playing is another exercise used during this session, as it helps set up social situations that these patients experience. A good situation for practice is waiting in line at the cafeteria. In one particular session, two boys were acting out this scenario and one of them pushed the other. The smaller boy, who was pushed, got upset and wanted to fight the older, larger boy. The therapist can use an opportunity like this to offer other options, which will be discussed during the Week Six session.

Week Five stirs up many feelings with these patients. For many, it emphasizes their feelings of isolation and unhappiness. They begin to understand the impact of AD/HD on their behavior and why other family members and potential friends are distant towards them. They want to change this situation but do not yet know how. This is a large step towards recognizing that they have to be proactive, as opposed to reactive, in their approach towards other people.

The feelings of helplessness reinforce the feelings of being a victim of AD/HD. The therapist's role is to recognize these feelings and to reassure these patients that there are strategies they can learn to manage their AD/HD behaviors, which will help them become better family members and friends. However, this is a long process and an eight-week group such as this will start them on the road to success.

Week Six: Strategies to deal with AD/HD

The therapist should begin teaching strategies to deal with AD/HD from the moment the patients first begin their educational social skills art therapy group. Some of the initial strategies taught are invariably "Stop and Think" and "Walk Away." The former suggests that the person should not respond to any stimulus until he or she has first *stopped*, taken a pause (count to 10) and taken adequate *time to think* about the consequences of responding. The "think" portion of this strategy also suggests that the person think about whether any response is actually necessary. As impulsivity is difficult to manage, this is a difficult task to conquer. The latter encourages a patient physically to remove herself from the situation that makes her want to respond in a way that she knows (but may not immediately remember) is harmful.

However, an organized presentation and group discussion of specific strategies does not take place until Week Six of the eight-week social skills group. By this time, the children have drawn pictures and talked about the impact of AD/HD on their lives, at school, in relationships and within their family. They have also discussed the impact of AD/HD on their performance in sports and other extra-curricular activities. Hopefully, they have come to realize that their medication has helped them academically, in sports, with peer and sibling relationships and even with their parents. Some may recognize changes such as a reduction in irritability, an increased sense of happiness and less frequent or less violent mood swings. Overall, much of the focus on the group has been on how they feel about the impact of AD/HD on every aspect of their lives.

This session focuses on learning strategies to empower them and improve their self-esteem by better management of themselves. In this way, they learn to avoid the types of situations that have proven frustrating

in the past. For example, when a child says, "I want to get rid of my bad temper" the therapist can offer strategies to understand the source of the bad temper and how to deal with feelings that produce outbursts. They may have a bad temper because they may have not gotten enough sleep, which leads to irritability and low frustration, which leads to an outburst.

The group becomes a safe place in which patients recognize bad temper and learn that it is not something about which they have to feel defensive or hypersensitive. It often comes with the "package" of who they are, so strategies are introduced to help them minimize their impulsive outbursts, to "temper their temper." AD/HD children are taught strategies such as "avoid setting up a no-win situation" and "eliminate activities in which you are not usually successful." Both strategies help alleviate outbursts of temper by removing some of the situations that cause them to occur.

In both the parent and child groups, the therapists introduce effective coping mechanisms and strategies through role playing and repetition. There is a transition from what the patients have been learning to actually embracing helpful strategies into their daily life. This is a difficult milestone to achieve. AD/HD youth are heavily invested in being normal, being in charge, getting on with their lives and not allowing AD/HD to control their lives. The following strategies, which have proven to be helpful, enable the patients to develop at least an initial level of mastery in dealing with AD/HD-related problems.

Identify and focus on the problem

The concept of creative problem solving is introduced in this session. This is similar to the Problem-Solving and Self-Instruction Training Model that Braswell and Bloomquist wrote about (Braswell and Bloomquist 1991). Many children are familiar with the idea and able to apply it to educational issues. They are asked to think about the question "What's my problem?" and then draw it. The problem can be family or school related. For example, one boy drew his temper and his anger toward his sister. Another child drew his younger brother tied up, while he shot an arrow at him. A young girl, whose brother had been adopted during a major holiday, decided she no longer wanted this "gift," and insisted her parents

return him. Next the therapist should ask, "What can you do about it?" All solutions are initially accepted. Creative problem solving entails:

- State and understand the problem.

- Develop a multitude of creative solutions.

- Review and eliminate options until reaching the "best" solution.

- Attempt the solution.

- Did the solution work (review following week)?

The therapist then discusses each solution seriously, discarding impractical ideas. ("I'm not really sure your parents will return your brother. What else could you do?") Finally, one idea is accepted. The child is encouraged to try this idea and report the results back to the group at the following meeting. In the next session, the therapist should review the creative problem technique and each child reports back his or her success or failure. If a strategy has failed, the group should identify a new one to be tried during the next week. During this creative problem-solving process, parents are told about the strategies and asked to encourage their child.

Throughout the problem-solving time, the group should discuss what they can realistically do, what their options are and whether they are actually trying them. For example, one boy related the creative use of his watch alarm to remind him to redirect his attention and help him to stop daydreaming (he had drawn a picture of himself in a classroom, the teacher talking while he daydreamed). Other members of the group had suggested he set his watch alarm every 20 minutes to help him stop drifting off (the alarm caused the watch to vibrate rather than make an audible noise). He tried this strategy and found that it worked.

Through this conversation, the children discover some things they can do about their specific problems and learn that the group's suggestions are on target. One boy said, "I've learned there are things I can do – and I can still be in charge." Another noted, "My family has their goals for me. My teachers have their goals. My brothers and sisters have theirs. But, I'm making my *own* goals and I'll keep them because they're my goals. I set them up myself!"

Once the concept of strategies is introduced and the creative problem-solving technique is taught and practiced, the word STRATEGIES is placed vertically on a large 18 x 24 foot paper (as in the I CAN exercise). The children are then asked to think of positive words for each letter. Unlike when they did the I CAN exercise, their attitude is much more positive and they frequently suggest words like *s*ucceed, *s*elf-control, *s*top and *t*hink before act, *t*ell somebody, *r*elax, *r*eact slowly, *a*nalyze the situation, *t*hink again, *t*alk first, use *e*ye contact, *e*xcellent brains, *g*o away from a bad situation, *g*et organized, *i*gnore, *e*xpress yourself in words and *s*tay away from bad kids.

The children in the group discover that helping one another can be fun. They want to see each other succeed. They develop a sense of belonging, a feeling of closeness with their peers. For most of them, this is a first-time experience. The sense that everyone in the group is the same, all equal and together, arises frequently in problem-solving discussions. The therapist then asks the children to draw a picture of the solutions they would use. This helps solidify the past five weeks and this week's discussion.

Joe is a good example of how this lesson can be effective. He drew a picture about never getting his assignments done on time or forgetting that he even had homework to do (see Figure 4.9). The group suggested that he write down his assignments in a calendar. He left that session saying he would try it; then he came back the following week to report that he had used a calendar and that it had helped. Achievement and pride were evident all over his face. Joe's parents, teachers and other adult advisors had been telling him to use a calendar all along, but he simply was not ready or willing to follow their suggestion. However, he was ready to use the same suggestion from a group of his peers because it was offered in an environment where he could hear and be open to act upon their suggestion. The educational social skills art therapy group provides these bright, creative, enthusiastic and energetic AD/HD children with a structured and visual learning environment in which self-discovery and problem solving becomes possible – and fun.

Teddy is another good example. He had a problem with fighting. During the problem-solving session, he said, "I don't want to be in fights," so the group talked about strategies (e.g., walking away, trying to reason

with bullies and taking a deep breath or counting to ten) that would help him avoid fighting. After listening to their suggestions, Teddy drew a picture with one boy who wanted to fight and another – himself – walking away from the tense situation. His solution was to not "take the bait," but rather to walk away from the fight. He learned that he did not have to fight simply because he was challenged.

Another important strategy is learning that AD/HD people often get bored and have difficulty sustaining interest. Consequently, the nature of the AD/HD disorder makes it natural that enthusiasm for the "cure" often begins to wane at this point and is predictable. Therefore, the AD/HD patients need to learn strategies that help them stay in learning situations, even if they are disinterested. It is important to remember that AD/HD is chronic and genetic; therefore, it does not disappear. If it is evident in a child, it is likely to be evident in the genetic chain. The character of the disorder also includes denial, cover-up and prevarication, not only by the AD/HD child but also by other family members in the same or earlier generations. Professionals working with an AD/HD child must expect this and be prepared to explain it. Teaching how to deal with boredom and setting appropriate expectations for oneself and others occurs in this group session.

Family Meetings

One recommended strategy is the family meeting, which the therapists should discuss in the parallel parent educational group (see Chapter 2). Both Blakemore and Sonuga discuss the importance of parent training in helping AD/HD children be successful (Blakemore, Shindler and Conte 1994; Sonuga *et al.* 2001). For example, a parent might say, "I understand you were practicing eye contact in your group today. We talked about it in the parenting group. That sounds really hard to do. How do you do it? Can I help you practice?" The old adage "Learn a skill and you remember it for a week; teach a skill and you remember it for a lifetime" holds especially true here.

Most families, even those without AD/HD, do not know how to convene or conduct an effective family meeting. Short family meetings are invaluable as they enhance communication between all family members,

help teach values and allow for the family members to share feelings, emotions and life experiences. Effective, positive (and brief) family meetings are imperative for AD/HD families. Where else can an AD/HD child or adult find acceptance, compassion and a safe environment in which to learn to communicate, share feelings and accept love? Unfortunately, the vast majority of family meetings are hastily convened and highly critical family experiences from which no positive benefit accrues. Therefore, it is important that the therapists teach parents how to conduct truly effective family meetings. The patients are encouraged to share their new learned strategies with their families. Since art is an important component for learning, drawing is encouraged for the family meeting.

Family meetings help bring the disorder into family conversation, thereby reducing any associated stigma with the diagnosis of AD/HD. They learn that no one is stupid, dumb or lazy and that AD/HD does not have to be a "family secret." In truth, this open, free-flowing, no-holds-barred family discussion of AD/HD is an essential "strategy." It is also one which mental health professionals cannot teach nearly as well in group as parents can teach – and model – at home.

Learn how to be an advocate

During Week Six the therapist should tell the group:

> You have learned a lot about AD/HD. You are "experts" now. You know about medication, how it works for you, and that it doesn't work for everyone. You know how the disorder gets in your way in school and how it can cause you to have problems with friends and family members. You have learned some tricks and strategies, which you can use to become more successful. But these questions remain. What are you going to do with all that you now know about yourself and about your AD/HD disorder? Are you going to take charge and be responsible for yourself or are you going to continue to blame your bad behavior and low achievement on AD/HD or on someone or something else? What problem-solving techniques, tricks or strategies can you focus on and use regularly? What problems still exist for which no problem solving strategy has been given to you?

They learn that part of "being in charge" of their life, their feelings and their overall performance is the willingness to take their prescribed medication – on time, and in the proper dosage.

Parallel parent education group information

At the same time as the children are learning about the impact of AD/HD on them, the therapist should be talking with their parents about family stress and management. They should reinforce with the adults the concepts of what their children cannot do and what they will not do, as well as the difference of what is and is not AD/HD behavior. Many of the parents have generalized everything the child does as simply bad, lazy or unmotivated behavior. At this point in the parent group, the therapists should have already discussed what AD/HD is and the impact of the disorder on the family. Also, a sibling group has convened during part of one session where they were taught some basic management strategies and given an opportunity to talk about their own family stresses (e.g., how and why AD/HD impacts the whole family and creates crises that makes them feel as if they are always putting out fires). Parents are heightening their awareness of how the disorder impacts their lives – or, for those who have AD/HD themselves, how it personally impacts them and their families. Specific strategies that are taught to the children are reinforced in the parent educational group during the parallel session: stop and think; walk away; eye contact; self-advocacy; recognition of what is/is not AD/HD behavior; count to three; and nonverbal cues such as taps and winks. The therapist encourages the families to share what they have learned through an official family meeting and to choose a strategy to incorporate within the family system, such as silent cues. The platform (family meeting) is set to review weekly the strategies, initial goal charts and reward appropriate behavior.

Week Seven: "The Garbage Can" drawing

Over the previous six sessions, the group has talked about the impact of AD/HD on their lives at school, in sports, with their friends and within their family. Typically, the children have revealed how unhappy they are and mentioned differences between themselves and their peers. The six

previous sessions lead up to this Garbage Can week, during which the therapist invites them to think about and *"Draw what they would like to throw away regarding their AD/HD"* (even though they know they cannot actually do this). It is important to discuss the concept of wishes with younger children, who may still believe that they can come true if only they wish "hard enough." This will lead them to disappointment when they are unsuccessful, and they may even blame themselves for not wishing the right way. After they are finished, the therapist should leave the drawings up on the wall.

Most children have wishes of what they would like to be or how their life could be different and these wishes are very powerful. Many AD/HD children express strong wishes to be "normal" like their peers. They want to fit in, have friends and not take medicine. They hate being "the family problem." Many say they would like to get rid of their temper or their problem with disorganization. Some children may even put AD/HD meetings in their garbage can.

For children who have trouble expressing themselves verbally, drawing becomes an effective tool of communication. For example, one middle school patient drew a large trashcan in the center of the paper and labeled it "Trash." He then drew many of the things he wanted to throw out, such as "the bad part of my memory," "parts of my attitude," "some of my temper" and "the part of my mind that makes me daydream, some of it." This was an important breakthrough because he had previously been unable to communicate his unhappy feelings about himself.

The "Garbage Can" drawing allows for expression of every child's wishes. It also impacts their parents and teachers, who can understand how painful having AD/HD is when they see the drawings.

Figure 4.13 Being too active

In Figure 4.13, this child would like to dispense with his hyperactivity. Joe and Alex wanted to throw away their pills, ADD meetings, school and homework, disorganization and forgetfulness.

Figure 4.14 ADD trash can

In Figure 4.14, Chris, threw away his parents, his clock, medicine, homework and ADD groups. He discussed how his parents were always on his back trying to manage his life. He expressed his frustration at having to attend the group, take medicine and even attend school. He was always late and hated doing homework.

Many of the things they draw are not realistic, but verbalizing their desires is a very positive experience for the children. Of course, some of the things that they want to get rid of are feasible and the therapist should be prepared to offer strategies on these items. For example, if a child says, "I want to get rid of having my bad temper," the therapist can remind the child of the strategies, such as "Stop and Think" discussed in Week Six.

Typically, there is plenty of enthusiasm for this project because the children's earlier experiences with drawings make them feel there is something they can do beyond simply sitting around and talking about their AD/HD-related problems. By this time, group members have had the opportunity to learn to express their feelings about AD/HD and develop some strategies to manage it. This "Garbage Can" activity is also fun, as it offers children the opportunity to be creative and use their imagination.

One should expect many different kinds of "Garbage Can" configurations. Each child has a different way of interpreting the directions. They are an invitation for them to be proactive. When their drawings are finished and posted for the group to view, the therapist should have each child talk about what they have drawn and how they feel in turn.

The drawings are often very dramatic and crystallize the areas of AD/HD that cause the most unhappiness for children. They also demonstrate that the children are not only aware of their problems, but also eager to deal with them. Finally, by sharing their "Garbage Can" drawings, the members of the group have an opportunity to lament together – in a playful way – how burdensome AD/HD can be.

These discussions give the group an opportunity to review and reinforce many of the strategies discussed in Week Six. The therapist should go over these again. For example, the group could talk about using coping mechanisms to become more successful and reinforce what those strategies are and how to use them. The children will also be able to demonstrate what they have learned and embraced, as they mention some of

the strategies they remember such as listening, focusing on what is being said by a teacher or parent, being patient, stopping and thinking, doodling, using signals and maintaining eye contact.

In one particular "Garbage Can" session, a child stated, "If I could get rid of anything that has to do with ADD, I'd get rid of the fact that I'm always late to school." This indicated that the child had already made progress, as she finally recognized that she has a problem with tardiness and, for the first time, expressed an interest in doing something about it. The group talked about some of the things she could do, such as placing a second alarm clock on the far side of the room to make sure she got out of bed to turn it off, taking a shower the previous night and sleeping in her school clothes or even asking her parents to wake her by spraying her with a water pistol. She chose using more alarm clocks and reported the next week that the strategy worked.

Another topic that frequently comes up is the "hypersensitivity" that leads to having one's feelings hurt. One AD/HD child described it as when people throw slings and arrows; most people can avoid some of them but he catches them all. In this instance, the group talked about the need to learn to step aside and let some comments go, instead of being so reactive. This is a very important skill for AD/HD children to develop as they are often called derogatory names by other children, as well as adults. AD/HD children need to recognize their defensiveness or stubborn stance as protection. This is very hard for them, but acknowledging and talking about the desire to be less defensive is a positive beginning.

The goal of this week is to have the children talk more about their feelings and both to acknowledge and validate them. Ultimately, this will help empower them to manage their AD/HD. The "Garbage Can" drawing is a playful exercise that reinforces their difficulties by recognizing them. Now the group is ready to understand what they have learned, drawn and pictured. The following, and last, group session will be a culmination of the previous seven weeks.

Week Eight: "The Bridge Drawing"

Typically by the eighth week of the art therapy group, some remarkable changes have taken place in the children's lives. Several of them may be

different in ways one might think improbable, even impossible. In one particular example, a boy named Russell arrived at the first session with an attitude that said, "I'm not happy and I hate being here, so I will be disruptive and nothing can change that." However, through the group process, he began to tone himself down and to become a better, even participatory, group member. Russell's quick sense of humor and flair for drama (like many of these children) brought a contagious, fun-loving energy to the group. At the same time, another boy named Joe, who came to group very quiet and withdrawn, gained more self-esteem because his peers admired his skill and competence in drawing.

Over time, the group begins to get a sense of how the artwork is bringing them together and unifying them. There is less competition for attention from the children; they listen more to each other. Even the pre-group chatter among them in the waiting room has a friendlier, more open tone. These observations will typically be reinforced by comments from parents and teachers. The children look forward to seeing each other's drawings, which for them is another way of interacting. Their drawings also enhance their sense of well being and the pleasure they derive from group companionship and cooperation. The fact that this happens near the end of the eight-week educational social skills art therapy group experience demonstrates that it takes at least seven or eight weeks before the members truly begin to feel comfortable with the group process, and with each other.

This session should begin with a review of what has transpired over the seven previous weeks, including what they have learned about AD/HD and what they have shared together. A review of their drawings is helpful. The therapist should recall discoveries and ask the group to join in remembering their own discoveries and positive experiences with peers, families and siblings at home and in school. The therapist should also review the many components of their AD/HD that were discarded in the garbage can, such as their temper, disorganization, even attitudes they no longer need.

Then the therapist should turn the discussion to the future and talk about crossing over a bridge to a new place, a new experience, and a new life. The therapist should tell them:

Now that you know what you do about AD/HD and yourself, you
have the opportunity to leave some things behind that you don't
need or want in your life. Leave them on one side of the bridge before
you cross. You may cross over the bridge, but take with you only
those ideas and experiences that have value, that are important to you
and worth having. Please draw a bridge to your future. Leave what
you don't need or want and take what is really important for your life
on the other side.

The therapist should then lead a discussion about their drawings. In Joe's
bridge drawing (Figure 4.15), he left behind his ADD and brought several
trucks carrying with them the strategies he had learned. The first one
carries "Less Forgetful," the second truck carried "Assistance" and the third
one is labeled "Remember." On the other side of the bridge are "Normal,"
"Less Forgetful" and "Less Temperamental." The bridge is strong, well
reinforced and over calm water.

Figure 4.15 Bridge to success

As the children cross the bridge, they bring some of the AD/HD charac-
teristics they like and highly value, such as their energy and creativity, as
well as the organizational skills they have learned. In one instance, a boy
brought "some of his temper" because he did not want to lose all of it.
Typically, they bring "the eye contact" lesson, "energy," "creativity,"

"friends," "learning to count to three" to avoid getting into a fight and the "three important words: stop *and think*." One 9-year-old boy drew a bridge over shark-filled waters. He wrote under the bridge, "I want to bring consideration and keeping my personal space, giving people their privacy and think before hitting." His structure needed reinforcement and another older group member helped him by drawing large pillars to hold up his bridge. It is not unusual to see this kind of cooperation during these sessions.

This drawing is a very positive experience for each group member. Children exude plenty of pleasure making the drawings, talking about what they drew and explaining why they are leaving some things behind while taking others with them to the "other side."

Typically, they leave behind those things that are most disruptive in their lives. Temper, for example, is often left behind. The children interpret temper in many ways – as simmering, hot-headedness or impulsivity. Every child finds a unique way of following the directions for the bridge drawing and depicting it in a personal, meaningful way.

For example, one boy drew a huge, pointed triangular-shaped mountain with a teetering bridge over the top. His picture hints at the precariousness of his situation. On one side of the mountain were the things he wanted to leave behind; on the other were all the things he wanted to take. It looked like an inverted rocking horse. This was very powerful, because he recognized he did not have all the strategies in place, at least yet – but he had *the idea* and openness to learn. He did not yet have all the skills because it takes a long time to build them, but just creating the idea, giving him the encouragement to conceive and the basic skills to accomplish them, made it possible for him to believe in himself.

The therapist should talk very specifically with each child about all the new skills they have acquired and discuss how and where they may use them. From the first meeting through the last group session, the therapist has worked to make each session a positive social and educational experience for each child. The therapist should also reinforce and remind the children that they have had positive social and learning experiences together and that such positive experiences are not only possible, but also probable as they continue to use their new skills.

Teamwork will also help the AD/HD child continue to have positive experiences. A team must be composed not only of mental health professionals, but also well-educated parents, siblings and members of the extended family, fully informed and understanding teachers, school administrators and the AD/HD child who knows how to self-advocate. The group should be reminded that not only have they been in group, learning and practicing new skills while sharing their experiences with other AD/HD children, but that their parents have also been in their own group (see Chapter 2), learning about AD/HD, discovering how to parent the AD/HD child more effectively and educating themselves to be effective advocates for their child with schools and other groups and organizations.

Summary

First, the group has been very successful in helping children identify their feelings about AD/HD and its impact on them in areas they know best: their daily, personal lives; their academic and social experiences in school; their medication requirements, and their poor relationships with siblings, parents and peers. Second, the children learn how to deal with their feelings about having AD/HD and related issues. They are taught, and then role play, new ways to handle problems to achieve better results. Third, they learn strategies and "tricks" that will help them to focus better, remember more, be less distracted, act less impulsively and stay trouble-free. Finally, during the seventh week they talk about and then draw a picture of AD/HD components they want to discard from their lives and toss forever into a garbage can. In the eighth week each child draws a bridge to his or her new life, a life in which they understand AD/HD and know how to cope with problems associated with the disorder. As the children contemplate crossing the bridge they decide what to take to their new AD/HD-aware life, and what they want to leave behind.

I feel compelled to say that AD/HD is a complex and chronic disorder. AD/HD is not easily or quickly fixable. At the same time, however, the inventive research and dedicated work of many medical and mental health professionals have produced diagnostic, interventive and pharmacological protocols through which members of the AD/HD pop-

ulation may now achieve new, higher and more exciting levels of personal performance and dramatically changed life experiences (Detweiler, Hicks and Hicks 1996).

The goal of the educational social skills art therapy group was to ensure that all the children have a thorough knowledge and understanding of the AD/HD disorder. They should not only understand their diagnosis and treatment plans, but also learn how to improve their lives by dealing with AD/HD. However, the therapist can help only if the patient accepts the responsibility to learn, to participate in the group and recommended therapy, to question until understanding exists, to advocate, to communicate and to be willing (if recommended) to be medicated.

Past experience has shown that some of this can be accomplished with AD/HD children during their eight-week educational social skills art therapy group. The art therapy drawings reinforce learning, as making art adds another dimension to a multisensory approach to learning. Art making incorporates fine/gross motor skills and visual input in addition to auditory input. The pictures are visual reminders of the group process and each patient's journey. The pictures also provide the parents with insight into their AD/HD child. They serve to reduce *denial* about past expressed feelings, as they are visual *evidence*. Furthermore, art is an activity that helps redirect energy and hyperactivity.

The success of these groups (over verbal only groups) can be attributed to art therapy. Holding on to the learning, however, is difficult for these children. They require a great deal of repetition and reinforcement for learning to stick. The drawings are used for review and reinforcement of each session. Through this verbal and visual repetition, the patient is being over-taught, which enhances their ability to learn. Also, the parents learn the same strategies in their parallel educational group, which helps to reinforce the patient's ability to learn.

AD/HD is not a simple disorder, solved once and for all with some magical medication and one eight-week educational program. Fortunately, the eight-week program has achieved a high level of success in informing the AD/HD population of the chronic and individualized nature of the disorder. Realistically, the eight-week group course is too short and children need much more practice in these skills. However, there is a practical reason for not making it longer. Most AD/HD children are

restless and will try too many things, but then get bored and move on. Their parents, who may also have AD/HD, have difficulty sustaining commitments. An eight-week commitment is manageable. The hope is that both the parents' and the child's experiences are positive and that they will agree to continue in an ongoing art therapy group. The short duration also helps the therapist determine if group therapy is viable for each individual patient and not all patients are invited to continue in an ongoing group.

Patients may choose not to continue in the ongoing group because of economic and insurance-related issues, which impact many AD/HD families. Also, some families have other agendas to deal with and simply are not ready for ongoing therapy. The therapist should also follow up with the children, as well as their parents, who do not continue in group therapy. These patients should be encouraged to return to the therapist/ADDI at any time and for any reason, including conferencing, tutoring, and further individual or group therapy, whether AD/HD-related or not.

Over the years I have learned that parents who are eagerly involved and enthusiastic participants in parental groups, who ask good questions, start using management systems as they are presented, read and learn all they can about the disorder and become solid advocates for their AD/HD child in every venue, most often become parents of the children who benefit most from art therapy. Child and parent education combine to produce better communication. The AD/HD child clearly perceives the parents' full commitment to effective treatment of the disorder. I also believe the entire family experiences positive psychological and physical manifestations of unconditional love from continuous, openly communicative, parental support of the AD/HD child.

The next chapter will provide an in-depth overview of the ongoing art therapy groups. There is a difference between an educational social skills art therapy group and the ongoing art psychotherapy group. Didactic information is part of the former group, while the latter focuses on therapeutic intervention. Consequently, emotional and developmental age is taken into consideration when placing a child in the ongoing groups. For those children that are not yet ready for the ongoing group, individual sessions can be helpful in preparing them for these groups.

5
Ongoing Art Therapy Groups with Children and Adolescents

Introduction

The ongoing art psychotherapy group has a different purpose from the eight-week educational social skills art therapy group. Its focus is on therapeutic intervention while enhancing social skills (Henley 1998). The eight-week group is more didactic – teaching children, adolescents and adults about AD/HD while using art therapy. Consequently, emotional and developmental age is taken into consideration when placing a child in the ongoing groups. For those children who are not yet ready, individual sessions can be helpful in preparation, while reinforcing learning from the educational group.

For children and adolescents with AD/HD, ongoing art therapy groups serve several important functions. Not only do they provide a way of helping the child encounter and correct his or her attention and impulsivity issues, but they also provide the opportunity to socialize and practice the social skills introduced in the eight-week group (Kanfer 1971; Yalom 1995). Since the members get to know one another over time, these ongoing groups come closer to simulating what is going on in the child's school and extracurricular life. The deepening and ongoing relationships that develop in an ongoing group are the basis of the group's therapeutic value. Often members become like family to one another, with all which that implies. Ongoing groups are important to adults for the same reasons.

This chapter looks at children's ongoing groups first and then moves on to consider the different issues that adolescents and college-age patients present to the ongoing group dynamic.

Structuring ongoing groups

It is not unusual for some of the children who have become acquainted with one another in the eight-week group to choose to continue together in an ongoing group. This is often extremely beneficial, as they have had the same initial group experience and begun to develop a relationship with each other. But whether or not they have been in an educational social skills art therapy group together is, in the long run, unimportant. They have all had the same eight-week experience. When the children in an ongoing art therapy group begin to behave in ways that show AD/HD behavior, there is a common basis with which to discuss what is happening, as they are all familiar with the same concepts. If the therapist says, "That's a terrific example of impulsivity," all of the children know exactly what she means.

It can be useful if the ongoing group is either boys or girls only, but a great deal depends on the number of children available and the type of AD/HD each has. Each group is built around a specific age range; ages 5 to 7, 8 to 11, middle school and high school are common.

Each group develops ground rules similar to those in the eight-week social skills groups (discussed in Chapter 4), but the rules are tailored to the requirements of the members of each group. For example, some groups may need specific rules about drawing over someone else's work, while others will need more direction regarding listening and speaking protocols. Groups for younger children, ages 5 to 11, typically meet for one hour a week. Older children, ages 12 and up through high school, can meet once a week for 90 minutes.

The first 10 to 15 minutes of a group session are typically used for snack. Younger children (5 to 7 year olds) will also have a show-and-tell period at this time. This gives them a chance to practice maintaining focus, eye contact and listening skills as their group members share what they've brought in. The younger children can sit on the floor or a mat and work on the floor. Older children, 8 upwards, will want to use chairs and work on

tables or on the wall. Games and toys may be part of the materials for younger groups. All ages use art materials such as 18 x 24 inch white paper, mural paper, cray-pas, markers, paint, collage materials, wood and glue.

Beginning with individual drawings

As in the educational social skills art therapy group, the ongoing groups begin with individual drawings. The therapist gives everyone the same directions for drawing: "Draw a picture introducing yourself to the group." Rather than drawing on one large mural paper, each patient has his or her own individual sheet. Discussion regarding personal space is important and often repeated to reduce problems such as drawing on another's paper. Rules are written, reviewed weekly and displayed in a highly visible space.

The children who have the greatest amount of trouble completing their first individual drawings are those who are highly compulsive or perfectionists by nature and cannot stop drawing or work too slowly. It is important to ensure that the very impulsive child who might draw on another child's paper does not have that opportunity, by providing each child with enough space and their own markers. Since the children do not share space or materials, they can become totally self-engrossed in this experience. Some children are very competitive and want their drawing to be better than everyone else's. They want more "stuff" in their drawing – they hyper-focus and have difficulty stopping. That is important for the therapist to see, because the drawings are a continuation of their diagnosis. One boy in an ongoing group suddenly understood why he had no friends. He was extremely aggressive, to the point of working right through the paper, making holes in it or drawing outside the sheet itself onto the wall (Case and Dalley 1990). He and other group members commented on how he destroyed his picture, which helped him become aware of his aggressive competitive impulses. This trait was not readily apparent in individual meetings with this child, which demonstrates the effectiveness of the group setting as a continuation of the diagnosis.

Direct observation is important. Note where and how the older children hang their paper before beginning to draw. Some hang it verti-

cally; this shows poor planning, as there is usually insufficient room to draw. Sometimes a short child will hang his sheet too high, because he wishes to emulate a taller boy. A child may wait to see where other children hang their drawings before venturing to do it herself; others may place their sheets smack in the middle of the wall, without any awareness of other group members. Some are unable to put pushpins into the wall correctly, suggesting poor fine motor control or muscle weakness. Note whether a child who is frustrated in hanging the paper gives up, or asks for help. Who they choose to stand next to also is important; sometimes they select someone they can easily copy from.

The use of materials, particularly in a group project, is important (e.g., do they grab from each other, or ask before sharing?). So are the colors they use (e.g., sometimes depressed children draw so lightly that it is difficult to decipher their drawings, or use only black or blue colors). I should emphasize here that one might go too far in interpreting things like colors. I heard a story about one boy who only used black, which worried his kindergarten teacher greatly, because black is often associated with depression. She alerted the school psychologist and the boy's parents. When someone finally asked the child why he drew only in black, the boy replied, "It's the only color that's left whenever the basket of crayons gets to me!"

That anecdote underlines the importance – and the limitations – of careful observation. Done well, observations help identify youngsters who have difficulty processing the information they have received, as well as executing directions. Some children have not yet made the decision to be "one handed" (i.e., they are ambidextrous, using both hands as they draw). It is important to note that fact and learn how it impacts their learning process. A few children, especially the very young, demonstrate a developmental delay such as silently and consistently moving their tongue and lips as they draw. Others subvocalize (talk to themselves in an undertone). This strategy can help them stay on task. One can ask whether those who subvocalize are interrupted by or helped by that action and whether they interfere with other children who are more sensitive to noises around them.

In art therapy in general, it is up to the art therapist to interpret what has been drawn and what is being communicated (Levick 1983).

However, with young children – age 7 or younger – it is not helpful to interpret their pictures to them. The children may feel threatened by the transparency of their feelings. However, art with older children and adolescents serves as a bridge to their unconscious and offers them an opportunity to understand themselves more clearly (McNeilly 1990; Thomas and Silk 1990).

When the children arrive at the first ongoing group session, they are asked to introduce themselves to one another through a drawing, just as was done in the educational social skills art therapy group. This drawing, and subsequent verbal comments about it, give each member a visual and auditory image of everyone else and provide a multisensory opportunity to listen to and learn about each other. Drawings also help these children stay focused and hold their attention. The image and words help them to remember information about one another.

The therapist should suggest to the children that they think about the things they would like to know about one another and what they would like others to know about themselves when making this drawing. Depending on their age, the therapist may lead a brief discussion of what is and is not relevant when they are introducing themselves and meeting others (e.g., how to begin an introduction, even how to enter a room in which you know no one). It helps to cover the rules for drawing and reflecting about the drawings, which include: "No unfriendly comments about the quality of artwork or about any individual."

Some of the children become very engrossed in their first drawing. They use it as a vehicle of self-expression because they are not able to be candid when talking about themselves. They may be shy or easily distracted and unable to focus. Drawings can help them organize themselves. As they draw, their relationship is only with the paper in front of them. They are able to be open, honest and revealing because the drawing is impersonal; it does not question, challenge or criticize (Thomson 1998). When sharing their drawings with the group, many children begin to feel more comfortable. All the necessary information is physically there in front of them. The drawing is a script, which gives them a framework, reminders and boundaries.

Peer influences

In an ongoing group one young teenager, Raymond, dwarfed all the other patients and was looked up to during their first session together because of his sheer physical size. When Raymond elected to complete his drawing entirely in black and white, every boy followed suit. Raymond also happened to be an excellent cartoonist. The peer influence as they copied him was striking. As much as each boy's drawing told us about his sports, food, family, hobbies and other interests, the use of only black markers told us more about the deep hunger they had to have friends and be accepted.

Girls will do the same thing. Recall the well-dressed, pre-teenage girl who created a stir in her all-female group when she wrote the word "THE GAP" in large letters and outlined the word in a box in her drawing. The store then appeared in the drawings of several other girls in the group. Their verbal introduction also included mention of their favorite store. This is another example of pre-adolescents reaching out for social contact, attempting to demonstrate their own social acceptability by identifying themselves as similar to a peer they deem to be a leader (Yalom 1995).

It is remarkable that a group of children who know nothing about one another will listen to a therapist who asks them to draw an introductory picture of themselves – and then actually do it. One might expect them to say, "No way, lady! I'm not doing that drawing." But in all these groups over so many years, I have never had one child refuse to draw. Part of the reason may be peer pressure. Another explanation is the positive experience they had in their first eight-week group. They are all going to do it, even when some of them do not really want to.

How the group process tends to unfold

In ongoing groups, as in individual sessions, the children take time to plan what they will draw, to draw what they have planned, and to visit and revisit what they have drawn. In ongoing groups there is the added facet of the children's growing relations with each other as they make art together (Dalley 1993; Waller 1993). Though they begin with individual drawings, they will quickly move into group murals and other group projects.

Every group is different, of course, but the way that ongoing group process operates is pretty predictable. The children or adolescents are encountering each other over time, which means that they can develop a history in which the inevitable AD/HD problems can arise and be corrected. Progress can be made and duly noted, giving everyone a chance to feel a sense of accomplishment. The artwork in the group provides a testament to this as well.

The murals are photographed in order to give each patient his own copy of the picture. We also build on the murals, so that what happened during the previous session is remembered and used to develop the next mural, or the next art activity.

One middle school coed group of eight patients built an intricate castle. They worked on it for months, over many sessions. Subgroups within the group were formed. They put the castle in a mystical environment. Some patients worked on the interior and some on the surrounding environment. At the end of each session, the therapist and group members would discuss the progress that took place. They would pull back and sit around it in a half-circle, look at it and ask: "What's happening? Who is doing what? What else do we need to do? Who has new ideas?" The children generated ideas and then determined who would execute them. If they did not know how to do something, they learned to ask for help. Eventually, even isolated and withdrawn patients were included in the process. The finished product was 4 feet x 4 feet x 3 feet tall with tiled floors and furniture. Knights and dragons were made of clay. A great deal of thought, planning and discussion took place. Following discussion, the therapist took polaroid pictures of the castle and wrote a description of the discussion to record each session. A booklet was made for each group member and distributed when the project was completed.

This group found that when they reached a difficult time or had trouble with a process, they needed to stop, sit back in a circle and reflect about what they were thinking and what they (group members) needed to do, and then resolve to move forward. Circles work because everyone can see everyone else. Everyone can make eye contact and is involved in the group. While that is hard for all children to do – especially those with AD/HD and learning disabilities – it becomes an integral part of learning good social and communications skills (Strand 1991). Problem solving

and conflict resolution skills are part of the group process. The project was exciting and held all their interest. AD/HD patients are often stimulation seekers (Quinn and Stern 1991) and having a fun, interesting project provides the impetus to work on self-improvement (Quinn 1994). In Ellison's article, she states that Guevrenione suggests that group provides an experience for these patients to learn how to enter a group experience, engage in reciprocal conversations and resolve conflicts (Ellison 2000a).

Group murals

Murals are an important tool for the ongoing groups (Harris and Joseph 1973). They are the script that is simultaneously written and acted out. It helps at first to suggest subjects, but with older children and adolescents the group can later be presented with a blank sheet of paper (4 feet by at least 6 feet long) and asked to develop – as a group – an idea or theme for their mural. This takes skills in which AD/HD children and adolescents are often weak such as listening, patience, negotiating, planning, cooperation, organizing, awareness of others, and sharing space and materials. But with practice, discussion and experience, the results can be extremely gratifying.

It is helpful if the therapist interrupts the drawing process occasionally to ask them all to stand back and "look" at the progress. You might ask them to identify who drew what. Self-awareness and awareness of others can be difficult for this population (Barkley 1998). The inability to process and plan often dictates the outcome. If they are unhappy with the completed mural, they discuss why – and that aids in the next mural's outcome.

A readiness and willingness to "look" at their participation can provide insight into their interaction with peers outside the group. The mural remains a concrete example of their difficulties. It is a learning experience that can be imaginative, playful and thought provoking (Ellison 2000a).

Working with children

In a group of seven 9-year-old boys, it was very interesting to watch the children create their first mural. They were given a 4-foot high by 8-foot long piece of white mural paper. The paper was placed on the floor and the children sat around it. Although they were all working on a single piece of paper and had the same theme, essentially they all made their own drawings. Each of the boys outlined heavily around his drawing to prevent anyone from intruding on his space.

Initially, each boy had his own defined space and markers. However, as space and markers ran out, they had to start sharing materials and space. The mural was then moved from the floor to the wall, where they worked together to complete it.

Creating the first mural helped these boys discover their concerns about people revising or impinging on their ideas or space. Discussion followed regarding how that made them feel and how they felt about being forced to share a smaller space. When they looked at the mural and remembered that the group had chosen a single theme, they discovered the drawing was not a mural with its own theme, but rather several pictures with the same theme. By looking carefully at the mural they could say "that's Johnny's," "that's Phil's" or "that's Hal's" because, although they were supposed to be sharing concept, space and materials, each continued to maintain his own space within the mural. This initial drawing led to a discussion of the difference between group cohesiveness and individual drawings.

This first mural was filled with typical male interests like planes, machine guns, tanks, fire engines and helicopters (Golomb 1990; Silver 1996). It was very aggressive: many people got killed. The focus of the mural was a school on fire. A fire engine and several helicopters arrived as the school was being bombed. Many different things were going on simultaneously and it was obvious that the boys were not aware of what another group member was drawing (Quinn 1994). When the drawing process was interrupted and group members were asked to step back and answer "Who did what?", most were unaware of others in the group (a familiar problem with this population).

They were then asked "Why don't you know what other people were doing?" Once aware, they were asked to look at the mural and discuss as a group "What else do you need to add to this mural?" Fires continued emerging in the mural and the members were presented with the problem of how to figure out what they could do with all the fires and explosions. Some of the children became very creative and began thinking about what they could do to put out the fires. This built on the creative problem-solving skills that they had learned in the first eight-week group. They dictated a story for their mural called "The Emergency." It read as follows:

> One time, there was a fire on the school and the house and there were fire engines coming and they sprayed the water at the fire. There was a pond close to the school and the house, so the fire trucks could get to the pond faster to get some water. There was a playground on the other part of our picture that had some people. A police car came to the fire – I wonder why? The ambulance was on the way just in case to help everybody get out safe.

At this early stage in this ongoing group, the boys were not yet comfortable with one another in terms of group dynamics. Their aggressive form of play is quite normal for AD/HD youths and for boys this age. In a real sense, their lives are similar to all the fires in the mural. They have had to find ways or to depend on adults to put out their own "fires." The children enjoyed the process, and spent several sessions completing this mural.

For their second mural, the length of the paper was reduced from 8 feet to 6 feet in length to encourage the boys to work together more closely. Before beginning work, they were encouraged to talk more with each other about the subject of this drawing than they had with their first mural. They were encouraged to plan ahead. They were more willing and inclined to do that after reviewing their work on mural number one. They decided to do a beach scene and also discussed who would draw each part of this mural.

They started by thinking about the following questions: "What will the theme of the mural be?" and "Where are you going to work on the paper on this mural?" and "Who is going to draw what?" A list of what they wanted the mural to contain was written and posted for everyone to see. At first, they reverted to the original spatial concept in which each

child remained stationary in his own space, sitting on the floor around the paper. Very soon, however, they moved the mural to a place on the wall where it could be hung so that each person could come to the mural to complete his part of the drawing. Visually, it is very different to stand back and look at a work that hangs, as opposed to one sitting on the floor. It is also easier to see what each member is contributing to the mural and to plan for your own input.

All the youngsters contributed to the beach and water scene, some drawing things under the water, others on top or alongside. One child wanted to draw a scene showing a favorite sport being played but did not have the drawing skills. He was able to ask for help from another boy. He achieved three results from his new ability to ask for help. First, he completed a drawing, which made him very proud. Second, he learned that it was okay not to be perfect in everything he did. Third, he found that it was a good idea to receive help from someone who had more ability in a particular skill.

Two boys in the group were especially isolated and withdrawn and worked alone most of the time. Because they were both artistic, they began to find leadership roles and a real sense of accomplishment by offering to help other children. The therapist encouraged this. The experience was a win-win for the two boys who had been so isolated, as well as for those whom they helped who previously were unable to ask anyone for help. This was a breakthrough experience in that everyone in the group was able to feel good about not having to be the best, most proficient, most outstanding person in everything they did in order to be accepted or to participate happily in a group of their peers.

The second mural took shape as a more satisfying experience. It was also an experience that helped to develop recognition of strengths, weaknesses and self-advocacy. These young children were less preoccupied with their individual drawing. They were involved in the process of artmaking as a group. Awareness of others' feelings emerged as they shared in this experience. The art process had provided an avenue for growth and self-awareness. The children's art expressions become "a container for feelings…and the expression through art has inherent therapeutic value" (Malchiodi 1998). As with the first mural and murals that followed, stories were dictated and photographs taken to record each

experience. Each child received a booklet with the photos and story; the mural was displayed in the waiting room. In this way, they were able to share this experience with their family.

Case Study: Allen and Dean solve a problem

Allen worked by himself on a corner of the mural and isolated himself from the other boys. Another child worked on the opposite side of the mural. He gradually moved to the corner where Allen was drawing and suddenly drew something on top of a part of Allen's drawing. Allen became very distraught and backed away even further from the group. He had tried to participate in the activity and chosen to draw in an area that appeared safe from encroachment by anyone. Despite his effort and planning, he believed his picture was ruined. He wanted to leave, *now*!

Allen was a very anxious, extremely perfectionist 6-year-old without any capacity to let people know when or why he was upset. He sat still, lips trembling. Allen was driven to make everything he did appear perfect. The picture on which he had worked so hard was destroyed. He saw no way to remedy what had been done. This experience required the entire group to stop and address three problems: "What can we do so that Allen will be okay?" "How do we deal with Dean who drew on Allen's picture?" "How could we fix the problem with the drawing?" They also discussed impulsive behavior, lack of boundaries, poor judgment and personal space.

They could not erase or undo the drawing that covered part of Allen's work. Could the group conceive of a way to convert the unwanted drawing by one child into something that would be compatible with or complementary to Allen's drawing? Could Allen become just a bit more adaptable, a little more flexible?

Dean, the boy who drew over Allen's drawing, became very upset as he recognized how distraught Allen had become by his inconsiderate act. It was the first time Dean became cognizant that he had hurt someone's feelings. You could see it on his face and in his eyes. He could not say, "I didn't mean to do it," "I didn't do it" or "It's his fault." Dean was AD/HD and PDD. He was very aggressive and had enormous difficulty dealing with his impulsivity. He was also a talented and creative young artist.

Artwork was important to Dean. Other children recognized him as being the best artist in the group. Art was the one area in his life in which Dean could shine.

They talked about a variety of potentially acceptable corrective options for quite a while before Dean suggested converting his inappropriate drawing into an octopus, with the part covering Allen's drawing becoming one of its tentacles. Dean's ability to conceive of a solution to a problem he recognized that he had created was a significant achievement for him and the entire group. His usual behavior was to deny complicity with any problem, regardless of all evidence that it was caused by his behavior. It took Allen a long time to deal with that resolution, yet it may have been his first-ever compromise.

This is the beauty of art therapy. No one can say "I didn't do that" because the evidence is literally right there, in black, white and color. It is tangible. In this case, Allen had an actual, real-life situation about which he could talk. And Dean had an experience that publicly demonstrated his inability to contain his impulsivity. They were not talking in generalities. They were able to discuss feelings that preceded the event and those which took place during and after it as well.

Dean was given an opportunity to correct a problem he had caused. He had always been "the problem" and highly defensive; he never was part of the solution or the problem solver. Up to this point, Dean's behavior had been problematic in the group. He had never showed any evidence of heart or compassion, or awareness of others' feelings. The group learned that painful experiences often result from impulsive, inconsiderate behavior; that there is usually a variety of ways to solve problems; that things do not always go exactly as planned; that some degree of flexibility is valuable; and that compromise often makes solutions possible. Those understandings led to a more successful second mural. They can make mistakes, but they can also try to fix them.

Without this mural experience, they would not have experienced a very important episode. Without Dean's overdrawing, they probably would have re-enacted this familiar scenario. Someone picks on Dean; Dean complains that someone always picks on him; Allen feels isolated and unnoticed. The incident gave the therapist an opportunity to revisit

the creative problem-solving technique with blame and shame being part of the process.

The mural was also important because it is the product or outcome of a process through which the therapist gains understanding of these children and through which they can openly and safely express their feelings. It is the process during the activity, rather than the end result itself that becomes so important to the art therapist.

In any case, the purpose was to move them from individual drawings, to being cooperative, to working together, to problem solving and to being cognizant of one another and sharing space. This was done carefully and conscientiously. They could not just come in and play. There was a formal structure to group that was very helpful. They relied on the structure, the rules and the adults who made sure certain rules were followed and that they would still have fun.

Working with adolescents

Several elements draw high school boys and girls to the art therapy group (many very reluctantly, it should be noted). However, therapeutic groups offer an opportunity to be with their peers rather than in individual or family therapy, both of which are toxic to this population (Riley 1999). They share underdeveloped social skills, weak academic backgrounds, impulsivity and poor judgment, which tend to get them in trouble. They are disruptive in school and at home, uninhibited and socially unaware, which causes them to fray the nerves of friends, teachers and relatives.

So we end up with a group of 14 to 18-year-old boys and girls who throughout their lives have been misread and misunderstood. They are highly sensitive, highly defensive and not at all trusting of adults. These teenagers see any form of criticism as a personal attack. They are very reactive – they often use fists first and words only as a last resort (or foul language, sarcasm and hurtful words). It is safer for these patients to jump into the ring and do battle without thinking than to talk, be vulnerable and let others see a thoughtful side of them.

But they are very vulnerable, fragile and at high risk of becoming school failures, truants or dropouts – perhaps to act out sexually, drink, abuse drugs and drive while under the influence. Many are tremendous

stimulation seekers; walking on the edge of life with risks of getting in trouble is exciting for them. The result is constant lying, doing immature things in class, taking dares, stealing and, at times, actual physical self-injury.

Riley (1999) suggests a school-based art therapy group for adolescents. My experience has led me to believe that this has not been successful. Adolescents are reluctant to attend and the amount of time is too limited. Since adolescents can concentrate for a bit longer than children, their groups can meet for 90-minute sessions weekly. Most teenagers stay in the group throughout high school. Many remain in touch, even after leaving for college. These 14 to 18-year-olds come to see the group as an extremely important part of their week. Even when they have exams, they make an effort to attend. For many, the group initially represents their only social interaction of the week. This is a good age for such a group to work. In mid- to late adolescence, youngsters become more amenable to learning how to live in society (Blos 1979). High school is ending and college looms. The question "What's next?" comes to the foreground. Older teenagers in a group are helpful to younger ones. They model the willingness to try what we are discussing, to enhance themselves.

Each session builds upon the previous one. They continue to create visual imagery and reference it in discussion – for example, "Remember when you drew yourself as a clown? Why are you acting like a clown now? Do you think you may be distracting others in the group? How do you think they are feeling about you right now?" This type of questioning, revolving around drawings and behavior, helps connect the experience in a reality-based confrontation.

One of the issues that often arises in adolescent groups is the resistance to taking medicine (Ellinson 2000b). This has roots in a larger issue – their desire not to see themselves, or be seen by others, as "different." Teenagers are individuating, working toward becoming their own person (Blos 1962). But because of AD/HD, many still depend on their families to provide structure and organization. Even something as simple as a reminder to take medication can provoke a bitter battle (Ohan and Johnston 1999). So, of course, can issues such as getting up on time, heading out to school or preparing for exams. Most adolescents can do these things and manage their social and academic lives; for the AD/HD

population, however, it is extremely difficult (Nadeau 1994). Many, especially those who are previously undiagnosed or who have other psychiatric or learning inefficiencies, have become work avoidant. Their forgetfulness or procrastination impinges on their academic performance (Quinn 1994).

At this age, the group is a much more important part of the therapeutic process than individual therapy. Peer interaction is crucial to them and art therapy, particularly work on murals, forms the foundation for that interaction. They use art therapy as a route to self-awareness and awareness of others (Abraham 1991).

Once, for example, a boy participating in a group mural decided to barricade his part of the marooned island they all were drawing. Samuel drew his own hut and his own food and surrounded his section with barbed wire fencing; there was no way anyone could get into his area. He was a good artist and had been in the group a long time, but socially he remained very isolated. As the rest of the group worked together on the island drawing, Samuel was completely oblivious to what he or they were doing. When they stood back and examined the mural, one boy said, "No wonder you don't have any friends. No one can get close to you!" For the first time in his life, Samuel actually "saw" how isolated he was.

Murals provide the stage for this kind of interaction to be played out. Ongoing group work – the fact that relationships and trust are given time to develop – provides the atmosphere that makes it possible for feelings to be shared and group integration to take place (Harris and Joseph 1973).

The deserted island mural is a good early topic for this age group. The idea that "no man is an island" is demonstrated pictorially when the group is asked to imagine themselves on a deserted island. As a group, they are asked to think about and discuss with one another these questions: What does the island look like? What will they need to survive? Such a relatively simple task as predetermining who will draw what and where takes planning and organization skills which many of these boys and girls lack. One can imagine, given their AD/HD and impulsivity, the difficulty they have in discussing before drawing, as well as taking turns and sharing materials and space.

Ongoing group work and the feedback from peers that it provides are especially important for adolescents as they prepare to move out of their

parents' homes and into a world of peers. As they get older there is less of a safety net. On their own as nearly adults where their peers are their whole social world, they need to manage their own behavior and cope constructively with the feedback others provide (Ellison 2000b; Riley 1999).

Members of different adolescent art therapy groups continue to meet and stay in touch with me after they have headed off to college. They said that group had been the single most helpful ingredient in learning how to become self-advocates, independent and successful in school and then later in their careers. They still refer back to individual and group drawings as reference to the group's history and how it helped each of them. They relate that the strong visual images serve as reminders of their difficult times and help reinforce strategies that they learned while partici- pating in an art therapy group. As college students, they face the challenge of independence and call upon the skills learned in their art therapy group: the ability to plan and organize; to use time efficiently; to seek help and self-advocate. There are all-important, necessary strategies for success (Wallace, Winsler and Nesmith 1999). They use daily coaching to maintain their academic and social goals (Nadeau 1994; Quinn 1994; Quinn, Ratey and Maitland 2000).

Using videotape – another useful medium

One day Jason rode his bike to group. He arrived late and burst in while group members were talking and preparing to draw. Still wearing his helmet, goggles and biking clothes, he began interrupting everyone – though completely unaware of either the disruption he was causing or how he looked. Every member was ready to "kill" him. Instead, they talked about how they could help Jason appreciate the impact of what he did. That's when we came up with the idea of videotaping the group. Because they did not want "outsiders" in the group, they decided to set up a wide-angle camera on a tripod. Time was left at the end of each group to review and discuss parts of the video. In the beginning there was a great deal of self-consciousness, but after a few sessions the boys forgot the camera was on. That was when they began to see – truly *see* – exactly how their actions impacted others. This is another version of "Stop and Think"

adding "Look and Listen." AD/HD adolescents require information to be delivered in short spurts. It needs to hold their attention and interest. Using visual and auditory input helps and adding grapho-motor (artwork) enhances the learning process.

Case Study: Bill

When Bill first came for treatment, he was experiencing a great deal of difficulty at home and in school. His home life was terrible. He made no connections to other people inside or outside his family. His behavior was explosive and disruptive. He attended a parochial school and had a history of school failure. His nursery school had asked his parents to remove him when he was 3 years old. As a young child, Bill exhibited no deductive reasoning ability, was impulsive and seemingly fearless. He also had a high threshold for pain.

Bill had been involved in a series of extremely impulsive school playground episodes, including strangling another child during an outburst. His teachers were angry with him and punished him. His parents were frustrated with him and punished him. His sister hated him and blamed him for ruining the entire family's life. His grandparents were confused and did not understand him. His pediatrician told his parents to spank him harder. Everyone thought there was something behaviorally wrong with him.

Work with Bill proceeded on a number of fronts. He attended a special camp for children with learning, attention and/or behavioral problems; his parents moved him to a school system more geared to individualized learning programs and he entered individual therapy. But it was during his tenure in ongoing group therapy that Bill began to put into practice the lessons and strategies from these other sources.

From the beginning, art therapy had made a difference for Bill. When Bill "talked," we heard only a series of monosyllabic mumblings. During early art therapy individual sessions, it was unrealistic to encourage him to elaborate verbally about his drawings or anything else for that matter. However, through art therapy Bill was able to express his feelings. His drawings said "This is how I feel." As he learned about his AD/HD disorder, he was able to say through his art, "This is what it's like for me to

isolation (Brooks 1994). They are often over-enthusiastic, interrupt, exaggerate, invade personal space or boundaries, and are extremely talkative, highly defensive and self-involved. It's not unusual for them to be forgetful and not follow through – both ingredients required to sustain a friendship. They miss or misunderstand social cues and frequently hurt other children's feelings (DuPaul and Stoner 1994). The idea that they could actually tell someone that his or her behavior or comments hurt or upset them was met with disbelief at first. But as they worked together on art projects, the youngsters found ample opportunities to experience just such an "unbelievable" situation.

It is often through their work on murals that group members make important discoveries about their right to communicate their feelings, especially when the actions of others directly affected them or the cooperative group activity. They also learn how doing this – explaining their feelings – can help the situation. Murals, often used in the group work, are a wonderful vehicle for this and were an art therapy modality which proved to be enormously helpful to Bill and the other members of his group. The group's murals became more and more elaborate as the group became more cohesive.

During the year that Bill's group met, I began to formalize my thoughts about coaching individual clients, including Bill. It was difficult for him to remember to "Stop and Think" before responding to his frequent and overwhelming impulsivity. Generally, after one "reminder" (silent signal that had been prearranged and agreed upon between Bill and me) during the early moments of each group session, Bill was able to sustain focus for at least the next 20 minutes. However, his impulsive behavior was disruptive to the entire group and to its progress. It became necessary to speak with him prior to the session in order to avoid the weekly disruption during the opening minutes of the session.

Bill's mother was asked to bring him to the office 15 minutes before the group met. During that time we talked about impulsivity and reviewed the personal signal or clue from me that said emphatically, "Stop whatever you are doing now!" It worked. Bill needed transition time to orient himself to the group environment and a pre-group reminder from me to "Stop and Think." Before long, I discovered that an additional five or seven minutes after group helped him also, because during that time we

were able to reinforce how positive and exemplary his behavior had been during group. Being complimented for good behavior was a new and wonderfully positive experience for Bill.

After the success with Bill, coaching has been added as an integral component of these groups. It provides the patients with an opportunity to preview and review the rules and behavioral goals established for them to have a successful experience. Having the parents coach the child or pre-adolescent before and after the group session has also proved helpful. These gentle reminders are necessary as AD/HD patients are activity oriented, often "in the moment." Coaching is an extremely effective preventative technique for predictable behavior (Quinn *et al.* 2000).

Art, videotaping and coaching are all integral components of ongoing art therapy groups. For high school patients, preparing for college is the next challenge. As one high school patient said, in observing other AD/HD group members, "If this is how I am acting I need to learn strategies on how to change!" The group experience offers these students opportunities to discuss and draw their concerns about completing high school successfully and for most worrying about how they will manage independent life at college. Most share (when asked to draw "What worries you about life after high school?") that they feel unprepared. Many worry about managing daily living, including remembering to take their medication, oversleeping, missing classes, roommates and maintaining a clean work space (for most impossible). Other drawings depict concerns about lack of organization, losing books, and mostly being distracted by campus life. Social life is also a big concern, as well as being exposed to alcohol and illegal substances. Their awareness of being high-risk students may lead them to identifying themselves at school and seeking help. The ways to accomplish this are discussed in the context of these groups. Solutions are drawn, giving them both verbal and visual images to rely upon when away.

Bill's drawing "Medicine" (Figure 4.6) came several years following his group experience. Both maturity and the realization of the help that medication provided him to focus occurred prior to attending college. In Bill's bridge drawing, his recognition of the skills he needs to be successful are illustrated (Figure 5.5, "Bridge to Success"). He brought with him time management, organization, concentration and strategies on how to

keep his friends. He left behind his disorganization, temper and activity level.

Figure 5.5 Bridge to success

These patients are often socially, emotionally and academically immature. For many, facing being independent can be frightening. Often they recognize the Herculean efforts that parents, teachers and therapists have provided in their success. One of Bill's last drawings in therapy illustrated this (Figure 5.6). Through this picture, Bill attributes his energy and the importance of not only sports but also art therapy to his academic success. In his final drawing (Figure 5.7), Bill depicts the changes that have occurred within his family since he entered therapy. There is no longer a "Big Storm."

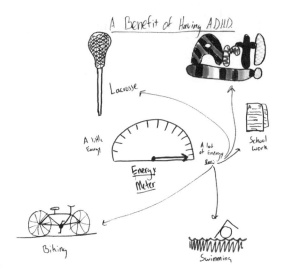

Figure 5.6 A benefit of having ADHD

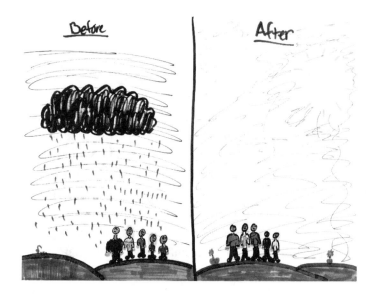

Figure 5.7 Before/After

Art therapy provides visual imagery and grapho-motor experiences, that enhance learning. Ongoing experience in an art therapy group allows for and reinforces change. AD/HD is a chronic problem requiring frequent and repetitive input. Artmaking is fun and interesting. The art therapy group experience provides a constant visual history, while allowing for practice of skills necessary for success with peers, family and in school. This is an excellent vehicle for learning for this population.

6
Adult AD/HD Art Therapy Sessions

Introduction

Many adults also have AD/HD, although they might not have been diagnosed. They bring their children in for evaluations and treatment, unaware that they too have the disorder. As they learn about their child's disorder, these adults begin to recognize the similarities between their lifelong behavior and that of their child. It is often at this point that they ask for their own evaluation (Hallowell and Ratey 1994; Murphy and LeVert 1995; Weiss 1999).

Once an adult has been diagnosed, treatment proceeds much as it does with children – through the use of group therapy, as opposed to solely relying on individual psychotherapy. AD/HD adults need many of the same strategies and "tricks" that have been discussed in relation to children to be successful: for example, learning how to keep lists, to break tasks down into more manageable steps are helpful for any age group. Many of these adult AD/HD patients have lived since childhood believing that they were not as capable, smart, well liked or acceptable as their non-AD/HD siblings or peers. Most have experienced frequent bouts of depression, during which they suffer from feelings of low self-esteem and self-worth. They often feel guilty, demoralized and blame themselves for the situation in which they find themselves (Ratey 1991). Many have become dependent on substances such as caffeine, alcohol or drugs. They may be constantly embroiled in conflict with others or use sex to gain occasional feelings of acceptance and calm in a storm of chaos (Ratey and Miller 1992; Weiss, Hechtman and Weiss 1999).

Art therapy provides adults as well as children with a useful modality to explore feelings that are now deeply entrenched. The adult AD/HD patient has lived in fear since childhood – lived in fear that his or her incompetence would be unveiled or in fear of discovery, failure or success (the latter fear stems from the belief that success cannot last and is merely a fluke). Depression is frequently a component of adult AD/HD. As with children, art offers the adult a way to express these intense feelings nonverbally and without intellectualizing them. Art therapy provides the vehicle to carry both thoughts and feelings from unconscious to conscious awareness.

Some of these AD/HD adults were diagnosed as hyperactive when they were children, but told they would "outgrow" the disorder. Therefore, they believed that whatever has taken place in their adolescent or adult life had nothing to do with AD/HD – but they still experienced the same problems, plus the distress of wondering why the problems persisted.

Just as AD/HD children frequently have trouble in school, AD/HD adults may have trouble with work (Nadeau 1996). Symptoms often include moving from job to job or doing at work what they do at home: starting but seldom finishing assignments; going from significant, initial enthusiasm for a project to becoming bored and unresponsive; growing irritable and defensive; exhibiting bad temper; and seldom expressing happiness or pleasure. Because of this, many AD/HD patients do not fit into large corporations. Instead they work in entrepreneurial ventures or are self-employed (Nadeau 1997). Being self-employed can be fulfilling and exciting, but without someone to help keep the AD/HD adult focused and on task, it can also lead to continual failure.

Many AD/HD adults have marital difficulties. Some of these patients were initially attracted to a spouse with attributes they do not possess, but then eventually resent their partner for those same attributes. In Figure 6.1 the non-AD/HD spouse, who is highly organized, attempted to help his wife de-clutter her office. This type of moving in as an attempt to help can often prove disastrous and set off a multitude of bad feelings.

The day I cleaned Adelaides desk from her horizontal organization she acted as if she was on a pogo stick with ANGER

Figure 6.1 The day I cleaned my ADD wife's desk from her horizontal organization, she acted as if she was on a pogo stick with anger

The marriage can be like a roller coaster (Claussen 1998). In turn, some spouses feel their relationship has become one in which they are parenting another child. Despite their feelings of frustration, most AD/HD adults still have an attraction to their non-AD/HD spouse, who can help them to "shape up" and keep them going forward. However, the non-AD/HD spouse often develops an increasing sense of dissatisfaction with the relationship and becomes depressed, feeling trapped in a relationship that seems to be going nowhere, feeling burned out and assuming full responsibility for raising the children (Capel and Brown 1997). Consequently, the non-AD/HD spouse may find pleasure or fulfillment outside the relationship in community activity, career, children or even substance abuse or extramarital affairs.

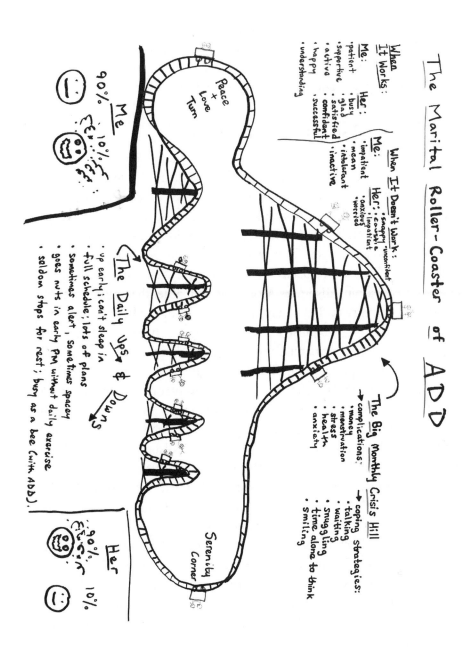

Figure 6.2 The marital roller coaster of ADD

Figure 6.2 is a dramatic picture of the ups and downs, turns and curves of a matrital relationship that includes an AD/HD spouse and a husband without the disorder. The chaotic lifestyle became too much for the non-AD/HD spouse and the marriage ended in a divorce.

Diagnosis and structuring treatment

As mentioned earlier, AD/HD adults often feel vulnerable and believe in their own incompetence. They may suffer from clinical depression. For these reasons, it is important to begin the process of helping patients by giving a thorough, differential diagnosis. This formal diagnosis serves to help the person understand that they are exhibiting the symptoms of a disorder which exists apart from them – an excellent first step to helping them gain a better perspective on their own behavior. Many have undiagnosed learning disorders. Most have seen other therapists, psychologists or psychiatrists. They may have been medicated for depression, anxiety or obsessive-compulsive disorder. They may have been diagnosed as passive-aggressive, or narcissistic personality disorder. Yet with all this help, most have experienced no lasting or significant change in their life. The diagnosis as AD/HD often seems to take away some of the mystery of what these adults have experienced throughout their entire life. The result can be a profound, psychological change. They become less defensive and more open to learning about themselves and their disorder (Hallowell and Ratey 1994; Murphy and LeVert 1995; Wender 1995).

In order to make the differential diagnosis, the therapist should invite prospective AD/HD patients to bring in their spouse or significant other (if they have one) to discuss the disorder as well. The therapist reviews the AD/HD patient's childhood years, looking back at time spent with siblings and other family members, encouraging them to talk at length about their social and academic history in school, their career history, about substance or alcohol abuse and sleep disorders. Other psychiatric and health concerns are also discussed (see Chapter 2 for more on diagnoses).

With the diagnosis in place, the therapist creates a treatment plan that may include medication. However, medication is only a small part of what

will help. Many AD/HD adults want a "quick fix" and it is often difficult to convince them that medication for AD/HD is not a cure-all. Because AD/HD adults are impulsive, many cannot sustain attention long enough to work on a treatment plan designed to meet their specific needs. People of all age groups with AD/HD are easily distracted, with a history of jumping from one idea or project to another. The therapist should explain the fact that the characteristics of the disorder often interfere with or work in conflict with their treatment plan. This means explaining that their impatience will give them away. As soon as something – such as treatment – does not work immediately, AD/HD people view themselves as having failed again. The patients need to know that this is not a personal failure; rather, it is part of their disorder. With AD/HD, there simply is no quick fix.

Some adults grow impatient, quickly abandoning either their medication or educational therapy, or both. Some eventually return to treatment, determined to resume working to make the changes they know are necessary. Others leave, only to revert back to a life with which they are familiar. However, it may be one in which they remain unhappy, unfulfilled and unsuccessful. All AD/HD patients, whether 7 years old or a senior citizen, should be educated to understand the characteristics of their disorder, which may prevent them from giving up on treatment so easily. Also important, their families must understand the disorder so that they can stop being angry with the AD/HD person over things that are difficult for anyone with this disorder to manage.

For many AD/HD adults, it is important that their bosses and co-workers understand the disorder as well. Colleagues will not become angry if an AD/HD person misplaces something or is assigned the most competent secretary in the office. For example, one AD/HD executive was incredibly demanding – he did everything at a very fast pace. However, his constant motion and impulsive demands were grating on his employees and peers. After explaining to his co-workers about his AD/HD, his workplace grew more tolerant of his behavior (e.g., the fact that he needed to get up and move around during board meetings). In fact, his company responded by giving him three secretaries, just to make sure that everything he needed was carried through in a timely, peaceful and organized manner.

Another man could not do small talk; as soon as he met someone, he needed to start right in with the business at hand. As he learned more about his AD/HD and was able to explain it to others, his partners and colleagues understood that he was not a nasty, impatient or demanding person as they previously thought, but rather someone struggling daily to manage his disorder. At the same time, he learned that the whole world was not against him as he thought; rather that he lacked the social skills which others expected of a man in his position.

There are three distinct steps in the process: diagnosis, treatment and education. However, these steps can take place simultaneously and continuously. During the early stages of diagnosis, a good deal of basic AD/HD education takes place through the discussion process and often also through the client's own urgent desire to read and learn as much as possible about the disorder. Once the initial diagnosis is completed and a treatment plan initiated, education continues. As the treatment plan is actualized and the patient's progress is monitored, the therapist should make appropriate adjustments in the patient's medication or education.

A five-week educational art therapy group is offered to newly diagnosed adults. In addition to the therapist, a physician – who can discuss the various types of medication, how they are prescribed and what they can and cannot do – should also lead the group. Art therapy is used in the groups to help patients express feelings regarding their diagnosis and life experiences with AD/HD. Strategies are taught to help with organization, managing time, setting realistic expectations and prioritizing. Strategies are also offered to help those with poor memories or forgetfulness. Finally, didactic information is offered on the diagnosis and impact on families and careers.

The first session should begin with a review of AD/HD so that each group member fully understands his or her diagnosis. Once this has been finished, group members are asked to draw: *"How has AD/HD impacted your life?"*

One adult drew how he experienced his life – expressing that he often felt confused, disoriented and forgetful (Figure 6.3).

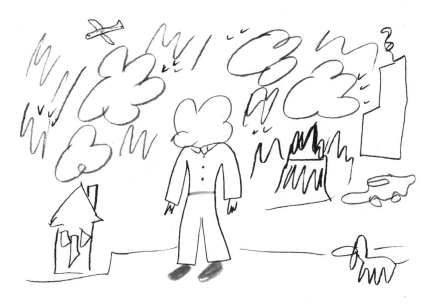

Figure 6.3 Head in the clouds

Figure 6.4 Caught in the middle

Another adult drew himself caught between two oncoming trains (Figure 6.4) He stated that he either felt incompetent or intelligent, but rarely trusted himself to make correct decisions in most situations. He's stuck on the track and feels chronically helpless. Other adults have made drawings depicting themselves as: "a Swiss cheese head, "unable to hold on to information; a clock with its arms going in many directions unable to manage time; as living in a state of chaos and disorganization; and always disappointing their spouse and enduring a constant state of familial conflict.

Within these five weeks, other drawings asked of the members are:

- "How does AD/HD impact your relationships?"

- "What is the impact of AD/HD on your career and/or home management?"

- "What are the features of your AD/HD that prevent you from being successful?"

For many, the inability to manage home, career, finances, children and friendships proves impossible and overwhelming. These problems are frequently drawn during the sessions. Lastly, group members are asked to:

- "Draw what strategies you have learned and will use to help manage your AD/HD."

Coaching, a strategy developed by John and Nancy Ratey, is another effective tool in the treatment plan for adults with AD/HD. It is an important strategy that is introduced during these five weeks. The concept revolves around using a coach (professional advisor) on a daily basis to aid in establishing appropriate expectations and achieving such goals as learning how to organize and manage a daily to-do list. The AD/HD adult contracts with their coach to have daily telephone contact and to use this time to focus on mutually established goals. Coaching extends a great deal beyond the evaluation, diagnosis and therapy provided to the patients. For example, setting appropriate personal or family goals is a project that benefits all families. The process may provide an AD/HD person's partner with the opportunity to coach them so that the AD/HD adult can avoid disappointment and anger within the family caused by broken promises, impossible goals or inappropriate remarks. Unrealistic family expectations are seldom realized. They not only enhance the

feeling of poor self-worth of the AD/HD family member, but also promote disappointment and disbelief by other family members. How many broken promises of activities, vacations or other fun experiences does it take to condition the family to either the insincerity or, even worse, to the dishonesty of the promising adult? Often an AD/HD adult patient will hire a professional coach who will help them set realistic goals and maintain them. These coaches establish contracts and help their clients to adhere to them. This may be done through daily contact by telephone, fax or e-mail (Peterson and Ratey 1995).

It is essential to recognize that each intervention needs time to be integrated. Changes in lifelong behavior patterns based on new information or interventions simply do not happen quickly. A concern with working with adult AD/HD patients is their impatience over the process of treating the disorder (i.e., their pursuit of a "magical cure"). A good analogy is diabetes, which is also a lifelong disorder. A diabetic must learn about the disease, alter his lifestyle, monitor blood sugar, take medication precisely on time and have frequent medical checkups. Like dealing with AD/HD, this is a process. The diabetic struggles with many of the same issues – no one wants or easily accepts the reality of diabetes. No one wants AD/HD either, but like diabetics, AD/HD patients must take responsibility for their own continuing treatment.

Ongoing adult art therapy groups

Once an adult has completed the five-week educational art therapy group, they may continue in an ongoing group. A good example is a group that was set up for AD/HD men, many of whom also have children with the disorder. Their work in the art therapy group focused primarily on understanding themselves as adult men, employers, employees, husbands and fathers. It took considerable time to get past a non-feeling, linear-thinking, problem-solving stage with this group and there were several reasons for this. One is the common male issue of being unfamiliar with group therapy, which necessitates trusting other people while being vulnerable about one's feelings. In addition, the life experience of these AD/HD men proved them to be very sensitive regarding their feelings, despite their maintaining a facade of "not caring." They have spent their

entire lives squashing their feelings down. Ultimately, however, partici-
pating in group therapy and learning about each other's life experiences
created a platform for these men to build upon and this group was able to
make considerable progress.

Art therapy is used in the ongoing group. When asked to draw "How
does AD/HD continue to impact your life?", the visual response from an
adult AD/HD group is similar to opening Pandora's box. Themes of
managing relationships, time, careers or even taking medication quickly
emerge. Lack of control of one's life is frequently depicted, as feelings of
constant bombardment both internally and externally are expressed.
Another common theme is being pulled in all directions and not being
able to prioritize, but instead attempting to concentrate full energy on
everything – equally. Unfinished projects, piles of papers and lack of close,
intimate friends have all been drawn as further illustrations of life's frustra-
tions and evidence of failure. These drawings – powerful expressions of
unspoken pain – lead quickly to empathic and sympathetic responses.
Many adults express feelings of relief at finally, after so many years, being
understood. Art therapy is used throughout the group sessions, helping to
reveal underlying feelings covered by layers of protection. Discussion and
insight follow; a visual group reference has been established.

AD/HD patients often do not generalize what they learn, but need
consistent repetition. Unfortunately, schools and workplaces do not
always have patience for repetition. AD/HD patients frequently hear
comments from bosses, parents or teachers such as "How many times do I
have to tell you?" Both AD/HD and non-AD/HD people are frustrated
over typical disorder-related behavior, which often leads to depression
because the AD/HD person is so hard on himself. Everyone becomes
frustrated because even though solutions seem to be in place, the AD/HD
person still makes mistakes. But once they appreciate the nature of the
disorder, they learn to expect this and to understand that AD/HD is a
chronic part of life (Nadeau 1997; Sudderth and Kandel 1997).

For example, a father of two young children, who worked at home,
needed help organizing his day. He quickly developed a computer
program for himself that detailed his day in 15-minute segments and then
carried his laptop everywhere. Soon he had created more chaos in his life
than he had before. He was so afraid of making mistakes that he overdid

everything. In group therapy, he learned to slow down and set appropriate and realistic goals to simplify his life, so he would not have to carry his laptop everywhere. He also learned to use a handheld organizer and Post-It™ notes. He had to learn to trust this system and use it repeatedly to reinforce it. He also employed a personal coach to help with the task.

Ongoing women art therapy groups

Another example of an adult group is art therapy women's groups that include women who have AD/HD, women whose children have it and women who are married to or living with AD/HD partners. Women and girls with AD/HD are frequently misdiagnosed and misunderstood. They are often not diagnosed until adulthood (Quinn 1997). One reason for this is that so often women exhibit better social adaptation than their male counterparts. Quinn has indicated that in recent research hormonal influence, notably with estrogen, plays a part in increasing AD/HD symptoms at puberty, pregnancy and menopause. She reported that changes in estrogen levels impact distractibility, memory, organization and the ability to focus. They also impact moods, exacerbating existent AD/HD symptoms and making school an educational nightmare for young women. Further, the organizational needs of womanhood – including career, marriage and child rearing – create a series of monumental tasks. Because social expectations of women differ from those of men, women and men often face slightly different challenges in dealing with their AD/HD (Nadeau, Littman and Quinn 1999; Nadeau and Quinn 2002; Quinn 1997).

Most of the women in these groups were feeling unsuccessful in their interpersonal relationships with men, at their jobs and failures as mothers. As a result, they were unhappy with themselves and their lives in general. The demands for many of being a full-time worker, home manager, mother and partner were overwhelming. Many also had children with AD/HD with the same symptoms and were unable to manage them. Most of these women had spent years seeing other professionals. They had been diagnosed as depressed, which only added to their feelings of inadequacy. They tended to have feelings of shame and self-blame. Some used illegal substances as a way to cope with their frenetic lives.

Women with AD/HD are more susceptible to depression and suicide ideation, anxiety and panic disorders, drug and alcohol abuse, learning disabilities, eating disorders, teenage pregnancies, cognitive impairment, lower IQ scores and intimacy problems (Quinn 1997; Solden 1995). In the case of the women in these groups, the underlying reason for so much of their unhappiness was that they or their family members were not yet diagnosed as AD/HD and so were untreated. As a result, these women – and so many other adults with AD/HD – were being asked by their partners and children to do things they could not do. For example, many of these women could not follow schedules, or maintain a household, yet when their husbands came home at night and found the house in disarray, they would be angry. Their previous therapists had all been well-meaning, but did not understand the neurobiological reasons behind their patients' disorganization and frustration, or the impact of AD/HD on their marriages, families and/or careers.

As the women went to therapist after therapist, their feelings of inadequacy were reinforced. "I *should* be able to do these things," they said to themselves, not realizing that the roots of their difficulties lay deep in childhood, when the messages they received from parents and teachers were that they were lazy, dumb or slow (Kelly and Ramundo 1993). These women also suffered from "repetition compulsion." They were mired in relationships with men who continued those same criticisms and voiced the same high expectations that the women had heard all their lives.

Like most adults, once they were diagnosed with AD/HD they experienced a range of feelings: a relief of finally being understood; sadness and perhaps anger at years of being misunderstood; understanding that they were not incompetent and hope for the future – for them and their family members. Placing all of these women together into a group was extremely beneficial because the environment was supportive and accepting. It allowed them to feel part of a "new family" that transcended the boundaries of their nuclear family. One woman wrote on her drawing, called "Fresh Start": "I see that this group of women can help each other deal on an honest level with each other's problems and help with input to get through their pain and crisis." The idea of a group that used art therapy was novel and unfamiliar to them, but they saw it as a new opportunity for

self-actualization and self-realization. This is a similar experience that the men have expressed in their groups.

The same concept of educating children, adolescents and parents about AD/HD holds true for women's groups. Initially the following concerns are addressed:

1. Educate newly diagnosed women regarding specifics of the disorder.

2. Emphasize to group members some good things about AD/HD.

3. Encourage them to speak freely with their family members about their AD/HD.

4. Teach them the ABCs of home management and parenting skills.

5. Teach and demonstrate problem-solving techniques.

6. Teach them skills that put them in charge of their lives and their children.

A more spontaneous art therapy plan

Unlike many of the groups discussed previously in this book, such as the educational and social skills art therapy group for AD/HD children, the women's art evolved directly out of the group's discussions and there was little pre-planning regarding art themes. The group is designed to be small, with weekly 90-minute meetings. Each member is asked to make a minimum ten-week commitment. The goal of the women's group was to help them understand how AD/HD has impacted their lives and made them vulnerable to self-destructive and demoralizing behaviors. A second goal is to learn strategies and put them in place to reduce internal and external tension. A third, and perhaps most important goal, is to provide a non-judgmental and accepting community to foster understanding and change. The group succeeds only if each woman is allowed to feel comfortable, which is in contrast to the rest of their lives where they have felt constantly judged and/or criticized. In a drawing one woman drew colorful gift boxes and labeled each one differently. They were labeled

"Peace," "Understanding," "Kindness" and "Hope." She called this drawing "Gifts From the Women's Group."

Some of the topics that the women in past groups have suggested to be discussed within the group were:

- How to learn to forgive yourself
- How to set appropriate expectations of yourself and other family members
- How to deal with mid-life issues
- How to learn to be patient
- How to learn better parenting techniques
- How to learn to be more flexible, less obsessed
- How to deal with stress, conflict and intimacy
- How to deal with issues revolving around medication
- How to help your family cope with AD/HD
- How to not feel like a victim
- How to develop friendships
- How to deal with procrastination, disorganization, clutter and managing time.

Most of the group's artwork was done on 18 x 24 inch paper, using markers or cray-pas. Drawings include topics such as "What did you imagine your relationships would be like?" These are very powerful – many pretty homes with white picket fences and lots of romantic hearts and flowers. Some women draw their spouse as their best friend, someone who listens to them and shares common interests. The follow-up drawing is to move from expectations to "What is your relationship actually like?" The drawings change dramatically, showing heartbreak, disillusionment and feelings of frustration, misunderstanding and unimportance. This opens up discussion, allowing the group to talk about appropriate and inappropriate expectations. When they are asked to draw their hopes and what they need to do to turn their lives around, many women get an "aha!" feeling. They begin to understand that they are not rotten wives, mothers

or housekeepers, but rather someone who is simply struggling because they or their children have AD/HD. They also realize that for their entire lives they have been misunderstood. This comes as a relief, but carries some baggage as well, which is depicted in their drawings as anger at their parents, doctors, spouses and others who for so many years misdiagnosed them or pinned the wrong labels on them.

The group talks a great deal about societal expectations of women. They also talk about what it is like for their child to be embarrassed because his or her mom is chronically late. They draw things such as time and forgetfulness that get in the way of being the type of wife, mother or worker they expected to be. Drawings often express their struggles with their adolescent AD/HD daughters and their extreme feelings emerge as they struggle for equilibrium.

Artwork is very important to the group, especially as familiar images, symbols or ideas begin to repeat themselves over and over (Levine 1989). For example, one woman drew an impenetrable wall; her side was barren land, while on the other was a beautiful garden. Looking at such a drawing – which represented her view of her world and what she perceived to be everyone else's – had a much more powerful impact than simply talking about it. Many group members identified with this particular drawing. After they look at artwork and talk about familiar feelings, they begin to understand that they have options such as meditating, walking, exercising, coaching or "digging a tunnel under that wall!" Then, as a group, they worked together to implement those solutions.

One women's group also made several murals, which is a powerful way of increasing a group's identity. For example, a woman once proclaimed herself ready to leave the group, to try what she had learned on her own. This led the group to work on a mural, where each member would draw what she wanted to "give" this woman to take as she journeyed forward. The group decided to trace all their hands – touching together in a circle. Inside each hand they wrote words of encouragement or concern for the woman who was leaving the group. "I'm worried about your relationship with your father," one woman wrote. "What a show of bravery it was to hear you share your history of sexual abuse with us," another said. "Please don't seal it away again." This very emotional group experience – the powerful feeling of sisterhood – was something which

the woman had never experienced. Every member wrote something genuine and warm; the colors were loving and calm.

The group experience is especially helpful to women going through divorce, or dealing with a partner's infidelity, as their drawings provide a means for self-expression. Art therapy sessions are useful to help in discussing the tensions while offering a different option for communication. Many women have been taught to avoid conflict at any cost – repressing their feelings to the point where they can no longer identify them, or becoming over-reactive to certain situations such as a child's moodiness, insolence or irresponsibility. Teaching the members to explore those feelings which they have denied is an important part of the group. The use of art to express repressed feelings aids in revealing unspoken thoughts. This implies that such thoughts are somehow socially taboo, like thoughts of wishing that their child had never been born. In the safety of the group, feelings of anger, frustration, grief and sadness can be more easily expressed through art and then put into words. The women in these groups are able to identify with each other through their shared visual experience.

Adult strategies

Adult groups like this women's group offer opportunities to practice new strategies. As mentioned above, coaching is encouraged among group members. For example, clutter is a universal problem for AD/HD adults and the group offered many different ways to deal with clutter – they checked up on one another by e-mail or telephone. They became each other's coaches, which proved to be more successful than their spouses or other family members coaching them.

Adult therapy is more didactic. The therapist can share new information about AD/HD, medication and articles on the topic of AD/HD and women with group members. In the group referred to above, it was recommended that members read *Women with Attention Deficit Disorder* by Sari Solden (1995). The therapist led a discussion following the reading. Most members of this group could relate to the chronic nature of AD/HD, which led many to express this in drawings involving their daily frustrations in getting through their day. They recounted their chronic difficul-

ties with schedules, organizing, managing time, and being consistent about family needs such as helping with homework and ritualizing bedtime. Even remembering their children's medication as well as their own can be easily forgotten. Being able to prioritize and staying calm in a potentially chaotic family environment is difficult to achieve. Because mothers are often the primary caregivers in families, even when both parents work outside the home, they are the key to their children getting the help they need. Often when a mother finds she has AD/HD, guilt is a primary source of her sense of frustration and failure at not providing a successful environment for her child. Worst of all, they don't know how to change, as non-AD/HD behavior is not natural to them. The group becomes the most successful source of help in learning new strategies for change.

Finally, the group is fun for the women. When one group member remarried, her group threw her a festive wedding party. A year later she returned to show off her new baby. Life is a process for this woman, as it is for all of us. Thanks to the women's group, she was able to become a happy, healthy, functioning human being.

Susan: A case study

Susan came to therapy following the diagnosis of her son. She soon realized that she manifested the same classic symptoms as he did – she was an intelligent and very talented artist who nonetheless suffered from depression and low self-esteem. Her career as an artist/writer had been unsuccessful, with many starts and stops. Her distractibility and impulsiveness led her into high-risk activities, while her difficulty in sustaining strong interpersonal relationships had been a chronic problem.

Her drawings enable her to make sense of a chaotic environment. Her earliest work – filled with devils, monsters and nymphs – provides a window into her deep depression. Her psychedelic-style drawings, developed while she was heavily involved with drugs, are hyper-focused and quite repetitive. Even her cute and clever Christmas card (an elf's button reads "Liberate Santa's Helpers Now!") is fraught with despair: string, tape and scissors are strewn everywhere.

When she failed college (where an art professor told her to attend writing school and a writing instructor told her to stick with art), she had no idea what to do. "I put everything I had into art and writing," she lamented, "but no one ever thought I measured up." Susan returned to her parents' home on Long Island and quickly married. When the first marriage failed, Susan remarried. When their son was born, she felt "catapulted from limbo into purgatory." She was isolated from her peers. A drawing from that period, filled with flying appliances such as toasters and vacuums, illustrates her feelings of hopelessness and helplessness as a full-time parent. Less than three years later, their daughter arrived.

At Susan's insistence, the couple sought out a marriage counselor. According to her, their problem was her husband's cavalier attitude. An only child, he had never had to share or compromise. He was also very controlling. In counseling, Susan learned that trait could be positive – for example, it helped her organize the household – but she felt oppressed, not in control of her life and more depressed each day. A drawing from that time shows an old, plump, dowdy housewife peering into a full-length mirror and seeing in reflection herself as a young girl in a full-length mink coat.

Susan never viewed herself as a successful artist. She was unable to do the myriad tasks related to self-promotion: printings, mailings and maintaining contacts. Her friends, who are successful illustrators, are well organized, good at contacting people and diligent about following up calls. By contrast, Susan cannot remember where she has written down messages. She finally solved that problem by leaving an enormous sheet of scrap paper on her drawing table and writing phone numbers on it.

Susan's home life grew worse and, to make matters worse, her son was diagnosed with AD/HD. His basketball coach (also diagnosed as AD/HD and who had a son with AD/HD) recommended that Susan's son should work with me. Susan did not realize that she would become involved in a direct way. At that time she was doing art for herself, spilling herself onto paper by designing Christmas cards and birth announcements with a "mental health release."

She gave birth to another child. Her son continued to do poorly in school. Susan felt incompetent as a mother. Meanwhile, her husband was little help. He frequently criticized her. Her depression worsened, until

she could barely function. At that point she did a classic drawing of depression: a woman huddled in a long tunnel on one side and emerging from chaos, with her eyes closed and the world closing in on her. She was put on a regimen of Zoloft and Ritalin. Figure 6.5 shows Susan huddling, trying to disappear and escape from the drudgery of her daily life.

Figure 6.5 Hell bent from heaven

I worked first with her son, a large, bright and very impulsive "class clown" who was having a difficult time in school. Then I worked with the entire family. Susan and her husband attended our parent group, while their son attended the social skills and education art therapy group for children. I came to know each family member well. Eventually I worked just with Susan, both individually and in our women's group.

During our individual sessions I gave her homework drawing assignments, such as "Draw what it is like to have AD/HD." She spent more than 16 hours on this drawing. Susan drew herself as a mother with AD/HD attempting to manage her household (Figure 6.6).

Figure 6.6 Impact of AD/HD on my life

She drew herself consumed by guilt, regret and fear. Her drawing portrayed chaos, depression, helplessness, hopelessness and tremendous feelings of being controlled, while feeling out of control. Despite plenty of color, there was little feeling of room or space. Clutter reigned; everything was at loose ends. She drew a clock in the middle of her stomach. "I'm always trying to meet or beat the clock," she explained. Calendar pages floated all over the picture. There were hands reaching out all needing her immediate attention. She appeared extremely vulnerable. She also added words that had been spoken to her all her life: "Accept what you've got. Try harder. Strive for perfection. Don't complain. Listen well. Work hard at everything. Get organized, and more." I was afraid she was on the verge of decompensating and would resort to her old self-destructive behaviors (depression, substance abuse and bingeing).

One of the most interesting parts of Susan's drawings was her use of the page's borders, which defined every piece. These were not merely decorative; they were a means by which she contained her entire life. They provided a boundary and structure. She often began a drawing with the border as a way of superimposing some control over her internal chaos.

She included her children's names; they were never far from her thoughts and concerns, in all her borders.

Although the women in the group loved her artwork, Susan remained skeptical. She liked their positive comments and the fact that she was affecting people. However, she continued to give her work away. After showing her pictures to the group, I asked Susan to draw how she felt when the group members looked at the drawings. She drew a relaxed woman watching from above (Figure 6.7). "It was almost like I wasn't there," she recalled. She also stated: "It was the first time I felt like I could *do* something."

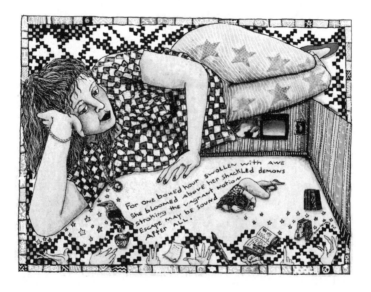

Figure 6.7 For one boxed hour swollen with awe she bloomed above her shackled demons stroking the vagrant notion escape may be sound after all.

The women made such specific empathic responses relating to the imagery and how it illustrated their own pain and feelings of worthlessness that Susan was overwhelmed. Her depression began to lift which was evident in her next series of drawings.

At this point the group discovered that Susan had a long history of bulimia. She shared with the group that, for the first time in years, she had not paid attention to her weight. She drew her bulimia (Figure 6.8).

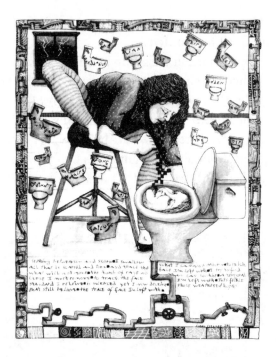

Figure 6.8 Seething between sin and scorn. I swallow what I cannot mourn to retch all that is scarred and torn. And trace the face I'm left with. I try to find what will not move. The tomb of rage no man can soothe. A temporal curse I must remove. To trace the face I'm left with. This fickle standard I relive. Is silenced yet I now deceive. Those weathered hopes that still believe. The trace of face I'm left with.

Susan called this her internal, external life. Her border changed, with piping – actual pipes – running through it. For once the border was not beautiful; it was invaded, far from charming. It gave us a real peek at what was going on inside her body and head. A storm raged outside the window. She drew many toilets, all labeled with words like "expendable," "liar," "weird," "ugly," "lazy" and "wrong." But as she drew herself leaning over the toilet, the vomit went both ways – into and out of her. And the vomit was not gruesome, it was colorful. Her ambivalence was starkly shown.

Susan then drew our relationship. This drawing depicts the transference relationship she was experiencing with me. She was able to purge

herself of her demons and felt relieved. Her motif was a ribbon coming *out* of the border, except this time the ribbon led Susan to life.

Her drawing showed a meaningful connection between herself and her therapist. Susan was touching a tear nestled in the therapist's hand. She described it as her "prettiest" drawing, showing as it did her connection to the world through a benevolent person who accepted her for who she is. It represented her birth as an artist, as she shifted from negativity toward hope.

Her next drawing showed her as she rebuilt herself – literally, using building blocks (Figure 6.9). Her human form was filled with stars. She was, in effect, putting herself back together again. For the first time she moved outside her borders; she drew plants and flowers *inside* her life. Her drawing showed rejuvenation, a safe feeling in the real world – not just her own world. I was excited because Susan was beginning to take charge of her own life.

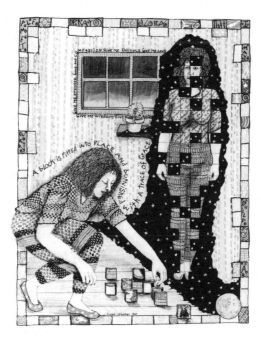

Figure 6.9 Building blocks

Susan continued to draw, depicting her rebuilding herself block by block. Her drawings became more hopeful and less depressed. She drew herself with options. She continued to have concerns for her son and he was drawn under the protection of her large hands. She worked hard to manage her family, artwork and sanity. She worked on her relationships with her parents and siblings (she was estranged from them as she saw herself as different, "the black sheep" in the family).

Eventually, her artwork was shown in a gallery and many of her pieces were sold. Her parents attended the opening of the show. They were able to appreciate her for her gifts and begin to understand and accept her differences.

Susan chose to leave the women's group. She became bored. (This is a chronic problem with AD/HD patients.) She did continue in individual therapy and worked with me to prepare her drawings for this book. She was able to understand the usefulness of art therapy in her understanding of herself, and her journey (Ulak and Cummings 1997).

When her son began to show success, Susan's drawing showed renewed faith – and she tied that in with religion. Years earlier she had left the Catholic Church for New Age worship, now she returned to Catholicism. She had always had a strong spiritual core; now she paid homage to it, by drawing herself back in the faith. She drew religious icons that helped her get through life. She showed herself as serene, not surrounded by craziness. She faced the viewer square, letting herself be seen straight on. She was hopeful; possibilities lay ahead. Her border was uncomplicated and unobtrusive. The colors were Southwestern (in homage to her parents, whom she had just visited in their new home).

Eventually she stopped drawing such intricate borders. Her inside and outside worlds began to merge; possibilities seemed endless, yet not overwhelming. There was plenty of motion, but no chaos. Instead, her drawings became more organized. In a drawing done several years later she wrote, "It is often by breaking that we understand how to become Whole. Look closely at the cracks." In this picture she drew herself past, present and future. On her road to recovery she drew pictures of women giving voice to their hearts and reclaiming the universe.

Art therapy and the understanding of her AD/HD gave Susan a new lease of life (Hadley 1999). Many AD/HD adults will relate to the disor-

ganization, chaos and incompetence that she felt and drew. Her pictures clearly depict her path from helplessness to hopefulness in an exciting, graphic way.

Time-limited group for AD/HD couples

It is important to treat not only the AD/HD adults, but their spouses as well. Group therapy is effective for couples, as it enables each member of a couple to explore their own contributions to the marriage, both positive and negative. In this setting, members have the opportunity to understand that they are not fighting this chronic problem in a vacuum. They can identify and commiserate with others in similar situations. It is also relieving to be able to appreciate, by comparison, the healthy aspects of their relationship, rather than concentrating on the difficulties alone. The couples learn that AD/HD adults are highly defensive and vulnerable and have lifelong problems maintaining intimate relationships. The non-AD-/HD spouses need affirmation that the problems of the marriage are not fixable by them alone, nor are they failing. The group emphasizes that both partners are responsible for change and healing.

Couples are carefully selected from either the parent or adult group, in this way to ensure a safe and confidential environment for all. Groups are structured to offer each member the opportunity to explore, through drawings, their expectations and disappointments in their marriage. The group is ten weeks in duration.

The goals of this group are to foster communication about AD/HD between spouses, as well as help sustain the motivation they need to deal with the complications of the chronic nature of AD/HD. AD/HD cannot be used as an excuse, nor can it be cured. It is, however, an integral part of each relationship. The couples group focuses on strategies for achieving more positive interactions between spouses such as anticipating difficulties before they become critical or determining appropriate assignments of responsibilities (Young 1999). Because of their defensiveness, AD/HD adults are not easily accessible through verbal interactions. For this reason, art therapy is an important modality to help facilitate the couples group.

The husbands and wives of the AD/HD patients have suffered, often nearly as much as their AD/HD partners, throughout their marriages. For

years, the non-AD/HD person has felt as if they were parenting another child. For many of the spouses of AD/HD people, the relationship was not what they expected. During courtship, they had enjoyed life with the spontaneous, upbeat and creative person they were dating. In the back of their minds, they expected that the person would eventually settle down. They also thought that over time they would be able to "change" those aspects of his or her personality they did not find appealing.

That does not happen, of course, and it becomes particularly troublesome to persons in a relationship with AD/HD people. The chronic lateness that they adjusted to when they were dating becomes a real roadblock to a successful family life. The unfinished projects and clutter become an increasing disappointment. The distractibility leads the spouse to feel not listened to or unloved. The emotional outbursts become a source of frustration and irritation. The "gift of the gab" becomes "constant chatter" and forgetfulness becomes less endearing (Berkowitz 1998). Any or all of these threaten to end the relationship.

As the relationship continues, the non-AD/HD partner realizes that these quirks are chronic and incurable. He or she becomes annoyed, frustrated and increasingly critical. The partner's inability to change is seen as an act of spite, or proof of lack of love. The AD/HD person, meanwhile, recognizes that a lifelong pattern is re-establishing itself. Throughout life, he or she has heard similar complaints from parents and teachers. Now even their spouse joins in the drumbeat of criticism (Kelly and Luquet 1994).

Added to this volatile mix are impulsivity problems such as job losses, gambling, drinking, fast driving, poor financial planning or shopping sprees. These behaviors – not uncommon in AD/HD people – create further disillusionment and frustration. It is no surprise that both partners in a relationship may feel unhappy, confused or depressed. A non-AD/HD wife might think, "He's such a smart man. Why can't he ever remember to pick up the drycleaning like I ask him when he leaves the house in the morning? If he loved me, he'd remember. He must not care about me any more." Meanwhile, the AD/HD husband says to himself, "She thinks I'm so incompetent – just like my parents always did. And why do I have to stop at the drycleaners all the time? Why can't she do it herself?" In fact, her request – that he do something at the end of the day

after being asked once several hours earlier – is very difficult for an AD/HD adult to remember. But when the request is made and not followed through – and similar situations repeat themselves day after day after day – both partners become angry. They get mad at their spouses and at themselves. They may even begin to wonder, "Why do I stay in this difficult relationship?" (Robin 2001; Searight 2000).

Many AD/HD adults join the group with a defensive attitude. They have enjoyed being part of their AD/HD groups, finding there a community, a kinship with people who understand them and share similar life experiences. They fear that this couples art therapy group will become a bashing session led by non-AD/HD spouses and worry that they will lose the important sense of empowerment they gained from their original groups. Therefore, the therapist must be aware of this and support them, if the group is to be successful.

Art therapy is an extremely important component of the couples therapy group. The fact that art therapy is nonverbal is critical to its success – for many of these couples, verbal communication has deteriorated dramatically. They need a way to interact without speaking and they are able to find this in art therapy. Also, because many AD/HD adults are gregarious and wordy, talk therapy would encourage them to go on and on and on – and everyone else in the group would become frustrated.

The therapist should explain at the start that this group will be different from others. They will use drawings as a vehicle for expressing their thoughts, concerns and feelings. For that reason, it is advised to limit the group to six couples; any more and the therapist would not have time for each group member to share. (Since my husband is a psychologist and also had AD/HD, both he and I lead these groups.) Each session should last 90 minutes. The first session starts with introductions and then working as a group to establish group rules and goals. The participants' main goal is to learn to communicate better with their spouse. The major goal for the therapist is to aid them in understanding their defenses and the impact of AD/HD on each of them while reducing their anger (Meyer 1998).

Each group member is given a spiral drawing sketchpad of 14 x 17 inch white drawing paper and a box of twelve magic markers. This will be their drawing pad to use throughout the group sessions. Each couple is

given a folder and instructed to bring it weekly. Handouts are given each week related to the topic being discussed (articles on AD/HD and intimacy, communication strategies, conflict resolution, living with an AD/HD spouse, creating an ADD-friendly family environment, etc.). The couples receive a telephone call the night before group to remind them to come and to bring their folders. After the initial discussion, the therapist should immediately ask them to begin by "Drawing a picture of what they imagined married life would be like *before* they got married." As they start to draw there is nervous giggling – typical of many adults, when placed in unfamiliar situations. More than one participant usually says something like "I feel like I'm in kindergarten." The therapist should assure them they will not be judged on how well or poorly they draw. When they are finished, they should make a second drawing, depicting "What your marriage is actually like."

The therapist should hang each couple's two drawings side by side. It is typically apparent that most men and women draw similar preconceptions of what their lives would be like: nice homes, picket fences, a couple of children, a dog, hearts and flowers. They are almost always scenes straight out of a fairytale fantasy. These expectations are typical of most people, AD/HD and non-AD/HD alike.

The second drawing, "What your marriage is actually like", demonstrates the enormity of their disillusionment. Frequently, both spouses in each of the couples show deep feelings of personal failure. As the group looks at all the drawings and searches for common themes, there is a feeling of togetherness when AD/HD and non-AD/HD people see so much familiarity. It is always a very emotional moment. Everyone recognizes how far they all are from achieving their hopes and dreams. There is overwhelming sadness, but at the same time they usually become more available for discussion and less defensive. The therapist should take advantage of this moment to explain that no one was to blame for what had happened to their relationships. Things could not have turned out differently so far, because when they were married no one knew that one of the partners had AD/HD. If they did know that their partner had AD/HD, they had assumed it was manageable and would not impact their lives. One AD/HD woman in response drew "A Loving Family" illustrating what she believed her marriage would be like. She wrote it will be

"one happy ever after." In a drawing depicting the reality of their marriage, her husband drew the lumps and bumps that they have faced together since marriage (Figure 6.10).

Figure 6.10 The marriage road

Then the therapist should turn the discussion toward developing more appropriate expectations, taking into account the new understanding of the impact of AD/HD on the marriage.

At the beginning of the second session, the therapist should ask everyone to draw "How AD/HD gets in the way of his or her marriage." They should not blame anything or anyone, but rather look for and analyze realistic roadblocks. The AD/HD patient often draws feelings of being misunderstood. They show their disorganization getting in the way of everything. They feel they are married to a parent, rather than a partner, who treats them like a child. They are frustrated and embarrassed at being "transparent," like a child whose parent seems to know more about them and what is going on around them than they do, in front of their spouse. After all, in every other area of life they can bluff their way through. Their neediness also comes through strongly. The drawings of the non-AD/HD partners also show strong emotions. In Figure 6.11, the non-AD/HD spouse drew the burden of AD/HD on him and on his marriage. The weight is overbearing.

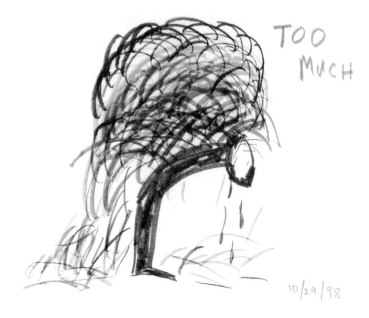

TOO
MUCH

10/29/98

Figure 6.11 Too much

One woman drew a broken heart. She explained that she thought her husband's forgetfulness showed a lack of caring for her. Whenever she tried to help him get better organized, he became enraged. She felt helpless and alone in her marriage. Another woman who has AD/HD titled her drawing "Where? When? What? Now?!?!" She drew a maze surrounding a clock with multiple distractions in every direction interfering with her getting to the finish line.

These drawings are meant to be provocative experiences. The non-AD/HD members realize they have been asking their spouses to do things they are incapable of doing. At the same time, the AD/HD people recognize that if their spouses understand they are not acting maliciously, they will be able to ask for help. The thought dawns that, for the first time, they will be able to work together as a team.

These realizations may usher in a "mourning period." Both partners are encouraged to let go of their wishes, fantasies and inappropriate expectations of each other and their relationship and recognize the reality of what their life is now. They also see that the more clearly they all under-

stand the AD/HD disorder – and its impact on both the spouse and their marriage – the greater the likelihood that things can change. The therapist should emphasize that a difficult task lies ahead, but as a flood of feelings emerges in each couple, a bit of optimism shines through. At this point the therapist should emphasize that the awareness they are realizing by drawing and discussion is the beginning of change and hopefulness.

The next drawing, during session three, is also geared to help with this rebuilding. Couples are asked to draw "What do you need to let go of in order for your marriage to succeed?" The idea is to use this more realistic view of the relationship as a basis for creating more practical goals and expectations. Going into this drawing, the AD/HD person will hopefully not feel as damaged, vulnerable and self-protective as before, based on the earlier session. At the same time, the non-AD/HD partner has also been relieved of the feeling that he or she must bear total responsibility for making both their lives work. Among the ideas these drawings typically convey are: letting go of the belief that they as a couple will always be on time; that the AD/HD spouse will become organized enough to leave in the morning without forgetting anything; that the list they make together at night will actually get done the next day; that items will be put away in their proper places; that the AD/HD spouse will be a better driver; that the AD/HD person will become a good conversationalist and the non-AD/HD person a more patient listener; and that the constant cloud over their lives and their marriage will lift.

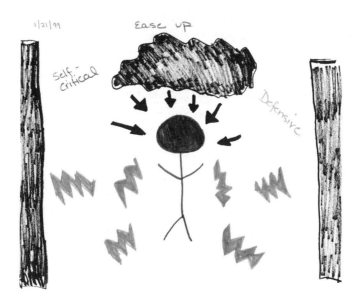

Figure 6.12 Ease up

In Figure 6.12 the patient drew the attitudes and feelings she needed to recognize were interfering with her happiness and marriage. Learning to recognize her defensiveness, feelings of low self-worth and self-criticism that stemmed from childhood helped her. She had been recently diagnosed and brought to adulthood a lifetime of being misunderstood.

As the group looks at the drawings and the many common ideas portrayed, the members are often incredulous. They realize that they are not the only couple in which one partner always feels accused of something and the other constantly feels the accuser. There is a palpable cooling of tension in the room, which happens because of group dynamics – individual couples therapy would not produce such a profound feeling of recognition. Like the others, this becomes a very poignant – and supportive – session.

Teaching anticipation and creative solutions

Using these drawings, the therapist should begin talking about the gifts of AD/HD and solutions to manage their disorder in the next session by introducing the concept of "anticipation" and "creativity."

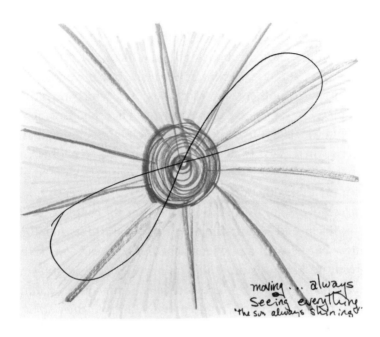

Figure 6.13 Moving…always. Seeing everything. The sun always shining.

In response to the question "What are the positive aspects of ADD?" many AD/HD patients drew their creativity, energy, spontaneity and love of fun. The AD/HD woman who drew Figure 6.13 understands her optimistic outlook, high energy and the ability to regroup as positive aspects of her AD/HD.

If one partner can anticipate that the AD/HD spouse will not be on time – and the spouse, in turn, can anticipate that the partner will be annoyed by their chronic lateness – then they can move on to the next step: "What can we do about this?" Acknowledging that time is the enemy, creative solutions emerge. One wife decided that she would never tell her husband the correct time that they needed to leave, but would vary it by

15 to 30 minutes earlier. This assured her that they would be prompt, or even arrive early. Her husband agreed to this solution and only asked her what time they were to be somewhere when they arrived.

One man drew himself as feeling like a stupid child, because his wife kept reminding him to take his medication. The couple devised the idea of a sign with the words "Take Your Medicine" on a large sheet of paper. Whenever she saw his behavior deteriorate (because he had forgotten to take his medication), she held up the sign and walked – silently – past him. He did not feel infantilized as before; when she saw it worked, she was happy to continue. Another wife, using this idea, wrote instead "I love you" on a sign. This was a signal between her and her spouse, which translated into "Did you take your medication?" A common solution that many patients draw when asked to depict "What Helps?" is to get help.

The therapist can also assign homework, such as asking couples to think about the things that drive them most crazy about each other and brainstorm creative solutions. In the next meeting, the couples are asked to "Draw a problem and solutions." One very distractible and forgetful woman drew herself with a phone attached to her head – with the line wired directly to her husband. This was her way of requesting him to become part of her solution – provide daily reminders by calling her throughout the day. Another couple proudly showed their solution to organizational problems: Post-It™ notes scattered throughout the house, car and anywhere else the AD/HD partner might need them. Comments like "Don't forget to get the cleaning" were written on them. One woman drew her husband on one side, "tasks" on the other and her husband's secretary square in the middle, acting as a conduit. When he saw the drawing, her husband realized for the first time that his life did not consist of two women – his wife and secretary – conspiring against him; rather, they worked together to help him succeed.

When making these drawings, some people try to outdo each other in creativity. They also become a bit playful, which is welcome as humor is an important part of problem-solving.

Sometimes one of the stumbling blocks is "small talk." AD/HD people typically have difficulty with this form of social interaction. Easily bored, they come across as brusque, rude, arrogant or pompous – impatient with the time it takes others to get to the point and eager to

move on to something else. The therapist can ask members of the group to role play. Situations are suggested such as attending a cocktail party. Members of the group take turns acting the role of either the spouse with AD/HD or the spouse without the disorder. This helps AD/HD people realize the importance of small talk and how to become better at it. It also shows the non-AD/HD spouse how to help. Discussion follows and suggestions are given, such as having a few friends over and practicing "small talk" to try outside the group. At the beginning of the next session, the group can discuss any issues that may have arisen regarding these suggestions and if they were successful or not. Learning how to creatively solve problems is a very helpful and playful tool; emphasizing humor and playfulness helps in reducing tension (White 1996). Drawings become a source of reference for homework. These provide visual images and solutions to problems.

In session five, the group members begin to look at the larger picture, drawing pictures showing themselves and their family in a public situation, about to meet new people. These drawings – of airports, restaurants, vacation spots, company picnics and the like – are particularly telling. One non-AD/HD person portrayed her spouse as a loud class clown; meanwhile she sat by his side dying of humiliation, wishing the earth would open and swallow her whole. Another AD/HD man lamented that he had no friends, but did not see this as his fault. However, after viewing the group's drawings, he recognized certain things his spouse had always said, but that he had never actually *seen* about himself – his constant talking and complete inability to let anyone else get a word in edgewise. He also saw what he considered to be obnoxious behavior by other AD/HD group members and suddenly realized that he was behaving that way too. On the spot, he vowed to stop.

In session six the therapist should ask the couples to "Draw the Gift of AD/HD." The purpose of this drawing is to begin to realize the positive qualities that the person with AD/HD brings to the marriage. Up to now most of the group members have only been aware of AD/HD as a handicapping condition. The drawings usually show elements of energy, creativity, humor, spontaneity, and fun. The therapist will then instruct the group to draw something funny that their spouse does. Often very personal and intimate personality traits are shared. For example, one

spouse shared in her drawing her spouse's way of imitating others that was meant to be and is funny. This session and exercise sets the tone for the next meeting when the work of learning strategies for better communication begins.

In session seven, work taken from *The Impact of Adult ADD on Intimate Relationships* (Kelly and Luquet 1994) is introduced. Handouts are given that include: "Behavior That May Exist in the ADD Partnership" and "Instructions for Couples Dialogue: a Communication Tool that Restores Connection." The technique emphasizes the use of "Mirroring, Validation and Empathy." Mirroring is the ability of one partner accurately to paraphrase what their partner is telling them. Validation is the ability of the receiving spouse to "make sense" of what they are hearing. Empathy is the ability to "understand" without judgment what their spouse is sharing with them (Kelly and Luquet 1994).

Several sessions (sessions 7, 8 and 9) are spent practicing this technique, allowing each couple an opportunity to grasp the concept of "mirror, validate and reflect" while understanding what empathic listening is. Group discussion revolves around the frustrations and difficulties in changing the way they communicate with one another.

During this time, the therapist will begin to discuss conflict resolution and ask group members to "Draw what makes you angry and how can you and your spouse solve this problem?" Disorganization, clutter, budgeting time or money (or lack thereof) are frequent themes that are drawn. Group members offer concrete suggestions and follow through the next week with inquiries on how each member is doing. The couples are encouraged to practice both their newly learned problem-solving and dialogue techniques.

In the final, summary group meeting, the therapist should ask everyone to think of what they have learned about themselves and their spouses. The therapist should also ask them to imagine their marriages now and draw "How will you use the information learned in this group to make the future better?" These drawings are much more optimistic. Spouses are more open and vulnerable with each other; the AD/HD person's defenses are much lower and the non-AD/HD person is more empathic. Both partners feel more equal and there is less of a parent-child relationship. Equilibrium, of course, is what makes a marriage work.

Projects in ongoing couples therapy

The time-limited group has served as a precursor to an ongoing couples therapy group. They have only begun the process of looking, listening and learning. Much practice is needed and the ongoing couples therapy group offers an arena for practice and refinement.

In my experience, most couples remain in the ongoing art therapy couples group, which continues to use art in many of the sessions. Anger and the expression and management of anger is drawn and discussed in the next sessions. Learning to recognize "hot buttons" and avoid them is an important task to recognize and learn. Asking group members to "Draw your anger" and discuss options for conflict resolution or finding humor by drawing "How are you funny?" and "How is your spouse funny?" bring another perspective to this ongoing group. Asking group members to draw "What is getting in the way of change in your marriage and in yourself?" is a recurrent theme. Distractions are an ongoing concern, as well as time management. One man in the group drew his path as one of endless distractions, making it impossible to stay in a forward direction. Using both humor and concerns regarding time, one patient drew an invitation: "You are invited!" "Come for Dinner at…six, seven, eight, nine and then ten o'clock!" She is able to recognize her inability to be on time and has alerted her friends.

One very poignant drawing asks group members to "Draw your personal wounds." The therapist then offers them Post-It™ notes to cover these wounds (band-aids). Over several weeks the wounds are uncovered and discussed. Alcoholism, drug abuse, overspending, poor self-worth, sexual problems, gambling, abusive behavior and poor parenting are some of the topics revealed. Group members become more vulnerable as they trust one another to share their most intimate secrets. This type of drawing takes a great deal of faith in one another and trust in the therapist to provide a safe and confidential environment.

The use of guided imagery, a technique that involves using a yoga relaxation exercise and then inviting group members to take a journey of self-discovery, is accompanied by working with clay to create the image they found on their journey. This is shared with the group. Learning relaxation exercises (such as yoga) and using creativity to express their

self-image in clay can be playful and revealing. Using the Gestalt technique of becoming the sculpture, giving it a voice and sharing with another group member (not their spouse), and then sharing the experience with the group, allows spouses freedom to share without threat of criticism. The images are taken home as a permanent reminder of the ongoing process and change taking place within oneself and with one another.

One ongoing group with which I work has been together for several years. Topics for drawing are suggested by the content of the group discussion. Areas of concern stay the same as learning takes place. The symptom of AD/HD is a chronic problem and requires repetition of ideas. Learning to take care of yourself in order to take care of family members is emphasized and goals are established in this vein. One woman in the group drew a large "ME" and said, "It's time for me to find time for myself." The group problem-solved with her how to go about this. Many AD/HD people are so busy being busy that they become frantic. They need help learning how to relax (even how to fall asleep). Using an art meditative session is helpful in providing imagery for relaxation. During this session, following a relaxation exercise, the group members are asked to visualize a place they would like to go, a place where they can relax, a place free from their daily chaotic lives. They are then instructed to draw this place. This image becomes important to them as they can refer to it during stressful times. It empowers each member to understand a way they can take care of themselves, a way to deal with their agitation, restlessness and irritability.

For adults and particularly for couples, the art therapy group becomes a safe haven from the outside world; a place where having AD/HD in their lives is "normal" and freeing. Not only does the art provide a safe vehicle for expression, but being in a group also helps adults with AD/HD and their spouses develop workable strategies for handling daily life.

7
Art Therapy with the AD/HD Family

Introduction

Many families talk too much. Some use language intellectually, abusively and/or defensively. At the same time, a family may have a poor sense of how to use space and boundaries – violating personal space in the home is no different from doing it in a drawing. For example, one boy often acted obnoxiously at home, but did not see his behavior in that light. During one session, he scribbled all over his family's mural. When asked about it afterwards, it was impossible for him to say, "I didn't do it!" His therapist and family were able to show him exactly why the rest of his family did not like it when he acted impulsively. Because of its nonverbal nature, family art therapy can be tremendously effective as it circumvents these tendencies.

AD/HD may only directly affect one member of a family, but that does not mean that AD/HD is solely the patient's problem. The disorder typically impacts every immediate family member – and often those in the extended family as well – in a profound and primarily negative way. The AD/HD person often feels like a victim and totally misunderstood and, in response to his or her vulnerability, may become highly defensive. Siblings of an AD/HD child – resentful of the time and attention parents give to that one person – respond with behavior maladjustments they observe in the AD/HD child. Some siblings act out while others become too "good," at the cost of their own well-being. Parents feel like failures and may blame each other for not doing more to help the situation. If a mother or father is AD/HD themselves, they may over-identify with and

171

become over-focused on the AD/HD child at the cost of proper parenting techniques. Young children, reacting to the constant tension and fighting in their home, frequently express fears that their parents will divorce and often become symptomatic themselves. For example, they may "copy" their sibling's maladjusted behavior as a way of seeking attention. Therefore, by the time a family takes part in family art therapy as a means of addressing problems ostensibly set in motion by an AD/HD child, the fabric of the family has unraveled.

AD/HD is exhausting for families. Moment by moment, members have to try to cope with their reactions to behavior they consider lazy, defiant, stubborn, incompetent, irresponsible, selfish, passive/aggressive or narcissistic, as well as heartbreaking. This gives the therapist a great deal to work with.

Only treating the AD/HD child or parent(s) does a disservice to everyone in the family. Each person needs attention in order to become part of a functioning family. Siblings must have the opportunity to voice their worries, concerns and anger – but in an environment that is safe. Children as young as four or five years old can participate to add their needs and demands to the family picture presented in therapy. It can also be useful in sessions to include grandparents, if it appears they can help their own sons and daughters become more effective parents. Even care-givers who are not blood relatives may take part in family art therapy if their role in the family warrants it. Therefore, including all relevant group members in family art therapy provides an effective way of learning to communicate without promoting defensiveness.

The initial goal of family art therapy is to examine the family fabric; to see not only what is unraveling, but which strong threads bind members together. Using a family systems approach, the therapist's primary goal is to understand what is operating within that system that provokes bad feelings (Minuchin 1974).

Watching their parents draw usually intrigues children. It is an unfamiliar way for families to interact, but can also be playful and fun. One can tell families they are embarking on a journey. They may not know where they are going, but they must be willing to travel along and trust their leader (the art therapist).

As in any family therapy situation, the family art therapist will observe: who communicates with whom, and how; what role each person plays in the family; how those roles developed; how appropriate or inappropriate those roles are; and what perceptions or misperceptions each member has of each other. Then, the therapist will be in the position of shattering illusions and pretenses, as well as calling into question long-standing characterizations. The therapist must also offer the possibility of change (Hoffman 1981).

Initial meeting with the family

As a rule, the therapist should have met with both the parents and the AD/HD child individually with the goal of understanding the families "flavor" before beginning family art therapy. If some family members have been through different verbal therapeutic modalities, they may not trust that family art therapy will work for them. However, all family members should have had some previous exposure to art therapy through the AD/HD child's experiences. This often means that they also bring with them an innate curiosity about this new idea of "family art therapy."

Many families begin in enormous pain and with a sense of desperation. Adults may feel incompetent, both as parents and spouses. The children in the family tend to feel worthless. The AD/HD child has usually come to see themselves as not valued or cherished and not able to contribute to the family in a positive way. Siblings often feel neglected or overlooked.

There is much anger and sadness. This is not what anyone imagined their family to be; they know they have fallen far short of the family image they see on television and film and in magazines. Their desperation means they have a strong desire to make their family better, but do not know how. After years of failure, it is not likely to be easy for them to believe something new will work, but they may be desperate enough to be willing to try. It is important to understand this dual, and somewhat conflicting, response. The family may appear to be saying (and may even say), "We'll try anything!" But privately they are thinking, "Nothing is ever going to work."

The role of the therapist is to be aware of who participates in the action of making the family art and how each member is represented in the drawing itself (Landgarten 1987). The therapist should encourage the family to approach their drawings in a way that is playful, fun, expressive and honest. Additionally, the therapist should save their work, which allows the family to go back later and see actual proof of progress. In the beginning of family art therapy, it is good for the therapist to talk about the fact that a broad range of artistic abilities will be expressed. Emphasize that this is not about producing fabulous works of art, but about using art to facilitate expression and channel their energy and creativity into improving their family life (Ulman 1975).

Frequently, when a family first comes to family art therapy, their verbal expression has broken down – accusations, defensive reactions and withdrawal are frequent and stock responses. The goals of the family art therapy should be made clear: art will be used to facilitate better communication. The therapist should also explain to the family that, over time, they would learn tools to better relate to one another in a more positive way.

In the early sessions, it is unrealistic to assume that family members will be able to employ these new communication skills. More likely, they will fall into the same negative communication patterns that have brought them to therapy in the first place. To avoid this as much as possible, it helps to set some ground rules. The purpose of these is to encourage members to feel safe saying whatever they want.

The most important ground rule is that what they talk about in the art therapy room stays there. It should not be discussed afterward (as on the car ride home, when one person says to another, "Why did you say I was never around? You made me look bad"). A second ground rule is that "I" rather than "You" messages should be used when a family member has learned about how another member feels about their drawing. Finally, family members should ask questions that are not seen as attacks. For example, a parent may learn to say, "I really feel so tired by the end of the day. It's like I'm at the end of my rope," instead of saying, "If you just did what I asked, we wouldn't have these arguments." Then the parent and child might together ask, "What can we change to avoid these dinnertime conflicts?" These seemingly simply ground rules require a great deal of

practice and patience, both of which are difficult for the AD/HD population. However, ultimately they form the basis for a mutual shared experience and the grounds for developing a new family history.

Given the tenacity of the patterns that families develop, there is still a possibility that, especially at the onset, negative discussion will follow the sessions. This engenders feelings of misunderstanding, mistrust, anger and withdrawal. Some family members may become reluctant to attend family sessions and one or more may be unwilling to express their thoughts and feelings openly because they fear retaliation outside the session. It is important for the therapist to probe for this, perhaps individually. In addition to setting up a safer structure for communication with the ground rules, the therapist will be teaching the family members, through the artwork, how to listen and learn about one another in a new, creative and safe way. The therapist will also be modeling empathic responses and techniques of active listening (Landgarten 1987).

It is imperative that the therapist, during these early sessions, keeps in mind the nature of AD/HD – patients may act impulsively, become impatient, be restless, unmindful of others' feelings and easily bored. Additionally, realistic goals regarding the appropriate expectations of each session must be maintained. This is an ongoing process and change takes place over a long period of time. The therapist should continually remind their patients that this is a new tool for learning to communicate by doing, listening and looking as opposed to talking.

Typical sessions

Many factors need to be taken into account in structuring your family art therapy sessions, including some of following:

1. Who has AD/HD? Age-appropriate expectations are necessary (e.g., a therapist can assume that an adult with AD/HD can sustain longer periods of attention and be less restless than a young child).

2. If the patient is a child, what is their age? Developmental milestones, especially emotionally, are often delayed in children and adolescents with AD/HD. With that in mind, the therapist

can assume that chronological age is not a good indicator of social and emotional adjustment.

3. Are there any children under 6 years old? These children will generally have a shorter attention span and be more restless. If this child has AD/HD, this will be even more exaggerated and, therefore, activities should be developed and geared towards their abilities.

4. How many people are in the family? If this is a family of five or more persons, the art therapist may consider inviting another therapist to join the session. AD/HD families are often more chaotic in nature. Therefore, having two therapists present may provide clearer boundaries and structure.

5. Do either of the parents have AD/HD? If so, the therapist can anticipate many distractions and disorganization. It will be the therapist's task to manage the sessions, providing and demonstrating skills of time management, organization, sequence and consequence.

6. Does one or more of the children have AD/HD? Depending on whether this is a hyperactive, passive or combined-type diagnosis, the therapist may also want to include another therapist to help maintain a semblance of control with fewer distractions.

7. What time of day should sessions be held? This is determined by many factors such as the parents' availability regarding their work schedules, the chronological and emotional age of the children, other outside activities in which the family participates and whether or not family members are under medication. (The therapist will want to schedule sessions when medication is at its optimum level.)

8. Are there other handicapping conditions such as dysgraphia, visual handicaps, physical handicaps or other psychiatric diagnoses within the family that may preclude a successful session? Additionally, other types of disorders may preclude

the use of some materials such as pica, intermittent explosive disorder and/or panic disorders.

The therapist should structure a session by dividing it into three parts, taking into account the different concerns above. The initial part of the session is used to review the week, discussing insights or situations that have occurred since the last session. During this time, the therapist listens to family problems that have arisen and makes decisions on the directions for the drawings to be elicited during the session. The second part of the session is for the actual drawing. The third part is for discussion, leading to closure, which includes a review of the process and progress of the session, as well as gaining an understanding of each person's artwork and, perhaps, assigning homework.

Depending on the factors described above, the session can be anywhere from 60 to 90 minutes in length. If small children are present, 90 minutes will be too long. If the younger child is the one with AD/HD, then the length of the session and the art exercise must take into account their short attention span, low frustration level, need for movement and need for changing, stimulating activities. The verbal process may also be shortened, but parent sessions without their children can occur to review and discuss the progress, as well as to learn and to plan for the following sessions.

Initially, the drawings in family art therapy sessions are often done individually, using 18 x 24 inch white drawing paper and magic markers. The paper and markers provide boundary and structure (Kwiatkowska, Simmons College Summer Art Therapy Institute 1978). As they progress in their understanding and respect for the process of art therapy, families will move on to cooperative drawings and family murals (Landgarten 1987).

One may begin with a family art therapy evaluation using 18 x 24 inch white paper and cray-pas (Kwiatkowska 1978). However, cray-pas break easily and may be too stimulating a media. The therapist should save the use of cray-pas until the ritual of family art therapy sessions is firmly established and can tolerate the addition of new materials. As mentioned elsewhere, it is important to keep in mind that AD/HD patients are often easily overstimulated. The family art therapy process

needs to provide structure and boundaries in order for it to be successful. Consequently, the therapist needs to be mindful of the effects that various art media can have on the art expressions of difficult populations (Rubin 1978).

There is no specified time limit for the number of weekly sessions, though it is good to discuss early on any time or financial constraints the family may have. Ideally, a therapist should meet with the family for as many months as is necessary to effect change for the entire family.

Individual drawings

One of the first drawings a therapist requests from each family member is entitled "How does AD/HD impact your family?" The isolation and lack of trust that permeates families with AD/HD tends to come through clearly in these drawings. One mother labeled her AD/HD daughter "the boss" and drew her as a teenage girl creating havoc, causing her parents to yell at her and at each other (Figure 7.1). In the same drawing, the younger sister was depicted cowering off to the side, wishing she never became part of the family, and yelling, "Stop it!" to everyone.

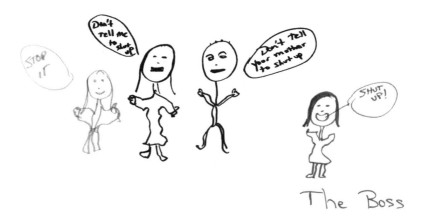

Figure 7.1 The boss

The non-AD/HD daughter drew the complicated relationship she had with her sister whose moods swings disallow for a close sibling relationship. The AD/HD patient drew a cartoon depicting a typical day in her life. This is a good example of the restlessness and boredom that interferes with the AD/HD patient (Figure 7.2).

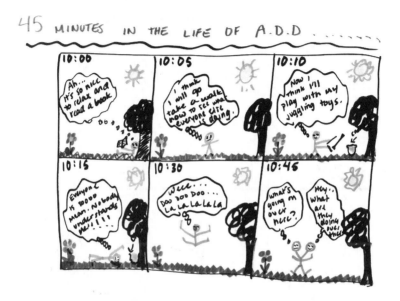

Figure 7.2 45 Minutes in the life of ADD

Another drawing by a teenage boy, whose sister has AD/HD, showed a large house with each family member isolated in separate rooms while his sister threw a massive temper tantrum in her bedroom. His other sister drew a picture titled "All Eyes on Her" (see Figure 4.10), depicting the unfairness siblings experience regarding the amount of energy parents spend on the AD/HD child. The eldest daughter refused to draw, afraid of the repercussion from her AD/HD sister. The AD/HD patient drew the picture shown in Figure 7.3. She drew herself in the center of her picture, with every other family member pointing his or her fingers directly at her as the cause of family discord. Her confusion revolved around the many mixed messages she received from family members.

Figure 7.3 I'm the family problem

Figure 7.4 Hopes/Dreams

In Figure 7.4, a mother drew a picture of the impact of her daughter's AD/HD on her and her family's life. This drawing moves from the birth of her daughter to present day, depicting all the components of AD/HD leading to impulsive, negative behavior and finally to a specialized boarding school.

Other family members also participated in this drawing session. The father divided his picture into four sections: in the first he drew his happy family when his daughter was very young; in section two he drew all her problems such as school failure, trouble with the police, drug involvement and rage and frustration on his part towards his daughter; in the third section he drew himself and his wife feeling desperate and seeking help; and the last picture is a self-portrait of him holding up the entire family, which is symbolized by very heavy barbells. The patient's brother drew a large broken heart, an ambulance taking his sister to the hospital and a very large Ritalin pill. AD/HD is certainly dominating this family's life. The youngest brother of the identified patient (an adolescent girl) drew her as a druggie; he also drew the "family meeting" with everyone out of control. His father is shouting, "This doesn't work!!" The patient drew herself as out of control, behind bars, unhappy and resisting parental help.

Another early drawing deals with expectations, "What do you hope will happen following family art therapy?" The therapist wants to see the hopes of the family in order to gauge their level of expectations. These drawings often portray ideas like "We'll never fight again," "My brother's AD/HD will go away," "We can go on vacation and have fun," and "Our kids will listen to us and do their chores." These are wishful ideas, revolving around potential family happiness. Such expectations, however, are unrealistic. It is important for AD/HD families to understand that all families have conflict. One of the goals of therapy should be to give these families a more realistic set of expectations for themselves and an understanding that the happiness they seek is more the product of understanding themselves as a family and working together than the result of meeting some idealized level of harmony. Therefore, it is helpful to point out that all children fight, including those in non-AD/HD families. All children test their parents' limits and feel they are unfair from time to time, just as all parents feel embattled at times. Not only does this exercise allow family members to express their feelings and hopes, but it is also an opportunity for them to discover that they are not so far from "normal" as they may have thought.

These first individual drawings allow the therapist to gain insight into unspoken wishes and fears. Additionally, the nature of the drawings enables other family members to realize the enormity of the impact of

AD/HD upon each of them. The therapist should teach the family members to look at these drawings without judgment, to ask questions in a non-offensive way and to understand the vitality of this new tool of communication. Also, the therapist has to monitor these initial drawing sessions carefully so that the family does not fall back into former tendencies, but rather gains insights about themselves and each other and is excited to proceed into group activity. It is critical for the therapist to determine the timing for this next step, based on mutual respect and appreciation that the members develop for one another. Finally, the therapist should continue with individual drawings until the family is ready to share a project without violating the space of other members.

The impact of AD/HD on the developing process of family art therapy

As family art therapy progresses, communication without anticipated attack, relaxed defenses and the ability to present one's vulnerabilities in a safe environment become possible. The therapist should now encourage the family to take more risks. Each family will have a different timetable. Even within the family, different members may emerge as more ready to move on. As the therapy progresses, more direct confrontation with problems becomes possible. One can ask each person to draw "What is the worst problem in your family and how would you fix it?" Family drawings often show fighting, name calling, mean spiritedness and the invasion of personal boundaries. This last is a particular problem in AD/HD families where, because of their impulsivity, AD/HD youngsters are prone to "borrow" other people's possessions. They do not see this as taking things or view it as inappropriate conduct.

One goal is to have all family members clearly understand exactly what AD/HD is, so that they can ultimately work together as a unit in a cohesive manner because AD/HD is a chronic problem. The key components of AD/HD – impulsivity, distractibility, impatience, disorganization and poor memory – impact therapy just as they affect family life outside the therapeutic setting. Another goal of family art therapy is to help each member gain an understanding of what is AD/HD behavior and what is not. Otherwise, they may continue to feel frustrated (Hallowell and Ratey

1994). For example, an AD/HD patient may not be able to sit still throughout the session. In this case, there are two important goals: first, the family members need to learn how difficult sitting still can be for an AD/HD person; second, the "fidgeter" needs to learn how to fidget or be restless more appropriately, perhaps by learning how to wiggle their toes instead of larger, more distracting movements. Helping the family see that change is possible is a very important goal of this process.

The impatience so common among those with AD/HD is also bound to surface in family art therapy. This impatience may translate into irritability and anger. People with AD/HD are used to "hit and run" behavior (i.e., saying hurtful things impulsively and then being unwilling to accept consequences for them or even being responsible for their comments at all – see Figure 7.5, "What I really meant..."). Sometimes they dismiss their outbursts altogether by saying "just kidding."

Figure 7.5 What I really meant

The AD/HD person is ready to move on, leaving behind hurt feelings and a re-emergence of wariness among other family members. The therapist can liken this behavior to a volcanic explosion – the AD/HD person no

longer feels volatile but the family is suffering from the fall-out. Art therapy offers the therapist an opportunity to ask family members to express how anger in the family looks. The therapist asks each family member to draw "How does your family deal with anger." Most drawings will illustrate the hot flash temper that AD/HD people often have. Chaos, rage, helplessness and hopelessness are frequent themes. Siblings often draw pictures depicting physical and emotional abuse. Hanging these drawings on the wall for each member to see is important. The therapist can use the ensuing discussion to introduce conflict resolution suggestions, which are crucial for the family's survival (Braswell and Bloomquist 1991).

The therapist's task is to predict this impatience, note it when it occurs and discuss its impact on the family and the therapy. Patients with AD/HD are forgetful and even well-delivered interventions do not stay with them easily. Consequently, the therapist must repeat these reminders throughout treatment (Hallowell and Ratey 1994). Far from being detrimental to the therapy, these moments when the family runs head-on into the problems precipitated by AD/HD behavior are just what the therapist needs to help them address and acknowledge how they impact the process. Such moments of hyperactivity or impatience are opportunities to help family members who are feeling frustrated by what they perceive as purposeful "bad" behavior, see through those behaviors to the AD/HD underlying them.

Drawing together helps them learn to do just that. For example, in an exercise called "Individual Scribbles" each person works on their own paper. They are instructed to close their eyes and move their marker or cray-pas over the paper until they feel finished. Then they are asked to choose one of the family members' drawings, and make it into a picture that they all work on (Kwiatkowska 1978). The decision to choose a single topic for the picture can be difficult. Again, AD/HD symptoms such as impatience and impulsivity can impede this decision-making process. The therapist's task is not only to observe, but also to interject what is happening to help detoxify the process and describe how the symptoms are interfering with the completion of the task. Since AD/HD persons are distractible as well as creative, it may be difficult for them to stick to the task at hand. Finding only "one idea" is not as much fun as

spinning off dozens of ideas, which, although creative, are often off-task. Therefore, the therapist needs to discuss this difficulty of staying on-task with the family. Often, this discussion is enough to promote resolution, as the AD/HD person does not like being predictable and will change their behavior as a result of its predictability having been pointed out to them in advance.

The family art therapy process becomes the subject of therapy as much as, if not more than, the artistic product itself. These are not easy tasks. They require listening, planning, organization and cooperation. The result is varied, but offers an opportunity for family discussion on how well they work or don't work together.

Working together on murals
Identifying family roles

Drawing murals is the starting point for family problem-solving. The discussion that leads up to the drawing of murals can be useful to connect the behaviors that surface during these events to ordinary daily rituals, such as getting up in the morning and getting ready for work or school. The therapist should lead a discussion on how their actions during the drawing project – badgering, harassing, cajoling, bribing, whining and being nasty or bossy – also come out during the morning rush. As each family member becomes more aware of their behavior, they will be more receptive to learning their role in their family. As mentioned in Chapter 4, creative problem-solving is a tool that the therapist should teach at this point (Braswell and Bloomquist 1991).

Drawing a mural incorporates a series of cooperative art activities. The ideas do not have to be spectacular. For instance, the therapist might suggest they draw a mural depicting a family vacation. Although it sounds simple, everyone must agree on such things as where they are going, what kind of transportation they will take, what provisions to pack, what the weather will be like and who will draw what. The central idea for the therapist of the mural process is to look at the strengths and weaknesses of each family member in order to understand AD/HD's impact on everyone. The therapist should observe who says what, who helps whom, who participates and who does not, whose ideas are acceptable, who is the

antagonist and who acts as peacemaker, who is the first to give up, who takes leadership and what happens when frustration or impatience sets in.

The therapist should further assess what has occurred after the completion of the mural. It is important to highlight key themes for AD/HD families. One theme that the therapist will observe is the impulsivity of the AD/HD member. For example, if an impulsive family member draws a boat that is too small to hold everyone, family members can use the mural to discuss how the size of the boat makes them feel and how this impulsiveness drives the entire family.

After this first structured mural, the therapist will have a clearer understanding of the family dynamics, as will the family members. The therapist may discuss the project with the entire family or with the parents alone if the children are quite young. Occasionally it can also be helpful to meet with siblings alone.

One reason to meet with siblings separately is that children often become protective of their parents and/or their AD/HD sibling(s). As a result, they may be more forthcoming without their parents or sibling(s) present. They may also be afraid to speak up in the group setting if they fear reprisal from their parents or sibling(s) if they say what they believe is really happening. It is not uncommon for some AD/HD children to be aggressive with their siblings. Non-AD/HD siblings often recant in a group setting to avoid trouble. These individual, private meetings give them the opportunity to vent and to get a sense of being understood by the therapist thus getting some help for themselves. The aim, however, is always to develop strategies through which each family member can support every other.

That first family drawing sets the stage for the next family meeting. The second mural is a follow-up to the first – for example, the therapist will suggest that on their family vacation a large disaster occurs:

> A big storm came up, your boat was destroyed, and you all ended up on a deserted island. Draw the island and anything you saved from the boat that will help make it comfortable and safe. You may be on this island a long time. What will it look like and what will you need to survive? (Harris and Joseph 1973)

A good example of the kinds of dynamics one is likely to find is a mural by a family with two children, an 11-year-old girl and a 7-year-old boy who was the identified patient. The family had planned to show a tropical resort, but the boy wanted soldiers and tanks. The mother withdrew, while the father tried unsuccessfully to dissuade the son. When this failed, he became angry. The girl became so frustrated, she also withdrew from the project. As an attempt to involve his family, the father segmented the island so that each member could draw as they chose. However, the entire island ended up surrounded by army troops and barricades. No one was in control and the parents missed the signs that their boy was acting like a family dictator, all the while looking for one parent to set limits and establish boundaries.

The artmaking and these sessions can be extremely useful in highlighting the family dynamics. It provides a view into the family that is often difficult to see when verbal behavior is highlighted. For example, parents may just sit back and let youngsters make every important decision about a drawing. Perhaps the parents are tired of endless conflicts. Maybe they deem it necessary for their children to feel part of the democratic process. Whatever the reason, such parental weakness undermines the entire family structure as well as children's social development (Baumrind 1967; Devocic and Janssens 1992; Landgarten 1987). In a far more helpful scenario, parents work together to slow down the AD/HD person. It is a good sign when families devise methods for getting off the island. In less healthy families, the water is filled with sharks and the island dotted with wild animals and active volcanoes. They cannot imagine a safe place where everyone enjoys each other's company. On the island discussed above, each family member is isolated from the other and surrounded by chaos and conflict. Additionally, the family's feelings of helplessness are clearly depicted. These kinds of murals will lead to problem-solving discussions led by the therapist for better resolution.

Family art therapy can help parents learn to become the family leaders they need to be by providing a place to review and practice the techniques discussed in Chapter 2 on parent education groups: "I" messages, empathic responses and active listening, as well as how to use visual and physical signals such as light touches to gain a child's attention. Family art

therapy sessions not only give parents practice in being more assertive with their children, but also give the children a chance to learn how to respond correctly to their parents' new "executive" status in the family. Review is an important concept here, as it is quite difficult for an AD/HD child and/or parent to integrate new habits easily (Barkley 1995).

When a therapist is presented with a mural that clearly demonstrates a lack of leadership and embraces a chaotic structure, the therapist should help the family understand that this representation symbolizes what home life might be like for them. This should be followed by a discussion with the family regarding parenting principles, as well as an exploration of what worked and what did not work in the process. It is important to note strengths such as the creativity, resourcefulness or thoughtfulness shown by certain members, as many families at this point are feeling disillusioned and frustrated. Remind them of where they were when they started, that this is a process and that learning comes from this process.

In the family described earlier, the goal of the parents was to take charge and to remove the 7-year-old child from his inappropriate role as the family leader. In this instance, the therapist spoke directly to the boy, highlighting his active role in the project while also wondering why he surrounded everyone with guns and bombs. The therapist also suggested to the parents that if either of them had been able to take charge, their child might have been able to be more cooperative. Parents in control make the environment safe. These parents were asked to consider what they could do to make the island a safer place, which led to a family discussion of what each of them needed to feel safe.

As can be seen through this example, mural making provides fertile ground for discussion. It is up to the therapist to identify and explore key themes suggested by the murals, some of which may appear more obvious than other ones. Murals and mural making are important in family art therapy as they serve as physical evidence of the family dysfunction that cannot be denied. Further, because murals are on paper, the family can work on the pictures together to arrive at solutions.

Homework assignments

After a mural is completed, the parents often realize how frustrated they were. The patterns of interaction that emerge in the process of doing the mural become the basis for a homework assignment. The therapist should assign each member of the family a task to work on at home. These assignments should be written and visible so that each member has a friendly reminder of the task. Place Post-It notes wherever they are likely to be seen; perhaps some publicly in the kitchen and others placed privately by individual members as reminders to themselves. For parents, it is also important to try to "catch their children being good" and compliment each other and their children whenever a family member shows signs of working to achieve their assignment (Brooks 1975).

In the example above, the therapist assigned the 7-year-old the task of working with his anger by using his words. The parents were told to practice listening to what their children said to them in order to validate their feelings and to take action to make the children feel safe. In the case of the mother in this family, this meant not withholding attention and affection; for the father, it meant not losing his temper. The sister was told that when she was frustrated, she could not withdraw to her room.

These are very difficult homework assignments and it is useful to let a family know that they should be able to celebrate if they are each able to accomplish their respective task at least once. What kinds of things will motivate a family to do a homework assignment? The assignment, in itself, will accomplish gains in self-esteem. However, a family "pizza night" or "movie night" are also good means of recognizing and rewarding everyone for their effort. In determining an appropriate reward, one must take into consideration the ages of children and family lifestyle.

Overall, homework assignments coupled with incentives often lead to behavior changes and provide continuity between family art therapy sessions.

Later sessions

As the family art therapy sessions continue, drawings can lead to spontaneous discoveries, even admiration. "I never knew you could draw so

well!" a daughter said to her mother. "I really had fun with you today!" the mother told her child. If the work is progressing, families come more readily to the group each week, anticipating the next activity. Parents begin assigning tasks, older children teach younger siblings and the AD/HD person begins to be seen by others as less disruptive to family life. At this point, the family may be ready to decide through discussion what they would like to do next. The therapist asks them to plan, organize, think sequentially and use the tools they have learned (such as "Stop and Think," discussed in Chapter 4) in order to work cooperatively.

But progress comes slowly and in fits and starts. Family work inevitably touches on issues within individual family members that are not related to the impact of AD/HD. One family decided to draw "our vacation together." The father, who saw himself as non-artistic, did not join in; instead he dictated his ideas to others. At the end of the session, everyone else vented his or her frustration with his non-participation. "You never do things with us; you just tell us what to do," one child said. With the mural spread in front of him, this was an eye-opener for the father. He could actually see what he had not done. In an individual session, he revealed that as a child he had never learned how to play. It was then possible to plan an activity in which he would feel comfortable participating.

The next time the family met, the therapist brought out a box filled with art materials such as buttons, fabric, glue, tiles and cardboard. The family decided to construct their dream house. It was important for the father to listen to his children as they described their ideal rooms – and he did. This wonderful project took several weeks. At the end, when they decided to make figures to stick in each room, the process was so pleasurable that they put everyone together at the dining-room table.

Summary

Art therapy works for the families of AD/HD children (and adults) in the same way that it does for the AD/HD person. It is unique, fun, creative and stimulating. Therefore, it appeals to families, and especially to those in the family who have the most difficulty in a traditional therapeutic milieu. The drawings serve as concrete evidence of progress and change. Family members often refer back to images drawn during these sessions with

more understanding of one another. The therapist becomes the family historian of their truce, using the artwork to draw out and later enhance the family system (Riley 1994). Family art therapy also gives members a chance to review and practice learning that took place in the educational groups (discussed in Chapter 4), further enhancing the learning process.

8

Summary and Resources

Art therapy is a well-documented, respected modality accepted by mental health professionals in a multi-modal approach to diagnosis and treatment of a wide variety of psychiatric disorders. However, many professionals are either not aware of, or simply not using, art therapy techniques as one of many effective diagnostic and/or treatment modalities for the AD/HD population. Hopefully, this book has documented the use of art therapy as a uniquely effective modality in both diagnosis and treatment over a long period of time, and with a broad demographic group of people – men, women and children, ages four to late seventies, from all educational and socioeconomic levels.

This book was conceived as a tool to offer other options to mental health workers. It was also written for parents and AD/HD patients to offer an alternative approach to understanding the impact of this disorder on them. The book is focused on informing the reader of the use of art therapy as one effective modality, in the diagnosis and treatment of AD/HD.

Since each AD/HD person is unlike another, art therapy can truly be effective with this population, as the art therapist's understanding of this disorder offers alternative creative therapeutic gestures that ultimately aid a patient's growth and understanding. The goal of this book is to help the reader understand the union between the use of art therapy and the AD/HD population. This is a difficult population to work with and to see change take place. It requires creativity, energy and knowledge of the diagnosis and its chronic nature.

Art therapy is creative, visual, and offers many benefits as described in this text to encouraging learning, change and understanding of the impact of AD/HD on the patient and their family members.

There are many resources to which patients, parents and other family members can refer if they wish to learn more about either art therapy or AD/HD. The remainder of this chapter provides a limited list of suggested resources.

ART THERAPY
Associations

American Art Therapy Association
1202 Allanson Road
Mundelein, IL 60060
USA
Tel: (+1) 847 949 6064
Webpage: http://www.arttherapy.org
Email: arttherapy@ntr.net

Australian Art Therapy Association
PO Box 303
Glebe
New South Wales, 2037
Australia

British Association of Art Therapists
1 Holford Road
London NW3 1AD
UK

International Arts Medicine Association
714 Old Lancaster Road
Bryn Mawr, PA 19010
USA
Tel: (+1) 610 525 3784
Webpage: http://members.aol.com/iamaorg

International Association for Art
Creativity and Therapy
Rumelinbachweg 20
Switzerland 4054

International Expressive Arts Therapy Association
PO Box 64126
San Francisco, CA 96164
USA
Tel: (+1) 415 522 8959

Journals

Art Therapy Journal of the American Art Therapy Association. Available from the AATA, 1202 Allanson Road, Mundelein, IL 60060, USA.

American Journal of Art Therapy, Vermont College of Norwich University, Montpelier, VT 05602, USA.

The Arts in Psychotherapy, Elsevier Science Inc., 660 White Plains Road, Tarrytown, NY 10591-5153, USA.

International Journal of Arts-Medicine, MMB Music Inc., 3526 Washington Avenue, St. Louis, MO 63103, USA.

ATTENTION-DEFICIT/HYPERACTIVITY DISORDER

Special interest newsletters/magazines

ADDitude Magazine
PO Box 2687
Houston, TX 77252-9693
USA

ATTENTION
1859 North Pine Island Road, Suite 1885
Plantation, FL 33322
USA

ADDendum
c/o CPS
5041 Black Lick Road
Annandale, VA 22003
USA

ADDult News
c/o Mary Jane Johnson
2620 Ivy Place
Toledo, OH 43613
USA

ADDvance
1001 Spring St, Suite 206
Silver Spring, MD 20910
USA

The ADHD Report
Guilford Publications Inc.
72 Spring Street
New York, NY 10012
USA

Challenge
Challenge Inc.
PO Box 488
West Newbury, MA 01985
USA

Journal of Attention Disorders
908 Niagara Falls Blvd
North Tonawanda, NY 14120-2060
USA

Learning Disabilities Association of America
156 Library Road
Pittsburgh, PA 15234
USA

Strategies for Success: Helping the Child with ADHD
1633 Babcock, Suite 231
San Antonio, TX 78229
USA

The ADHD CHALLENGE
PO Box 3225
Peabody, MA 01961-3225
USA

Catalogs

SourceADD Catalog
1255 Rosewood, Suite A
Ann Arbor, MI 48104
USA

ADD Resources
Mail Order Material
154 Curtis
Valparaiso, IN 46383-9111
USA

A.D.D. Warehouse
300 Northwest 70th Avenue, Suite 102
Plantation, FL 33317
USA
Tel: (+1) 800 233 9273 for catalog

Organizational help and coaching

AddImpact
Nancy Ratey, Ed.M.
Wellesley, MA 02482
USA
Tel: (+1) 781 237 3508

Attention Deficit Disorders Institute
Frank Safran, Ph.D.
127 Kings Hwy N.
Westport, CT 06880
USA
Tel: (+1) 203 221 4707

American Coaching Association
PO Box 353
Lafayette Hill, PA 19444
USA
Tel: (+1) 610 825 4505

National Association of Professional Organizers
1033 La Posada Drive
Austin, TX 78752
USA
Tel: (+1) 512 454 3036

Organizations/conferences on AD/HD

ADDA (National Attention Deficit Disorder Association)
PO Box 972
Mentor, OH 44063
USA

AIEN (Adult Information Exchange Network)
PO Box 1701
Ann Arbor, MI 48106
USA

CHADD (Children and Adults with ADD)
1859 North Pine Island Rd, Suite 2885
Plantation, FL 33322
USA

LDA (Learning Disorders Association)
4156 Library Road
Pittsburgh, PA 15234
USA

Online resources for AD/HD

Check under AD/HD, ADD, Adult, Children and Parent Support Groups:

American Online
CompuServe
Prodigy
Listservs
Medline

Book resources for children

Blazer, B. (1998) *A Child's Guide to Concentrating: For kids with ADHD.* Morristown, NJ: Shire Richmond.

Caffrey, J. (1997) *First Star I See.* Fairport, NY: Verbal Images Press.

Galvin, M. (1988) *Otto Learns about his Medication.* New York: Magination Press.

Gehret, J. (1991) *A Child's Guide to Paying Attention.* Fairport, NY: Verbal Images Press.

Gehret, J. (1992) *I'm Somebody Too.* Fairport, NY: Verbal Images Press.

Gordon, M. (1991) *Jumping Johnny, Get Back to Work! A Child's Guide to ADHD.* DeWitt, NY: GSI Publications.

Gordon, M. (1993) *I Would if I Could; A Teenager's Guide to ADHD/Hyperactivity.* DeWitt, NY: GSI Publications.

Gordon, M. (1992) *My Brother's a World-Class Pain: A Sibling's Guide to ADHD/Hyperactivity.* DeWitt, NY: GSI Publications.

Holmes, S. (1995) *I'm Just an Ordinary Kid.* Fairport, NY: Verbal Images Press.

Levine, M. (1993) *All Kinds of Minds.* Cambridge, MA: Educators Publishing Service.

Levine, M. (1990) *Keeping a Head in School.* Cambridge, MA: Educators Publishing Service.

Meyer, D., Vadasy, P. and Fewell, R. (1985) *Living with a Brother or Sister with Special Needs: A Book for Sibs.* Seattle, WA: University of Washington Press.

Moss, D. (1989) *Shelly the Hyperactive Turtle.* Rockville, MD: Woodbine House.

Nadeau, K. and Dixon, E. (1993) *Learning to Slow Down and Pay Attention.* Annandale, VA: Chesapeake Psychological Publications.

Neuville, M.B. (1991) *Sometimes I Get All Scribbly.* Austin, TX: Crystal Press.

Parker, R. (1992) *Making the Grade: An Adolescent's Struggle with ADD.* Plantation, FL: Impact Publications.

Parker, R. (1993) *Slam Dunk: A Young Boy's Struggle with Attention Deficit Disorder.* Plantation, FL: Impact Publications.

Quinn, P. and Stern, K. (1991) *"Putting on the Breaks"": Young People's Guide to Understanding Attention Deficit Hyperactivity Disorder.* New York: Magination Press.

Shapiro, L. (1993) *Sometimes I Drive My Mom Crazy, But I Know She's Crazy About Me.* King of Prussia, PA: Center for Applied Psychology.

Sternberg, K. (1997) *Mama's Morning.* Bethesda, MD: Advantage Books.

Thompson, M. (1992) *My Brother Matthew.* Rockville, MD: Woodbine House.

Weiner, E. (1999) *Taking A.D.D. to School.* Valley Park, MO: JayJo Books.

References

Abraham, A. (1991) 'The projection of the inner group drawing.' *Group Analysis 23*, 4, December.

Achenbach, T. (1991) *Manual for the Child Behavioural Checklist and Revised Child Behavior Profile.* Burlington, VT: T.M. Achenbach

Achenbach, T. and Edelbrock, C. (1986; 1991) *Manual for the Teacher Report Form and the Child Behavior Profile.* Burlington, VT: University of Vermont.

Ackerman, P., Dylman, R. and Oglesby, D. (1983) 'Sex and group differences in reading in attention disordered children with and without hyperkinesis.' *Journal of Learning Disabilities* 16, 7, 407–415.

American Art Therapy Association (1996) *Fact sheet.* Mundelein, IL: American Art Therapy Association.

Ayres, A. (1979) *Sensory Integration and the Child.* Los Angeles: Western Psychological Services.

Ball, J., Tiernan, M., Janusz, J. and Furr, A. (1997) 'Sleep patterns among children with attention-deficit hyperactivity disorder: A reexamination of parent perceptions.' *Journal of Pediatric Psychology 22*, 3, 389–398.

Barkley, R. (1990) *Attention Deficit Hyperactivity Disorder: A Handbook for Diagnosis and Treatment,* PhD. New York: Guilford Press.

Barkley, R. (1995) *Taking Charge of ADHD – The Complete Authoritative Guide for Parents.* New York: Guilford Press.

Barkley, R. (1997) *ADHD and the Nature of Self-Control.* New York: Guilford Press.

Barkley, R. (1998) *Attention-Deficit Hyperactivity Disorder: A Handbook for Diagnosis and Treatment,* 2nd ed. New York: Guilford Press.

Barkley, R. and DuPaul P. (1990) 'School situation questionnaire, revised' and 'Home situations questionnaire, revised.' *Attention Deficit and Hyperactivity Disorder: A Clinical Workbook.* New York: Guilford Press.

Baumrind, D. (1967) 'Childcare practices anteceding three patterns of preschool behavior.' *Genetic Psychology Monographs 75,* 43-88.

Bender, L. (1938) 'A visual-motor gestalt test and its clinical use.' *American Orthopsychiatric Association Research Monographs,* 3.

Benedetto, N. and Tannock, R. (1999) 'Math computation, error patterns and stimulant effects in children with Attention Deficit Hyperactivity Disorder.' *Journal of Attention Disorders 3,* 3, 121–134.

Berkowitz, E. (1998) 'Learning to love and live with an ADD Wife.' *ADDvance: A Magazine for Women with Attention Deficit Disorder 1,* 4, 23–27.

Blakemore, B., Shindler, S. and Conte, R. (1994) 'A problem solving training program for parents of children with attention deficit hyperactivity disorder.' *Canadian Journal of School Psychology 9,* 1, 66–85.

Blos, P. (1962) On Adolescence. New York: Free Press.

Blos, P. (1979) *The Adolescent Passage.* New York: International Universities Press.

Braswell, L. and Bloomquist, M. (1991) *Cognitive-Behavioral Therapy with AD/HD Children.* New York: Guilford Press.

Brooks, R. (1994) 'Children at risk: Fostering resilience and hope.' *American Journal of Orthopsychiatry 64,* 266–278.

Brooks, R. (1995) *Fostering Resiliency in Children.* Trumbull, CT: Connecticut Association for Children and Adults with Learning Disabilities Conference.

Buck, J. (1978) *The House–Tree–Person Technique.* New York: Western Psychological Services.

Burns, R. and Kaufman, H. (1972) *Actions, Styles, and Symbols in Kinetic Family Drawings.* New York: Brunner/Mazel.

Burte, J. and Burte, C. (1994) 'Ericksonian hypnosis, pharmacotherapy and cognitive-behavior therapy in the treatment of ADHD.' *Australian Journal of Clinical Hypnotherapy and Hypnosis 15,* 1, 1–13.

Cane, F. (1951) *The Artist in Each of Us.* New York: Pantheon.

Cantwell, D. P. and Baker, L. (1991) 'Association between attention deficit-hyperactivity disorder and learning disorders.' *Journal of Learning Disabilities 24,* 2, 88–95.

Capel, J. and Brown, K. (1997) 'The impact of ADD on couples.' *Attention, Magazine of CHADD 3,* 4, 18–22.

Case, C. and Dalley, T. (eds) (1990) *Working with Children in Art Therapy.* New York: Tavistock/Routledge.

Claussen, B. (1998) 'Coping with a spouse who has AD/HD.' *Attention, Magazine of CHADD 5, 2,* 53–54.

Cohen, C. (2001) *Raise Your Child's Social I.Q.* Silver Spring, MD: Advantage Books.

Conners, C. (1990) *Manual for Conners's Rating Scales.* New York: Multi-Health Systems.

Conners, C. (1997a) *Teacher Information Form for Conners's Rating Scales.* New York: Multi-Health Systems.

Conners, C. (1997b) *Parent and Teacher Rating Scales Revised Version: Long Form DSMIV Scale.* New York: Multi-Health Systems.

Corkum, P., Rimer, P. and Schachar, R. (1999) 'Parental knowledge of attention-deficit hyperactivity disorder and opinions of treatment options: Impact on enrollment and adherence to a 12-month treatment trial.' *Canadian Journal of Psychiatry 56,* 12, 1097–1099.

Dalley, T. (1993) *Art Psychotherapy Groups. Group Work with Children and Adolescents.* London: Jessica Kingsley Publishers.

Detweiler, R., Hicks, A. and Hicks, M. (1996) 'The multi-modal diagnosis and treatment of Attention Deficit Hyperactivity Disorder.' *England-Journal of Therapeutic Care and Education 4,* 2, 4–9.

Devocic, M. and Janssens, J. (1992) 'Parents' child-rearing style and child's sociometric status.' *Developmental Psychology 28,* 925–932.

DSM II (APA 1967), DSM III (1968), DSM IIIR (1980), DSM IV (1987), DSM IVR (1994). *American Psychiatric Association.*

DuPaul, G. and Stoner, G. (1994) *ADHD in the Schools: Assessment and Intervention Strategies.* New York: Guilford Press.

Ellison, P. (2000a) 'Building social skills in children with AD/HD: A multimodal approach.' *CHADD AD/HD Resource Manual,* pp.40–42.

Ellison, P. (2000b) 'Strategies for adolescents with AD/HD: Goal setting and increasing independence.' *CHADD AD/HD Resource Manual,* pp.68–70.

Fagan, J. (1996) 'Medical problems in the classroom: The teacher's role in diagnosis and management.' In R. Haslam and P. Valletutti (eds) *Attention Deficit Disorder,* 3rd ed. Austin, TX: Pro-Ed.

Goldstein, M. and Goldstein, S. (1991) *It's Just Attention Disorder* (video). Salt Lake City: Neurology Learning and Behavior.

Golomb, C. (1990) *The Child's Creation of a Pictorial World.* Berkeley: University of California Press.

Hadley, N. (1999) 'Maintaining art therapy connections: Verbal dialogue–image connections.' *International Journal of Arts Medicine 6*, 1, 31–33.

Hallowell, E. and Ratey, J. (1994) *Driven to Distraction*. New York: Pantheon Books.

Hamilton, M. (1969) 'Diagnosis and rating of anxiety.' *British Journal of Psychology 3*, special publication, 76–79.

Hammer, E. (1967) *Clinical Applications of Projective Drawings*. Springfield, IL: Charles C. Thomas.

Harris, J. and Joseph, C. (1973) *Murals of the Mind*. New York: International Universities Press.

Henley, D. (1998a) 'Art therapy as an aide to socialization in children with ADD.' *American Journal of Art Therapy 37*, 1, 2–7.

Henley, D. (1998b) 'Art therapy in a socialization program for children with Attention Deficit Hyperactivity Disorder.' *Art Therapy: Journal of the American Art Therapy Association 37*, 2–12.

Hoffman, L. (1981) *Foundations of Family Therapy*. New York: Basic Books.

Jensen, P. (1999) 'Fact versus fancy concerning the multimodal treatment study for attention-deficit-hyperactivity disorder.' *Journal of Psychiatry 44*, 10, 975–980.

Jensen, P., Hinshaw S., Swanson, J., Greenhill, L., Conners, C. and Arnold, L. (2001) 'Findings from the NIMH multimodal treatment study of AD/HD (MTA): Implications and applications for primary care providers.' *Journal of Developmental and Behavioral Pediatrics 22*, 1, 60–73.

Kanfer, F. (1971) 'The maintenance of behavior by self-generated stimuli and reinforcement.' In A. Jacobs and L.B. Sachs (eds) *The Psychology of Private Events: Perspectives on covert response systems*. New York: Academic Press.

Kelly, K. and Luquet, M. (1994) 'The impact of adult ADD on intimate relationships.' *Couples Therapy Manual*. Chicago, IL: Institute for Imago Relationship Therapy.

Kelly, K. and Ramundo, P. (1993) *You Mean I'm Not Lazy, Stupid, or Crazy?* Cincinnati, OH: Jerem Press.

Kwiatkowska, H. (1978) *Family Therapy and Evaluation Through Art*. Springfield, IL: Charles C. Thomas.

Landgarten, H. (1987) *Family Art Psychotherapy*. New York: Brunner/Mazel.

Lavoie, R. (1994) 'Tales from the road: What's going on out there?' *CHADD Conference*, New York, NY.

Levick, M. (1983) *They Could not Talk and so They Drew.* Springfield, IL: Charles C. Thomas.

Levine, E. (1989) 'Women and creativity: Art in relationship'. *Arts in Psychotherapy 16,* 4, 309–325.

Levine, M. (1986) *Self-Administered Student Profile – Form For Ages 9+ (revised).* Cambridge, MA: Educators Publishing Service.

Malchiodi, C. (1998) *Understanding Children's Drawings.* New York: Guilford Press.

McCarney, S. (1989a) *Attention Deficit Disorders Scale – Home Version.* Columbia, MO: Hawthorne Educational Services.

McCarney, S. (1989b) *Attention Deficit Disorders Scale – School Version.* Columbia, MO: Hawthorne Educational Services.

McGoldrick, M. and Gerson, R. (1985) *Genograms in Family Assessment.* New York: Norton.

McNeilly, G. (1990) *Group Analytic Art Groups.* New York: Tavistock-/Routledge.

Meyer, S. L. (1998) 'Creating an ADD-friendly family environment.' *ADDvance: A Magazine for Women with Attention Deficit Disorder 1,* 4, 5–8.

Miller, A. (1999) 'Appropriateness of psychostimulant prescription to children: Theoretical and empirical perspectives.' *Canadian Journal of Psychiatry 44,* 10, 1017–1024.

Mills, A. (1992) 'Art therapy on a residential treatment team for troubled children.' *Journal of Child and Youth Care 6,* 4, 49–59.

Minuchin, S. (1974) *Families and Family Therapy.* Cambridge, MA: Harvard University Press.

Mooney, K. (2000) 'Focusing on solutions through art: A case study.' *Australian and New Zealand Journal of Family Therapy 21,* 1, 34–41.

Murphy, K. (1992) *Evaluation Interviews for Adult ADHD.* Amherst, MA: University of Massachusetts Medical Center.

Murphy, K. and LeVert, S. (1995) *Out of the Fog: Treatment Options and Coping Strategies for Adult ADHD.* New York: Hyperion-Skylight Press.

Nadeau, K. (1994) *HELP4ADD@HIGHSCHOOL.* Silver Spring, MD: Advantage Books.

Nadeau, K. (1996) *Adventures in Fast Forward.* New York: Brunner/Mazel.

Nadeau, K. (1997) *ADD in the Workplace.* New York: Brunner/Mazel.

Nadeau, K., Littman, E. and Quinn, P. (1999) *Understanding Girls with ADHD.* Silver Spring, MD: Advantage Books.

Nadeau, N. and Quinn, P. (2002) *Understanding Women with AD/HD.* Silver Spring, MD: Advantage Books.

National Institute of Mental Health (1994) *The National Institute of Mental Health Study on the Multimodal Treatment of Attention-Deficit Hyperactivity Disorder,* Publication No. 96–3572, Washington, DC: NIMH.

Ohan, J. and Johnston, C. (1999) 'Attributions in adolescents medicated for attention-deficit/hyperactivity disorder.' *Journal of Attention Disorders 3,* 1, 49–60.

Olive, J. (1991) 'Development of group interpersonal skills through art therapy.' *Journal of Maladjustment and Therapeutic Education 9,* 3, 174–180.

Pappas, M. G. (1982) *Sweet Dreams for Little Ones.* San Francisco: Harper.

Pelham, W. (1999) 'The NIMH multimodal treatment study for attention-deficit hyperactivity disorder: Just say yes to drugs alone?' *Canadian Journal of Psychiatry 44,* 10, 981–990.

Peterson, D. and Ratey, N. (1995) 'Bringing order to disorder: The value of coaching.' *ADDvance: A Magazine for Women with Attention Deficit Disorder 1, 4, 3.*

Pfeiffer, L. (2000) 'Promoting social competency in attention deficit hyperactivity disordered elementary-aged children.' *Practicum Report,* Nova University, Fort Lauderdale, FL.

Phelan, T. (1990) *1-2-3: Magic! Training Your Preschoolers and Preteens to Do What You Want,* 2nd ed. Glen Ellyn, IL: Child Management Press.

Quinn, P. (1994) *ADD and the College Student: A Guide for High School and College Students with Attention Deficit Disorder.* New York: Magination Press.

Quinn, P. (1995) *Adolescents and ADD: Gaining the Advantage.* New York: Magination Press.

Quinn, P. (1997) *Women and ADD: Myths and Realities.* Presentation at the Connecticut Association for Children with Learning Disabilities Conference, Trumbull, CT.

Quinn, P. and Stern, J. (1991) *Putting on the Brakes.* New York: Magination Press.

Quinn, P., Ratey, N. and Maitland, T. (2000) *Coaching College Students with AD/HD.* Silver Spring, MD: Advantage Books.

Ratey, J., (1991) 'Paying attention to attention in adults?' *CHADD 5, 2, 13.*

Ratey, J. (1994) *CHADD Conference.* San Diego, CA.

Ratey, J. and Miller, A. (1992) 'Foibles, frailties, and frustrations seen through the lens of attention.' Presented at Attention Deficit Disorders Conference. Boston, MA: Harvard Medical School, December 1995.

Reynolds, W. (1986) *Reynolds Adolescent Depression Scale (RADS) Form HS.* Odessa, FL: Psychological Assessment Resources.

Riley, S. (1994) *Integrative Approaches to Family Art Therapy.* Chicago, IL: Magnolia Street Publishers.

Riley, S. (1999) *Contemporary Art Therapy with Adolescents.* London: Jessica Kingsley Publishers.

Ring, A., Stein, D., Barak, Y., Teicher, A., Hadjez, J., Elizur, A. and Weizman, A. (1998) 'Sleep disturbances in children with attention-deficit-/hyperactivity disorder: a comparative study with healthy siblings.' *Journal of Learning Disabilities 31,* 6, 572–578.

Robin, A. (2001) 'Can your marriage survive AD/HD?' *ADDvance: A Magazine for Women with Attention Deficit Disorder 4,* 3, 16–20.

Rubin, J. (1978) *Child Art Therapy.* New York: Van Nostrand Reinhold.

Safran, D. (1989) 'The use of art therapy for diagnosis and treatment of Attention Deficit Hyperactivity Disorder with children and adolescents.' Presentation to CHADD of Bergen County, NJ.

Safran, D. (1991-4) 'Diagnosis and management of AD/HD: Use of art therapy in social skills groups with the Attention Deficit Disorder population,' 'ADD – the impact on the family' and 'The multimodal approach to Attention Deficit Hyperactivity Disorder.' Presentations given to CHADD of Fairfield County, CT.

Safran, D. (1993) 'Multimodal approach to diagnosis and treatment of Attention Deficit Hyperactivity Disorder.' Presentation at Hallbrook Hospital, Westport, CT.

Safran, D. (1994a) 'Multimodal approach to diagnosis and treatment of Attention Deficit Hyperactivity Disorder.' Presentation at the Learning Disabilities Association Conference, New York.

Safran, D. (1994b) 'Multi-disciplinary treatment of AD/HD includes art therapy groups.' Presentation at the American Art Therapy Conference, Chicago, IL.

Safran, D. (1995) 'Multi-disciplinary treatment of AD/HD includes art therapy groups.' Presentation at the American Art Therapy Conference. San Diego, CA.

Safran, D. (1996) 'Multi-disciplinary treatment of AD/HD includes art therapy.' Presentation at the American Art Therapy Association, Philadelphia, PA.

Safran, D. (1997a) 'Use of art therapy with AD/HD clients.' Presentation at the Delaware Art Therapy Association, Philadelphia, PA.

Safran, D. (1997b) 'The multi-disciplinary diagnosis and treatment of AD/HD using art therapy.' Presentation at the Wayne State University, Detroit, MI.

Safran, D. (1998, 1999) 'AD/HD – Impact on mothers: The Mother has AD/HD, now what?' and 'AD/HD can kill a marriage – couples art therapy groups.' Presentation at the American Art Therapy Association, Portland, OR and Orlando, FL.

Safran, D. (2000) 'AD/HD and art therapy.' Presentation at the American Art Therapy Association, St. Louis, MO.

Safran, D. (2001) 'An art therapy approach to Attention Deficit-/Hyperactivity Disorder.' In C.A. Malchiodi (ed.) *The Clinical Handbook of Art Therapy.* New York: Guilford Press.

Safran, D. and Safran, F. (1995) 'Joining hands: The multi-disciplinary model for treatment of Attention Deficit Disorder.' Post Conference Course at the American Art Therapy Association Conference, San Diego, CA.

Searight, H. R. (2000) 'Close relationships, intimacy, and AD/HD.' *The CHADD Information and Resource Guide to AD/HD.* Landover, MD: CHADD.

Shaywitz, S., Schnell, C., Shaywitz, B. and Towle, V. (1986) 'Yale Children's Inventory (YCI): An instrument to assess children with attention deficits and learning disabilities: Scale development and psychometric properties.' *Journal of Abnormal Child Psychology 14,* 347–364.

Silver, R. (1996) *Silver Drawing Test of Cognition and Emotion.* Sarasota, FL: Ablin Press.

Snider, V., Frankenberger, W. and Aspenson, M. (2000) 'The relationship between learning disabilities and attention deficit hyperactivity disorder: A national survey.' *Developmental Disabilities Bulletin 28,* 1, 18–38.

Solden, S. (1995) *Women with Attention Deficit Disorder.* Grass Valley, CA: Underwood Books.

Sonuga, B., Edmund, J., Daley, D., Thompson, M. and Laver-Bradbury, C. (2001) 'Parent-based therapies for preschool attention-deficit-/hyperactivity disorder: A randomized, controlled trial with a community sample.' *Journal of the American Academy of Child and Adolescent Psychiatry 40,* 4, 402–408.

Strand, S. (1991) 'Counteracting isolation: Group art therapy for people with learning difficulties.' *Group Analysis 23,* 3, 255–263.

Sudderth, D. and Kandel, J. (1997) *Adult ADD: The Complete Handbook.* Rocklin, CA: Prima Publishing.

Thomas, G. and Silk, A. (1990) *An Introduction to the Psychology of Children's Drawings.* New York: New York University Press.

Thomson, M. (1998) *On Art and Therapy: An Exploration.* London: Free Association Books.

Train, A. (1996) *ADHD, How to Deal with Very Difficult Children.* London: Souvenir Press.

Ulak, B. and Cummings, A. (1997) 'Using clients' artistic expressions as metaphor in counseling.' *Canadian Journal of Counseling 34,* 4, 305–316.

Ullmann, R., Sleator, E. and Sprague, R. (1991) *Acters Profile – Boys and Girls Form.* Illinois: MetriTech.

Ulman, E. (1965) 'A new use of art in psychiatric diagnosis.' *Bulletin of Art Therapy 4,* 91–116.

Ulman, E. (1975) *Art Therapy in Theory and Practice.* New York: Schocken Books.

US Department of Education (1991) 'Policy Clarification Memorandum: IDEA (20 U.S.C. #1401) and Section 504 (29 U.S.C. #794) of Rehabilitation Act of 1973.' Washington DC: US Department of Education.

Wachtel, A. (1998) *The Attention Deficit Answer Book.* New York: Plume Penguin.

Wallace, B., Winsler, A. and Nesmith, P. (1999) 'Factors associated with success for college students with ADHD: Are standard accomodations helping?' *Annual Meeting of the American Educational Research Association.* Montreal, Canada.

Waller, D. (1993) *Group Interactive Art Therapy: Its Use in Training and Treatment.* Florence, KY: Taylor and Francis/Routledge.

Waschbusch, D., Kipp, H. and Pelham, W. (1998) 'Generalization of behavioral and psychostimulant treatment of attention-deficit-/hyperactivity disorder (AD/HD): Discussion and examples.' *Journal of Behaviour Research and Therapy 36,* 7/8, 675–694.

Weiss, L. (1999) *Attention Deficit Disorder in Adults.* Dallas, TX: Taylor.

Weiss, M., Hechtman, L. and Weiss, G. (1999) *ADHD in Adulthood: A Guide to Current Theory, Diagnosis and Treatment.* Baltimore: Johns Hopkins University Press.

Weiss, M., Hechtman, L. and Weiss, G. (2000) 'AD/HD in parents.' *Journal of the American Academy of Child and Adolescent Psychiatry 39,* 8, 1059–1061.

Wender, P. (1995) *Attention-Deficit Hyperactivity Disorder in Adults.* New York: Oxford University Press.

White, M. (1996) 'How adult ADHD affects relationships: Strategies for coping.' *Challenge 6*, 1–4.

Widener, A. (1998) 'Beyond ritalin: The importance of therapeutic work with parents and children diagnosed with ADD/ADHD.' *Journal of Child Psychotherapy 24*, 2, 267–281.

Yalom, I. (1995) *The Theory and Practice of Group Psychotherapy.* New York: Basic Books.

Young, S. (1999) 'Psychological therapy for adults with Attention Deficit Hyperactivity Disorder.' *Counseling Psychology Quarterly 12*, 2, 183–190.

Zametzin, A. (1990) *Neurobiology of ADD* presented at the second annual CHADD Conference, Washington DC, November 9th 1990 (audiotape). Planation, FL: CHADD.

APPENDIX 1

Parent Educational Group Tools

"I" v "You" messages

The purpose of this is to help parents understand a child's position in the family through role playing. The concept of "you" messages, in which a message is delivered to the recipient in an accusatory tone with the emphasis on "you" always do this, or "you" never do that. We break the group up into pairs and ask one of the pair to play the child and one to play the parent. The "parent" towers over the "child" and points his/her finger at the "child" who is on his/her knees to accentuate the size difference. A "you" message is delivered to the child in a stern, accusing voice. Roles are then reversed, so both can have the experience of delivery and receipt of a "you" message. In feedback, the "child" and "parent" are asked to talk about feelings in both roles. In the second part of this exercise parents are given a tool, the "I" message, in which they are able to learn a way of communicating how their child's behavior affects them without a put-down.

Active listening

This tool teaches the parent the difficulty AD/HD children have listening. It requires practice with parents to encourage them to ask their children to make eye contact as well as to be aware of the need children have for eye contact in aiding listening by removing distractions. This includes parents learning the value of physical contact for cueing. Touching the child, using a calm voice and making eye contact are variations of cueing that aid in sustained focused attention.

1-2-3: Magic!

This important tool is used to help parents take appropriate executive roles in their families. We use the video by Dr Phelan to help parents learn the techniques. The book is also distributed to supplement and support what they have seen on the video. Two sessions are devoted to the concept of behavior management with lecture and question and answer time devoted to specific problems that parents are having with their children at home.

The immediate reaction recommended by *1-2-3: Magic!* helps children to "stop and think" and to cease behaviors that are inappropriate before they get out of hand. Discussion is open to any method of delivering immediate consequences for inappropriate behavior with little emotion and little talking. Parents are encouraged to read the book and begin using this tool immediately.

Behavioral charts

This tool is used to help parents identify and encourage appropriate activities along with an objective system of delivering modest rewards and praise for success. It is suggested that the chart be produced by all members of the family as a part of or offspring of a family meeting, which fosters ownership of the tasks requested. Charts must be age appropriate. Tasks should be limited to very specific behaviors that parents wish to foster, and must be consistently followed by parents. Charts vary according to the age of the child. Every child in the family should have a chart.

Family meetings

These should be no longer than 20 minutes and not during mealtimes. It is best if they are held on a weekly basis. Family meetings can be used to review the previous past week and preview the upcoming one. Other suggested uses of the meetings are to set goals for the upcoming week, review and revise family charts, distribute rewards from the previous week's performance and plan family activities. A calendar should be used as a visual tool to help with time management. Posting family activities on

the calendar also helps with organization and predictability. (Color code activities on the calendar for each family member.)

Visual cues

Because children with AD/HD have difficulty staying focused, they need parental help in attracting and holding their attention when communication is necessary. Several of the visual cues described in the groups are listed here, as examples of helping children know where and when to look for communication:

- Post-It™ notes
- blackboard or message board
- red signs held up for "stop" behavior
- green signs held up for "start" behavior.

These tools are examples of those taught to parents in the educational groups. A great body of literature has been written about behavior management strategies. The primary goal is for parents to be consistent and predictable, and to use techniques with AD/HD children that help them learn and maintain their interest in better behavior. When parents are not consistent, children lose faith and tend to become more resistant to change.

Understanding the core symptoms of AD/HD, it is important to stress that the tools be simple and realistic for both parent and child. To make things too complex creates a higher risk for failure.

Reference material for parents
Books and articles

Barkley, R. B. (1990) *Attention Deficit Hyperactivity Disorder.* New York: Guilford Press.

Brooks, R. B. (1992) 'Fostering self-esteem in children with ADD: The Search for islands of competence.' *CH.A.D.D.er 6*, 3, 14–16.

CHADD (1988) *Attention Deficit Disorders: A Guide for Teachers.* Plantation, FL: CHADD.

CHADD (1993) 'Medical management of attention deficit disorder.' CHADD Facts 3. Plantation FL: CHADD.

Conners, C. K. (1969) 'A teacher rating scale for use in drug studies with children.' *American Journal of Psychiatry 125*, 884–888.

Conners, C. K. (1989) *Conners's Teachers' Rating Scale – 28 (CTRS-28).* Tonawanda, NY: Multi-Health Systems.

DuPaul, G. J. (1991) 'Parent and teacher ratings of ADHD symptoms: Psychometric properties in a community-based sample.' *Journal of Clinical Child Psychology 20*, 3, 203–219.

Fowler, M. (1992) *CH.A.D.D. Educators Manual: An In-depth Look at Attention Deficit Disorders from an Educational Perspective.* Plantation, FL: CHADD.

Hallowell, E. M. and Ratey, J. (1994) *Driven to Distraction.* New York: Pantheon Books.

Office of Civil Rights (1994) *OCR Facts: Section 504 Coverage of children with ADD.* Washington, DC: Office of Civil Rights, Department of Education.

Pelham, W.E. (1989) 'Behavior therapy, behavioral assessment, and psychostimulant medication in the treatment of attention deficit disorders: An interactive approach.' In L. M. Bloomingdale and J. M. Swanson (eds) *Attention Deficit Disorder: IV. Emerging trends in attentional and behavioral Disorders of Childhood* (pp. 169–202). New York: Pergamon Press.

Phelan, T.W. (1990) *1-2-3: Magic! Training your Children to do What You Want,* 2nd ed. Glen Ellyn, IL: Child Management Press.

Silver, L. B. (1992) *The Misunderstood Child: A Guide for Parents of Children with Learning Disabilities.* Blue Ridge Summit, PA: Tab Books.

Silver, L. B. (1993) *Dr. Larry Silver's Advice to Parents on Attention Deficit Hyperactivity Disorder.* Washington, DC: American Psychiatric Press.

Solden, S. (1995) *Women with Attention Deficit Disorder.* Grass Valley, CA: Underwood Books.

Wender, P. (1987) *The Hyperactive Child, Adolescent, and Adult.* New York: Oxford Press.

Zametkin, A. J. (1991) 'The neurobiology of attention deficit hyperactivity disorder.' *CH.A.D.D.er 5*, 1, 10–11.

Zametkin, A. J., Nordahl, T. E., Gross, M., King, A. C., Semple, W. E., Rumsey, J., Hamburger, S. and Cohen, R. M. (1990) 'Cerebral glucose metabolism of adults with hyperactivity of childhood onset.' *New England Journal of Medicine 323*, 1361–1364.

Videos

AD/HD: What Do We Know? Narrated by Russell A. Barkley. Guilford Publications, Dept. 8A, 72 Spring Street, New York, NY 10012.

AD/HD: What Can We Do? Narrated by Russell A. Barkley. Guilford Publications, Dept. 8A, 72 Spring Street, New York, NY 10012.

It's Just Attention Disorder. Sam Goldstein. Childswork, Childsplay. Center for Applied Psychology, Inc. P.O. Box 1586, King of Prussia, PA 19406.

1-2-3: Magic! Training your Preschooler and Preteen to do what you want them to do Thomas Phelan. Child Management Press, Glen Ellyn, IL.

Teaching/training materials

Educators Manual. Mary Fowler in collaboration with R. Barkley, R. Reeve, and S. Zentall. Case Associates. 3927 Old Lee Highway, Fairfax, VA 22030.

ADAPT: Attention Deficit Accommodation Plan for Teaching. Harvey Parker. ADD Warehouse.

Home Token Economy. Jack Alvord. ADD Warehouse.

Listen, Look, and Think: A Self-Regulation Program for Children. Harvey Parker. ADD Warehouse.

Materials used for diagnosis

Achenbach, T. M. (1991) *Child Behavior Checklist for Ages 4-18*. Burlington: University of Vermont.

American Psychiatric Association (1994) *Diagnostic and Statistical Manual of Mental disorders*, 4th edn. Washington, DC: APA.

Conners, C. K. (1989) *Conners's Teachers' Rating Scale – 28 (CTRS-28)*. Tonawanda, NY: Multi-Health Systems.

DuPaul, G. J. (1991) 'Parent and teacher ratings of ADHD symptoms: Psychometric properties in a community-based sample.' *Journal of Clinical Child Psychology 20, 3, 245–253.*

Nadeau, K. and Quinn, P. (2001) *Self-Assessment Symptom Inventory*. Silver Spring, MD: Advantage Books.

Office of Civil Rights (1994) *OCR facts: Section 504 Coverage of children with ADD*. Washington, DC: Office of Civil Rights, Department of Education.

Organizations

ADDA (Attention Deficit Disorder Association)
1788 Second Street, Suite 200
Highland Park, IL 60035
USA

CHADD (Children and Adults with ADD)
8181 Professional Place, Suite 201
Landover, MD 20785
USA

Rules established and posted by the therapist

- Use appropriate words, not hands or feet.

- Maintain eye contact with speaker.

- Respond to visual or physical cues such as a tap on the shoulder.

- Wait your turn.

- Stop and think.

- Be respectful of others. Think about how put-downs or mean comments have made you feel, and try not to do that to other people.

- Do not destroy others' artwork.

- Practice being a good listener.

- Do not go into others' personal space without being invited.

- Use appropriate indoors voice.

- For children aged 4 to 10, the therapist reinforces their efforts by "catching them being good" and putting a star next to their name. Use a "good job" list posted on the wall of the room.

- For older children and adolescents, the therapist reviews each member's behavior at the end of each group with positive feedback.

- Encourage group members to participate.

Subject Index